The Business
of Graphic Design

The Business of Graphic Design: a sensible approach to marketing and managing a graphic design firm.

Ed Gold

Watson-Guptill Publications
New York

First published 1985 in New York
by Watson-Guptill Publications, a division
of Billboard Publications, Inc.,
1515 Broadway, New York, N.Y. 10036

Library of Congress Cataloging in Publication Data
Gold, Ed, 1931–
 The Business of Graphic Design

 Includes index.
 1. Commercial art—United States—Marketing.
 2. Commercial art—United States—Management. I. Title.

NC1001.6.G65 1985 741-6'068 85-15221
ISBN 0-8230-0543-7

Distributed in the United Kingdom by Phaidon Press Ltd.,
Littlegate House, St. Ebbe's St., Oxford

Printed in Singapore

First Printing, 1985

4 5 6 7 8 9 10/90

Dedicated
to Irv

Acknowledgments

This book could never have been written or produced without the help and support of an awful lot of extraordinary people. I am deeply grateful and indebted to all of them.

Don Akchin, for his amazing job of organizing and editing a very complicated manuscript.

Wayne Markert, for taking the time to put the lens of a bona fide grammarian on a manuscript that was in dire need of it.

Jane and George Keller, Al Schwartzman, and Al Shapiro, for their expert advice on both the words and the design.

Robin Soltis and Claude Skelton, my associates and two of the best young designers in the country, for their help in making the design work.

Jim Craig, without whom I would never have even started this book.

Mary Suffudy and Candace Raney, my editors at Watson-Guptill, for their enthusiasm and totally blind confidence in me.

David W. Barton and all my colleagues at The Barton-Gillet Company for helping me learn the tough lessons of business which I have tried to pass along in this book.

I would also like to thank the scores of designers who found time which wasn't really there to talk to me, share their experiences and take me into their confidence.

But most of all, I would like to thank my dear wife, Bobbye, for her encouragement, advice, supreme patience and good humor, not to mention all the hours she spent typing and retyping the manuscript.

Contents

Introduction

One morning in the spring of 1983, I found myself in London with free time on my hands. It occurred to me that it might be a good idea to do something useful with that time—something that would permit me to take a tax write-off for my trip, for instance. Since I teach a couple of design courses, I thought that an interview with a leading British designer might generate some good lecture material on the differences and similarities between British and American design firms.

I called the offices of Pentagram, and, as luck would have it, I managed to get through to John McConnell, one of the firm's nine partners. John very graciously agreed to see me. As we talked, I found myself more and more fascinated with Pentagram's structure and business procedures (which are described in detail by partner Colin Forbes on pages 126 to 129). It became clear that while each of Pentagram's principals is a terrific designer, the real secrets to Pentagram's success are the good business practices and managerial attitudes displayed by each of the partners.

As it turned out, I didn't quite have the chutzpah to try for the tax write-off, but I got something even more valuable from the interview: the realization that few graphic designers are well prepared to run a business. This book is an outgrowth of that realization, and an effort to rectify the situation.

The U.S. Department of Labor estimates that there are about 133,000 graphic designers in the country, almost half of them self-employed. Of an estimated 3,500 operating design firms, about 500 go out of business each year.

These businesses often fail because their owners simply haven't developed the kind of sound business practices they need to cope with the day-to-day demands of a going business concern.

This need not be so. The practices and principles involved can be understood by any reasonably intelligent person who is willing to make this leap of faith: *Being a business person does not mean making a pact with the Devil.*

Judging by the curriculum offered by almost all art schools, this statement is a hairsbreadth from heresy. A designer's training focuses almost entirely upon the artistic side of the profession. A very few design schools offer courses in business—and even then, only to selected students. Although cooperative education programs offer a limited taste of the "real world" environment, that taste seldom includes anything pertaining to business or management.

By the time the student has graduated, he may or may not be an excellent young designer, with good contacts and friends and perhaps a few future clients. He may have a job waiting for him. But he probably hasn't the vaguest notion of how to run a business of any kind, much less one as complex as graphic design. He does not know what clients will expect of him, what government will demand of him, or what employees will require of him. He probably doesn't know how to determine his costs or his fees. He knows little and cares less about sales or salesmanship, proposals and contracts or any of the 101 critical details that spell the difference between a successful graphic design firm and a business failure.

This book is an attempt to fill in those gaps. It is a book about the business aspects of the graphic design business. There is no discussion about right and wrong ways to design; there are already many fine books on this subject. Rather, the purpose of this book is to help the graphic designer become as good a businessman as he is a designer. It outlines simple, basic business principles which will enable the graphic designer to make the most of his talent, with the least hassle.

It is intended for graphic designers at all levels:

The owner of his own studio: To point out those procedures most likely to help him run an efficient operation, without sacrificing the aesthetic concentration which is his reason for being in the business.

Owners of firms that maintain design departments: To help them understand and provide the kind of leadership, facilities, and support that will best help their designers provide the kind of service their clients demand.

Managers of design departments: This book describes those operational procedures that have worked successfully to build efficient, effective design departments.

Young graphic designers, now working for others: To help them understand and begin to learn the business principles they will need if they are ever to open their own practices.

Graphic design students: With approximately 50,000 art students graduating each year and only about 2,500 full-time jobs available, the competition for available jobs will be intense. Graphic design firms are more likely to hire those designers who can demonstrate that they not only understand the principles of design, but also understand the needs of clients and how graphic design can satisfy those needs.

The book is based in part on my own experiences in working with graphic designers for over 30 years. It is also the result of hundreds of interviews with designers from one end of the country to the other. The first section of the book is practical information on essential aspects of the graphic design business: structuring your business, setting fees, making presentations to clients, sales and marketing, managing people, managing time, and managing money. In the second section, 24 of the most successful designers in the world give first-hand accounts of how they manage their businesses.

I have tried deliberately to keep the language simple and free of jargon. I only regret that I have not found a suitable pronoun in the English language to indicate both men and women. Unless the person is clearly a woman I have used "he" and "his" throughout the book only to avoid filling it up with clumsy, complex constructions like "he/she" "he or she" and "his and/ or hers." I am well aware that most working graphic designers in this country are women, and I am proud to be a member of a profession that has been practically free of sexual discrimination from its beginning. With few exceptions, designers have been judged primarily on portfolios, not on gender or preferences. I regret that the English language does not permit this reality to be communicated with grace.

Should You or Shouldn't You?

Al Schwartzman is a talented graphic designer who owns and operates his own firm in Connecticut. He has been in business for himself for about ten years. I asked him one day, "If you had it to do all over again, would you still start your own studio?" He answered, "Yes, but I would have done it sooner." This is essentially the same answer that hundreds of other principals of graphic design studios across the country have given me when asked the same question.

Granted, the question was posed to designers who had already proven to themselves that they could run a studio successfully. Most of them, however, confessed that they had secretly longed to hang out their own shingle for years, but they were scared stiff to take that step. There were too many unknowns. "Where do I start?" "Will I be able to attract clients?" "How much money will I need?" "I know nothing about business. How do I keep track of costs?"

The majority of graphic designers are usually found working for others, but when these designers are asked if they are content working for someone else, their answer is usually that they would prefer to work for themselves.

Their reasons for wanting to work for themselves involve four issues:

1. They feel frustrated artistically,

2. In many cases they feel they are underpaid,

3. They complain about being isolated from the client and from the problem-solving process, and

4. Some resent others' taking credit for their designs.

These designers face a dilemma. They long for control over their lives, both creatively and financially, but they lack the kind of knowledge which would take the mystery out of operating a business. To complicate matters for them they are also suspicious of the very people from whom they could learn sensible business procedures: businessmen.

THE CONSPIRACY

It isn't too difficult to understand the various reasons young designers fear opening and running their own businesses. From the day a young artist begins to take a serious interest in art there seems to be almost a conspiracy to keep him in his place.

First he learns that artists aren't supposed to be concerned with making a living. The romantic nineteenth-century image of the poet-artist concerned only with his art is the one we all carry in our heads.

At some point in his life, however, the young artist-to-be becomes the young graphic designer-to-be. He then comes smack up against the contradictory nature of graphic design as a profession. Graphic design is at one and the same time an art and a business. But art schools do little to foster in the student designer a healthy respect for business and businessmen. They almost seem to go out of their way to encourage suspicion and mistrust of the marketplace and merchants.

This problem is perpetuated by a system in which student designers are taught by designers, lectured to by designers, judged by designers, and spend practically all their waking and working moments in the company of designers.

By the time they have managed to get out into the world of commerce, most of them are barely prepared to understand a client's language and needs, much less run their own businesses.

Another factor which seems to work against the designer starting his own business is the master-apprentice tradition of the graphic design industry. Graphic design is one of those professions which happens to develop superstars. The dream of most student designers is not to replace these chosen few but to work for one of them. These superstar designers are their gods, and they don't want to kill their gods, they want to become disciples.

The majority of graphic designers are poorly educated for business, are insecure both as designers and businessmen, have little interest in business and little respect for those who do.

Is it any wonder that few designers go out of their way to quit their jobs and open their own businesses in spite of the fact that most of them so badly want to? This is not to say that owning and operating a graphic design studio is something that should be entered into lightly or something all designers should do.

Each year thousands of people open their own businesses, most of which close rather quickly. The reasons these ventures fail are many, but usually the failures are due to some combination of too little money, lack of experience, an unwillingness to pay the price in personal terms, and sometimes just plain bad luck.

Clearly, there are many designers who would be far better off working for someone else. Perhaps they haven't learned enough to run their own businesses or maybe their personalities are such that they could never feel comfortable as their own boss. It could also be that they are lucky enough to have a terrific employer who appreciates them and lets them know it. For these designers it obviously makes more sense to continue working for others than to open their own firms.

But there are many other designers who could, and perhaps should, begin to think about opening and running their own studios. To help make this venture a success, they need to consider carefully their motives and their aspirations.

The fact is that there are good reasons for a designer to start his own business and there are bad ones. If you want to open your own business for all the wrong reasons, you're asking for trouble. On the other hand, if your reasons are solid and you're well prepared to deal with the responsibilities and problems that owning a business involve, then starting your own company makes perfect sense.

SOME OF THE BAD REASONS

1. "I WANT TO BE A GREAT DESIGNER."

Being a great designer has little to do with whether or not a person owns his own business. That ambition has far more to do with talent and experience. Not enough of either is more likely to prevent a designer from being inducted into that rarified atmosphere reserved for the great designers than whether or not he owns his own business.

For many designers, in fact, the kind of pressures that are created by the need to administer and manage a business can actually go a long way towards preventing the development and flowering of whatever potential for greatness there might otherwise have been in them. When the choice comes down to compromising a daring and imaginative design or not eating or not meeting a payroll, you'd be amazed how quickly art flies out the door.

2. "I WANT TO BE FAMOUS."

Although we can certainly point to many designers, such as Lou Dorfsman and McRay Magleby, who achieved great fame while working for others, it is true nevertheless that the chances of one's name becoming a household word (at least in the households of other designers) is far greater for those whose names are on the doors than for those who merely work for others. However, the facts are that the nature and size of a business or institution play more of a role in affecting the exposure that one's designs get than whether or not they were done for your own business. This exposure, plus the necessary talent, ability, and experience, makes designers famous. Merely owning a studio of your own will not do it.

The opportunity for national recognition is dependent upon the designer's work's being widely circulated, exhibited and/or exposed. One avenue for this exposure open to designers is the annual design exhibitions, of which there are about 50 different national ones. But entering many of these exhibitions can get expensive, and only the larger firms or institutions can usually afford the expense.

National recognition can also come from working on large and complex programs for major clients. But small design firms often find it difficult to get large corporations to give them extensive and complicated assignments.

If fame is your goal, then you probably have two choices: Work for a firm or institution which offers you the opportunity for national exposure, or open your own firm but accept the fact that it will probably have to be a large one, with all the attendant sales and managerial problems that go with the running of large design firms.

3. "I WANT TO BE FREE TO DESIGN THINGS MY WAY."

Fine artists please themselves; graphic designers please others. If you're already having trouble convincing your boss or his clients that your solutions are the right ones, what makes you so sure that in your own business you'll be any more successful persuading others that your way is the right way?

4. "I WANT TO MAKE MORE MONEY."

Some designers make a lot of money. The majority just make a living. The only way to make any money in graphic design is to find clients who are willing to pay for your work. It stands to reason that, if it's money you're after, you'll have to go out and get clients and make them happy.

Clients are usually happy only when their needs are satisfied, but often the client doesn't agree that the solution the designer has proposed will satisfy those needs. In such cases the designer faces the choice of changing his design, changing the client's mind, or changing his client.

If it's money you're after, deciding to work with only those clients who offer the best opportunities for excellent work is a choice which will require a lot of

patience and willpower. It's possible that by producing superior work over a long period of time, enough clients who desire your kind of work will seek you out. You then begin to make a living, but you might have to go through many lean years first. I'm not suggesting that this would be a wrong choice for some designers. I'm merely saying that, if this is your choice, recognize the price to be paid.

Think about all those times when some client will be asking you to make changes in your designs which you don't want to make. The design, you think, will be something less than it should be. How will you deal with this situation?

You could try to argue your case more eloquently, more persuasively, but constantly justifying your decisions could give you a large headache and possibly a bad case of ulcers.

You could also simply refuse to change the work. If you do, be prepared to lose the client and perhaps begin to get a reputation for being difficult. It is far better not to work for the client in the first place (see chapter on contracting).

5. "I WANT MORE SECURITY."

The truth is, there's practically nothing as insecure as owning your own business, and a service business, such as a graphic design firm, which is based on the talents of the owner is the most difficult of all businesses to make secure. Anything that interferes with its ability to serve can jeopardize the business, whether the owner has control over the problem or not: illness, suppliers that don't produce, the mail, the weather, a surly receptionist. And this doesn't even take into consideration the owner's own ups and downs.

But, while there are many bad reasons to start your own business, there are also some excellent reasons why you *should* open your own design business.

SOME GOOD REASONS

1. YOU ARE NEEDED.

You are certain that you have something of genuine value to offer clients, which you find you're unable to supply in your present circumstances. There is no precise way to know when what you have to offer has real value to a client. You just have to feel it.

2. YOU CAN MAKE A GOOD CASE FOR DESIGN.

You clearly understand the role that design plays in meeting business objectives and are convinced that you can persuasively state that case to clients.

3. YOU CAN PERFORM.

You think you're a better designer than your boss, who's doing quite well.

Sometimes you find this out from your peers. Michael Vanderbyl did. In describing the events that led to his opening his own design firm, he told me of the time when he was working for another firm and also doing some free-lancing on his own. He entered some of the free-lance work he had done in a San Francisco design competition. When he found out that more of his free-lance work had been accepted into the competition than that of the firm for which he was working, he realized that he was ready to go out on his own.

4. YOU UNDERSTAND BUSINESS AND BUSINESSMEN.

You have enough knowledge of business, either by personal education or by taking formal business courses, to keep track of and manage your own business as well as to understand what a client's prime business concerns are.

5. YOU'RE READY TO MARKET YOURSELF.

You have taken a few sales and marketing courses or seminars. There are many colleges and universities offering night courses in business, which are relatively inexpensive and accessible. In addition, such organizations as The Graphic Artists Guild sponsor many seminars in business for designers.

6. YOU FEEL COMFORTABLE AS A LEADER.

As the owner of your own business, you will have to be a manager and motivator of others. If this role is one you have difficulty dealing with, you may not be cut out to run your own firm.

7. YOU'RE DECISIVE.

You are not afraid to take responsibility. As the owner of your own business, you will have to make decisions each and every day which affect the futures of you and your staff. There will seldom be anyone to tell you which decision is the right one. Most of the time the clues that tell you what to do will be ambiguous and vague. Yet decide you must, all by yourself.

8. YOU ARE A WELL-ORGANIZED PERSON.

If there's one thing which sets the good manager apart from the bad one, it is that the good one is well organized and logical. You can't run a business, which is a complex of many diverse parts, if you aren't well organized.

9. YOU LIKE PEOPLE.

As the owner of your own business you will not only have to deal with many more people than you had to when you worked for others, but you will also have to sell them on your ideas or motivate them to perform at their best for you. If you really don't get a kick out of dealing with people, this will be very difficult for you.

10. YOU'RE A SELF-STARTER.

You don't need anyone to push you to do a job. Because there won't be anyone there to push you.

11. YOU'RE COOL.

You don't easily get rattled under pressure. While you probably think you'll have no problems dealing with the pressures of deadlines, if you've been in the business for any length of time, you have to remember that there will be the added pressures of trying to get the work in, as well as getting it out with quality, at a profit, which will be added to your responsibilities.

12. YOUR HEALTH IS GOOD.

This is no minor concern. In a one-person business there won't be much happening if you're the type who spends a lot of time in bed nursing colds and viruses.

However, even if you can't give an enthusiastic "yes" to all the above, but you have no other choice, then you have to forget everything and just go for it.

Primo Angeli, who owns a very fine design firm in San Francisco, told me of being asked once to describe the first firm he worked for. He replied that he hadn't found it yet. The truth was that no one would hire him when he graduated art school.

As in the case with Primo, for many designers, both inexperienced and experienced, the choice is no choice at all. They are beginners and can't find a job at all, or, for one reason or another, have lost their present job. If they want to work as graphic designers, they will have to open their own businesses.

Unfortunately, graphic design isn't one of those professions which can be learned easily merely by doing it. It really does help to spend some time working in a professional environment with more experienced colleagues. Thus, for designers right out of art school, being forced to sink or swim often means sinking.

On the other hand, more experienced designers who find themselves suddenly out of work are hardly in the frame of mind to take a risk confidently. No matter how quickly or slowly the separation occurred, it always comes at the wrong time. A panicky feeling that they will never be able to find a job is always on the mind of the out-of-work.

Designers are, by training, somewhat more compulsive about working in the first place. For a designer, there is probably nothing more difficult to deal with than not having a job. Out-of-work designers, then, will do everything possible to work for someone else, rather than themselves. Only when it becomes obvious that they really have no other choice do they begin to seriously consider the possibility of self-employment.

But we then come back to the central problem: never having actually run a business of their own, they are overwhelmed with doubts and fears. Where will they get clients? How will they pay their bills? What do they know about bookkeeping?

A SIMPLE START-UP

Sooner or later these would-be studio principals find themselves in a bookstore trying to get a quick education in starting a small business. The books usually only add to their fears. The message contained within them is clear: "Starting a small business is risky, tough and can be costly." Unfortunately, this message is all too true. Designers thinking about starting their own businesses have every right to be hesitant before putting out their shingles.

There are, however, some important differences between the start-up needs of most small businesses and those of a graphic design studio. In many ways it's a lot easier to open a graphic design studio than most other businesses.

At the risk of oversimplifying, let's examine the needs of a typical business. Almost every business can be broken down into four basic parts: buying, selling, paying, and pleasing.

The typical business transaction is to buy goods at one price, hopefully low, and sell them at another, hopefully high. A delicate balance must be maintained between having enough stock to keep the business going and not enough to result in needed capital sitting in inventory too long.

For the graphic designer, the situation is quite different. Since the only inventory the graphic designer has to worry about is what's in his head and what's at the end of his arm, one of the biggest drawbacks to opening his own business is eliminated: the need to buy material for resale, and, hence, the need for a large capital outlay.

While other professionals, such as dentists, physicians, lawyers, and architects, may not have to worry about the need to lay in a large supply of widgets and find ways to unload them at a profit, they nevertheless have to deal with a number of other very real problems that graphic designers don't have to face. To outfit even minimally a small dentist's office costs in the very swanky neighborhood of about $100,000. A physician's office could easily cost just as much, depending on the type of practice.

Lawyers and architects, together with their fellow professionals, physicians and dentists, have much greater restrictions on how they can be certified, how they can market themselves, how, as well as how much, they can charge for their services, etc.

A designer is somewhat better off. His need for equipment is minimal, inexpensive and requires little room. Large out-of-pocket costs on jobs can be billed directly to his clients so there is little demand for cash beyond what is needed to pay the rent and his own salary.

Woody Pirtle started his business with $3,000 and a $10,000 line of credit with his bank, which he never had to use.

SELLING AND PLEASING

Of the four parts that make up the equation for most business and professional practices—buying, selling, paying, and pleasing—only two demand a designer's serious attention: selling and pleasing, neither of which involve a lot of capital.

The retailer accepts the fact that in order to survive in business he must find a way to sell his product inventory as quickly as possible for the highest possible profit that demand will allow. So, too, the designer has to be prepared to sell his products—his brains and talent—actively, aggressively and intelligently.

Few designers have been trained for sales and fewer have a talent for it. In later chapters we will discuss specific sales and marketing techniques, but for now it is enough to mention that one of the first considerations when contemplating whether or not to open a design business is how well prepared you are for selling your own graphic design solutions.

Pleasing, the other half of the two essential ingredients to a successful design practice, involves a number of issues. You need to please clients, please the government, please employees, please your peers, and, finally, please yourself.

Clients must be pleased because, if they are not, they won't be kept.

The government has to be pleased in the form of taxes paid and papers filed, because if they aren't, the designer might not only find himself facing some costly legal fees, but the very real possibility of spending some time in the slammer.

Employees, if any, will have to be pleased if the designer ever expects to get to the point, which most designers aspire to, where he is mostly using his mind instead of his hands.

Peers will have to be pleased, not because their opinion of a designer's work is more important than his own or his clients', but simply because it's good business to be held in high esteem by your peers.

The designer will have to be pleased with himself because graphic design is a tough and demanding profession that's hard enough to practice day after day when one likes doing it. It's practically impossible to run a successful graphic design practice when one can't stand to go to work every day.

If the designer can merely get these two vital elements of his business under control, selling and pleasing, he is well on his way to operating a successful design firm of his own.

Planning Ahead

hen should you begin thinking about starting your own graphic design business? Here's the answer from Bob Rytter, one of the most successful graphic designers in the country: "The first day you show up for work at your first design job."

If the day ever comes when you decide to stop just thinking about it and start doing it, if you have prepared yourself properly, it should not be difficult to begin.

In the preceding chapter we outlined some good reasons (and bad reasons) to start your own business. If your decision is to *go* ahead, then by all means *plan* ahead.

If you don't have a deliberate plan, four things could happen:

1. You might never start your own business.

2. You might start your own business, but not at the right time.

3. When the right time comes, you won't be prepared to seize the opportunity.

4. You might start a business, only to find very quickly that the business is in serious trouble and you are overworked, underpaid, and unhappy.

Planning is not mysterious. It means thinking through what you need and when you need it and then doggedly going out to get it.

WHAT YOU NEED TO GET STARTED
To get a graphic design business started successfully, you need to have these essential elements:

1. Adequate training and experience.

2. A business plan.

3. Working capital: At least one major client and/or enough money to pay bills and stay alive for several months.

4. Four dependable, trustworthy professionals: a lawyer, accountant, banker, and insurance agent.

5. A place to work.

ON-THE-JOB TRAINING

Bob Rytter's advice is sound. From the first day on the first job, observe with the eyes of one who plans to own his own business someday. Even if you change your mind later, nothing has been lost by learning how it's done.

No young designer has to be told to use a first job to get experience in solving design problems and developing the hand skills and head skills of the craft. Yet few realize the equal importance of learning to run a business intelligently.

Regardless of where you work, you can learn something about good and bad ways to manage a business. Learn how jobs are estimated, costed, and billed; how projects are scheduled and coordinated; the importance of cash flow. Take some business courses at night. In short, view the early working years as years of apprenticeship, not only as a designer, but as a businessperson.

Designers can get clients only if they are able to help clients and can prove it. So before you try to start your own business you must have an excellent portfolio of your own completed work to show. Clients will want to see completed projects that indicate that the designer can get approvals and can supervise a job to its completion. Clients tend to dismiss work in which the designer played only a minor role.

This suggests that a designer should concentrate on working on projects of his own and supervising the production, dealing with clients, managing complete projects. Designers have to learn as quickly as possible to make themselves answerable and responsible. They must also measure where they stand in these areas and document their abilities.

Clients will want to hire a designer who will produce the best possible work within certain givens; who will deliver it on time; and who will keep within the agreed-upon budget. Clients are much more interested in results than in procedures. Designers have to learn to understand what results a client is looking for and how to help the client achieve these results. They have to learn how to work with clients. And to direct projects. (To begin thinking in these terms, analyze projects you have worked on. What role did you play? How did the job turn out? What might have been done better?

What was done well? What lessons were learned? Were there any awards won? Who was the client? What was the problem? What was the approach taken? What were the results?)

Furthermore, designers have to learn how to determine their fees so that they can compete with other designers. They have to learn how to make a profit so that they can stay in business at all.

They have to learn how to manage their money so they can build a secure future. The surest road to creative freedom is having the least amount to risk. So designers who have built good bank accounts have the most creative freedom. They can afford to turn down jobs or clients which don't offer them the most creative possibilities.

A designer has to learn how to manage his office and his employees. These, perhaps, are the most difficult parts of running a business, and the tasks designers are generally the least prepared for. Seldom do designers learn in school what other college graduates learn—salesmanship techniques, accounting techniques, some business procedures.

THE BUSINESS PLAN

Here's the foolish way to go into business: Just hang out your shingle and charge anyone who walks in your door the most you can get.

It's easy. Hundreds of designers do it each year. But only a handful survive as independent businesses.

The fatal flaw of this approach is that it brings you into the marketplace without a clear definition—in your mind, or in the mind of clients—of where your business fits. Are you charging the highest prices in town and offering the most complete services? Are you charging the lowest prices and doing quick-and-dirty work? Or are you just acquiring a reputation as somebody who will always bend on price?

The wiser approach is to enter the marketplace with a business plan. That plan addresses your strategy—where your firm is positioned relative to other firms and what other firms charge, where you want it to be positioned, and what you intend to do to get it there. It involves conscious decisions about the size of the firm, its legal structure, and its pricing strategy.

To reach these decisions, these are some of the questions that must be answered:

1. Is the service your firm can offer in great demand locally?

According to the law of supply and demand, high demand tends to increase prices, while low demand depresses prices. If the service you offer is in low demand at the moment, you can assume that high prices probably will not be competitive. In that case you must decide whether to charge low, competitive prices, expand into markets of higher demand, or maintain high prices and wait for the demand to increase.

In describing his early years, Stan Richards, of The Richards Group in Dallas, tells how, while passing through Dallas on the way to Los Angeles, he talked to Marvin Krieger, a senior art director for a Dallas advertising agency. Krieger was greatly impressed by Stan's work, but warned that there was little need for work of that quality in Dallas at that particular time. He said Stan would probably have a difficult time finding work, but if he could survive without compromising either his standards or his sense of self-esteem, sooner or later the demand for a high-quality product would rise, and Stan would be the only one in the area who could provide it. Stan took Krieger's advice and toughed it out through some very lean years. Krieger's counsel proved to be absolutely accurate.

You also must distinguish between demand for a service and demand for your individual firm. The service you offer might be in great demand, but the perceived value of your firm might be low for a variety of reasons—a primary one being that you're the new guy on the block and without established credentials. Such a situation might call for setting lower prices initially to build a body of published work.

2. Is there much competition in the market you serve?

The number and caliber of competitors also affects prices. It pays to pay attention. Too often, design firms ignore the signs of tougher competition, only to find out too late that they have lost their competitive edge. When that happens they are facing a double problem. 1) They can't reduce their prices without appearing to be conceding the perceived loss in reputation; and 2) they can't continue to charge the high prices without losing more and more work. They could tighten their belts, cut back their staff and reduce overhead, in order to survive on a lower volume, they can step up their efforts to recapture their reputation in their traditional market, or they can seek new markets and add new services. All these remedies are costly and painful. It's far better to be sensitive to your competitive environment and more willing to add some long-range planning to your firm's arsenal.

If you find yourself competing with many other firms offering similar quality and service, you can assume that price will be a strong factor in the final selections. It is in your interests to shift your clients' focus from price to less quantitative areas—in particular, those where you can claim a decisive advantage.

3. How badly do you want certain kinds of jobs?

If your overall strategy calls for expansion into a new market area (telecommunications company annual reports, for example) a project that will bolster your experience in that area may be important enough to you to justify a price discount. But be careful. Information has a way of circulating throughout the marketplace. If your firm acquires a reputation for being low priced it will be very hard to quote higher prices to other clients. If the word gets around that your prices vary too much, you will be under constant pressure to justify or reduce them.

Furthermore, it will be very hard to pursue the kind of jobs reserved for those firms who are perceived by the marketplace as providing high quality at high prices. Most clients, like most ordinary consumers, tend to associate higher prices with higher quality. In a business which is as subjective as the graphic design business there often is no other measurement for unsophisticated clients to use.

HOW MUCH MONEY WILL YOU NEED?

Figuring a reasonably accurate budget for your first year in business is terribly important. It will be difficult enough to get going, considering all the things you have to do, without adding to it the considerable burden of financial surprises.

In order to create a budget you will have to put together the figures which tell you how much money you will need in three areas.

A. You. How much you need to live on.

B. Initial start-up expenses. Most of these would be one-time expenses, such as decorating, equipment furnishings, installing a telephone, putting up signs, buying a typewriter, legal fees and such.

C. Continuing expenses or overhead. Such things as rent, gas and electricity, cleaning services, stationery, materials, etc.

Start by filling in the figures on the table on page 20. Assume that you plan to set up an office somewhere other than your own home. If your final figures show you will need more money than you can raise, compute it again on the basis of an office in your home. Don't lie to yourself on the figures. You have no one to fool but yourself. Remember, there are no "norms." You must figure out your own costs as they apply to your own personal situation.

(A) PERSONAL BUDGET

This is a very difficult budget to try to work out, but it is probably the most important, since it affects you and your family directly. Identify a figure which will provide for your household's minimum living needs for no less than one year. Then add another 10 percent to that number, to cover all those things that cannot be planned but are virtually inevitable—the refrigerator that suddenly breaks down, braces for the twins (remember, in your own business you'll have to provide your own medical plan or pay the medical expenses yourself).

(B) ONE-TIME EXPENSES

Below are some items which you may need to be concerned with. You may not need to plan for all of them, but they can serve as a guide. Once again, it would be a good idea to add a 10 percent contingency factor to the estimate of these costs.

Filing cabinets	Legal costs
Storage	Telephones
Shelving	Decorating
Chairs	Typewriter or word
Light tables or drawing	processor
boards	Opening announcements
T-squares and triangles	Slide projectors and trays
Drawing instruments	Airbrushes
Markers, technical pens	Drawing table lamps
Waxer	Conference table
Built-ins	Process and flat color
Reference books	charts

Make up your own list. Pin down as many of the figures as possible by making phone calls, writing for catalogs, or checking with friends or acquaintances already in business. Remember, too, that most of these expenses will be deductible items on your income tax.

(C) OVERHEAD EXPENSES

These are continuous expenses. Some of them will be known in advance, or fixed, while some of them can only be guessed at. Add a 10 percent contingency to all costs to cover yourself.

Boards	Telephone bills
Paper	Cleaning services
Overlay material	Mail
Brushes and inks	Typing services
Tapes	Letterheads and
Rubber cement	envelopes
Wax blocks	Magazine subscriptions
Spray cements	Bookkeeping costs
PMS papers	Salaries
Pencils	Travel
Slide holders	Sales promotion
Erasers	Advertising and public
Rent	relations
Insurance	Photography of samples
Utilities	Taxes

PROJECTED BUDGET, FIRST YEAR

	Itemized Costs	Total Costs
PERSONAL EXPENSES:		

Sub-total:

ONE-TIME EXPENSES:

Sub-total:

OVERHEAD EXPENSES:

Sub-total:

Total:

10% contingency:

Final yearly projected budget:

	Yearly Sub-Total	10% Contingency	Yearly Total
Personal expenses	$20,000	$2,000	$22,000
One-time expenses	$ 3,000	$ 300	$ 3,300
Overhead expenses	$10,000	$1,000	$11,000
TOTAL			$36,300

The $36,300 total in this hypothetical example represents what a designer will need to open and operate an office for a year. The money won't be needed all at once. In fact, not all of it absolutely must be in the bank, since there may be fee income during the year. But it would be more prudent to make plans without counting on that hoped-for income.

If you have some definite projects already under contract, of course, that's a different story. You might try to get your client to pay some of the bills in advance to help your cash flow. You could also use their signed contracts as leverage in negotiating a loan. If you succeed, don't forget to include loan payments in your overhead expenses—and don't forget to make the payments on schedule.

By having adequate start-up capital, and thereby not struggling from week to week, you will be able to concentrate on doing the best job you can on each project, and to make lots of sales calls to let people know you're in business. You'll also be free to be more selective in your choice of jobs.

You know how much money you have in the bank. Going through the exercise of figuring your first year's budget will give you a better idea of how close that brings you to being ready to start your own business. It also gives some direction to how you can afford to do it: from an office or from your home; by yourself or with the help of an assistant or a secretary.

And developing the budget is a valuable tool when the time comes to approach friends, family, investors, or lenders for funds. It doesn't predict whether you'll succeed in business or not, but it does provide some gauge into the cost of trying, and the amount of risk at stake.

WHERE TO FIND CAPITAL, or the not-ready-for-prime-rate players

There are three basic ways to come up with start-up capital. You can save it, you can raise it by selling stock, or you can borrow it.

Self-capitalization, or saving, has the decided advantage of putting you under no legal, ethical, financial, or psychological obligations to pay back someone else should you be less than a total success. Admittedly, saving enough to underwrite an entire year in business is hard, and slow—perhaps impossibly slow. By the time you accomplish it, you may be retirement age.

But some of your own funds will certainly be part of any funding package. After all, can you expect others to risk money on your behalf if you haven't shown the commitment of risking your own?

The best way to save is by setting goals. Saving is a test of discipline and self-sacrifice, as well as a dry run of fiscal management. Target a fixed percentage of your take-home pay for this goal. Ten percent might be a good place to start. If, after six months, you have fallen short, you may either try to make up the difference and try harder for the next six months, or scale back your percentage to a more realistic figure.

A second source of capital is your family and friends. You might approach them either for business loans (to be treated as such, and paid back with interest) or as investors in your firm, whose purchases of stock do not require immediate dividends. (Issues regarding how to structure your business are covered in detail in the next chapter.)

In either case, your business plan—showing how you have sized up the competitive situation, where you expect to find your niche, how you intend to win clients, and how much money you need to make it all work smoothly—can only help your efforts to secure capital.

The plan is an absolute prerequisite for calling on the third source of funds, your friendly banker. In truth, bankers are rarely friendly to graphic designers, at least in a business sense. Bankers tend to share a preconception of artists shared by many artists themselves: that they are too scatterbrained to run a business. Scatterbrains are not good credit risks.

Breaking through this preconception will be an uphill struggle, but it is not impossible. It will require that you take the right approach and do your homework. What a banker wants to know is how you will generate the revenues to repay the loan. Show him. Show him your precise requirements, and some well-documented forecasts of your earnings. Provide the evidence that you are capable of sound business management. And look the part—come dressed for success.

Perhaps the best way to secure the support of a banker is to approach a banker with whom you have a long-standing relationship. A known quantity is always more bankable than a stranger.

THE GANG OF FOUR

Long-standing relationships are worth building not only with your banker, but with three other key professionals as well—your accountant, your lawyer, and your insurance agent. All four can be important advisers and supporters. It is worth the effort to find persons in each field with whom you feel rapport and trust.

Referrals are easy enough. But don't take someone else's word. Get to know the professionals personally. Have lunch. Ask lots of questions. Be satisfied that they understand the graphic design business or want to be educated about it. It is important, long before you take the plunge into business ownership, that you have confidence in the professionals you'll be depending on for expert counsel. Test each relationship yourself on a small scale. Borrow a small sum from the bank, and pay it back on time or ahead of schedule. Buy a small piece of property, and ask your lawyer to draw up the papers. Buy some insurance. Have your accountant handle your personal income taxes.

A PLACE TO WORK

The relative advantages and disadvantages of renting office space versus working from your home are covered in more detail in the next chapter.

The important considerations are expenses and professionalism. Expenses are self-explanatory. By professionalism, I mean making clients feel that they are dealing with a bona fide, professional business. Clients need to have the security of knowing they are working with a firm that can do the job. Consequently, if a client visits your "office" and finds himself down the hall from your bedroom, you are not, in his mind, a real business. If he calls and gets a recorded message on an answering machine, you are not, in his mind, a real business.

You CAN have a home office, as long as clients don't visit there, and as long as a breathing human being at least 18 years old picks up the telephone.

There are other alternatives, too. When Jack Summerford opened his own design firm in Dallas, he and two friends formed a corporation which purchased a small but attractive building near the central business district. Each of them then leased space in their building from their corporation. The corporation also rents space to two other designers, to whom Jack gives occasional free-lance work; these designers also are there to answer Jack's phone when Jack is out of the office. Result: many of the advantages of a medium-sized design firm, with very little of the attendant overhead.

Leases and Other Legalities

The business plan is completed, and the first-year budget looks good. Now it's time to get down to the nitty-gritty—to make commitments and sign papers.

OFFICE SPACE

The first thing you'll need to figure out is whether you have enough money in the bank to allow you to set up a separate office or whether you'll have to work out of your home.

Most beginning free-lance designers work out of their homes. The advantages are obvious. The cost for rent, utilities, and furnishings is minimal, and a home office provides a useful income tax deduction.

There are some obvious problems with a home office, however. The fact that so many designers begin this way and then usually try to set up an office elsewhere as fast as possible speaks volumes for the difficulties. One frequent problem is distance. Your home may be located far from the places you have to go in order to do business. Traveling time, which takes up a major part of the day, affects scheduling and limits the number of jobs you can handle. A bigger problem is distraction. It is a hardy soul who can concentrate on the work at hand in the face of crying infants, interruptions from neighbors and salesmen, or the tempting presence of the refrigerator.

Michael Manwaring brings up a different problem created by having an office at home. The work is always there. Every time you walk by the office door there's an urge to pop in and continue working on some problem you have put aside. This conflict can put a strain on you and on family relationships.

Another problem to be aware of before you choose to set up your business in your home is that of the image it creates for your business. Some clients can get very nervous if they get the idea that they are dealing with an amateur or a one-person company.

But if you have no other choice and there are no zoning regulations that would prevent it, go ahead and set up shop in your own home. To eliminate some of the inherent problems, however, you should develop a business plan which will take you into your own office within a specified time frame.

WHERE?

When the time comes for you to set up an office elsewhere, there are a number of factors to consider. Of central importance is, Where should the office be located? This choice will be determined to a certain extent by zoning laws, but beyond complying with local law, here are things to consider in your decision about a location:

ACCESS

You and your clients will have to be getting together regularly, so don't make it too difficult for these meetings to happen. You also don't want to spend too much time traveling because it simply leaves too little time for doing. Make sure that the office is located close to major access routes.

SERVICES

You will be needing the services of various suppliers—stat houses, typesetters, delivery services, secretarial services, etc. If you're located too far from these services, it will cost you more and may cause delays in the completion of your jobs, which might jeopardize them.

ADDRESS

It is not necessary to have an expensive address, since there won't be too many clients coming to your offices in your early years, but you should pay some attention to how the address sounds to a client. If the address sounds like it's in one of the better areas of the city, that raises the prestige of your business a notch or two in the client's mind. The reverse is also true, and you don't want clients to perceive you as less than professional.

LIGHTING

Make sure that the offices you're interested in have good natural lighting. Not only is it easier on your eyes, but it might also save you a little money on your electric bills.

STORAGE SPACE

A successful business accumulates an incredible amount of material over the years. Most of it will have to be kept neat, clean, orderly, and easily accessible. If generous storage space isn't already available in the office, try to imagine how you might add it. One of the most imaginative uses of storage space I've seen was in the offices of Pentagram in New York. It consisted of a series of sliding storage shelves on tracks set in the floor.

ACCESSIBILITY

Make sure that you'll be able to use the office 24 hours a day, seven days a week. If you're like most graphic designers, the 40-hour workweek is just the beginning. You'll have some serious problems with your business if you can't get into your offices when you have to.

IMPROVEMENTS

A space in need of considerable renovation might be obtained at a lower rent. On the other hand, if it costs too much to make the neccessary improvements, or if you're not the kind of a person who can do most of the work yourself, you might find yourself tight for cash. Furthermore, it might be a better use of your time to be out looking for jobs to work on than staying in your new offices plastering walls.

WORKING OUT A LEASE

Once you settle on office space you'd like, you have a legal hurdle to get over, the lease. More than likely, you'll be given a standard lease form to sign, but you don't have to accept it the way it is written. First, make certain "your" lawyer, "your" accountant, "your" banker, and "your" insurance agent read it over very carefully. Strike out anything you don't like and anything they don't like. Make any additions or changes you want to the lease. Be prepared to negotiate. Don't make concessions without expecting concessions in return.

A key question is how long the lease should run. Since we're talking about your first design office, a short lease—one or two years at the most—would help protect you from getting in over your head, in case the business should turn sour. On the other hand, if the business were to be wildly successful, you would probably be looking for new and larger space anyway after a few years.

If, by luck, you happen to find an office which in every way would satisfy all your present and future needs, the best thing to do would be to take a short lease with an option to renew it for a period of time.

DESIGN DECOR

A design firm's offices play a major sales role, especially if the firm is trying to attract large corporations. The more prosperous the clients you seek, the larger the appropriate investment in rental space and furnishings.

In any case, the offices should be clean, neat and bright. Dirty, dreary, and sloppy offices are not conducive either to dealing with clients or doing the work itself.

The major items which will be needed are: a drawing table; a counter top on which large pieces can be laid out for viewing; shelves to file any large items; file cabinets; drawing materials; spare chairs for visitors; lamps for the drawing boards. You will also need large wastebaskets, ashtrays, coat hooks, filing trays, a first-aid box, a cash box, a Rolodex file or address file. Other items which may be needed are a bulletin board, a typewriter or word processor, a slide projector and screen, a photocopier. If cleaning services are not provided as part of the lease agreement, you'll need to arrange for them.

HOW TO STRUCTURE THE BUSINESS

Once you've found a place to do business, you need to give your business a structure. There are four legal frameworks to choose from, each with its advantages and disadvantages. I'll describe these in general here, but in order to make an intelligent decision on what is best for you, have a talk with your trusted lawyer and accountant.

THE SOLE PROPRIETOR

"Sole proprietor" describes a business owned and operated by one person. Most free-lancers do business this way. The owner may use his own name or he may name the business anything he wants, as long as the name doesn't imply that the business is incorporated or doesn't violate the restrictive laws of the state in which the business will be operating. These laws vary from state to state.

ADVANTAGES

1. It's easy to start one. There are very few legal hoops you have to jump through, and it costs practically nothing in most states to establish a sole proprietor business. If you're not going to hire any employees or give the business a name other than your own, about all you have to do is get a resale number in those states that have sales-tax laws. If you do hire employees you also have to get an employer's number; applications can generally be found at any post office.

If you intend to use a name which might indicate that others are involved in the business (Joe Smith Design Studios, or The Joe Smith Company), then you will need to file a certificate with the County Clerk or other such local authority. You need this certificate to open an account and deposit or cash checks made out to the company. People who might extend credit to you also may check on your certificate to find out who the principals of the Joe Smith Company are.

2. You're your own boss. You can do whatever you please with your business. You have only yourself (and possibly your spouse) to answer to. You have only yourself to irritate.

3. You get to keep all the money. Assuming there is any.

DISADVANTAGES

1. Unlimited liability. A biggie. You can lose everything. Your stereo, your home, your cat, everything. The law makes no distinction between your business debts and your personal debts, so if you buy too many things for your business and don't get paid fast enough by your clients to pay your bills—or, worse yet, don't get paid at all—you could be in big trouble. You're also vulnerable to lawsuits. Let's say a client happens to slip on a sheet of paper in your office and hurts his back, and your insurance doesn't cover the generous settlement a sympathetic jury awards him. You can lose everything you've got.

2. Lack of stability. If you die or become disabled, your business does the same. Some people might say, if that happens, who cares? I won't be around anyhow. Aside from being a somewhat insensitive statement, it is also inaccurate. Your creditors will care. They might be more reluctant to extend you credit knowing that your business might not be around if you're not.

3. Taxes. The income (or losses) of the business are treated as personal income, and taxed as personal income. In the current progressive tax system, tax rates grow steeper at higher income levels. Anyone who has a significant additional source of income such as a spouse's salary, or dividends, will end up paying higher income taxes. In addition, there are certain tax advantages that are not extended to the sole proprietor or partnership structures, but only to corporations. Your lawyer and accountant friends can tell you more about these.

4. The teeny-tiny syndrome. Many potential clients are nervous about dealing with a one-person design firm. Generally, one-person design firms end up doing most of their work for advertising agencies. Few are able to deal directly at the client level, which limits their ability to grow beyond the mere hand-skill services.

PARTNERSHIPS

Young designers who are not content merely to be free-lancers and want to start a "real" design firm usually decide to form partnerships. Under a partnership structure, all partners are equally liable for each other's actions, regardless of what their particular partnership agreement may be. Each partner is taxed as an individual (limited partnerships limit the amount of liability a partner is responsible for, but these are generally useful for real estate or tax-sheltering purposes, and are seldom used by design firms).

ADVANTAGES

The reasons so many young designers start out in partnerships with other young designers are readily apparent:

1. It costs less. Each designer only has to come up with a portion of the bucks.

2. It gives them access to more capital and credit.

3. It allows them to pool their labor and take on some larger jobs. If two designers have slightly different skills and interests—perhaps one is a terrific illustrator while the other is great at designing ads—they can expand each other's capabilities.

4. It's a morale booster. There is a certain psychological lift in being able to share the many pleasures and burdens of a business. Just having someone with whom you can discuss a job or exchange points of view can be extremely helpful. Furthermore, there's security in being able to rely on someone who has a real stake in the business, who can cover for you in times of illness, or while you're on vacation. The strain of feeling that you alone are keeping the business going can quickly wear a person out.

DISADVANTAGES

The majority of designers I interviewed shared a similar history; at one time or another, early in their careers, they had formed a partnership with one or two other designers and had later dissolved the partnership to go into business for themselves. Partnerships can be intense relationships. Even the very best of friends and most compatible of designers can get to the point where the thought of packing a .357 Magnum when coming into the office begins to look very attractive.

If you intend to set yourself up in a partnership, my advice is to do it in a businesslike way. Don't believe the "It-can't-happen-to-us" stuff. It can, and it probably will. Each partner should get his own lawyer and draw up a legal, binding partnership agreement that spells out in as much detail as humanly possible what each partner's responsibilities and commitments will be. You wouldn't use the same lawyer to represent both you and your spouse in a divorce, so don't use the same lawyer for you and your partner or partners. You must protect your own interests. In the course of drawing up the agreement you'll be amazed how many points of disagreement there are. If you can get through the process of drawing up the agreement without coming to blows, you might be well on your way to forming a very good partnership.

Remember, the problems partnerships run into are usually personal, but many of them have their roots in the basic legal structure of partnerships.

1. Liability. Like the sole proprietorship, the partnership structure also has the problem of unlimited liability,only this time there's a kicker. The law treats the business and the personal life of a partner as one and the same, so in a partnership the actions of any one partner, or even of that partner's spouse, can affect the personal assets of all the other partners. This means that if one of the partners goes nuts and buys half of Manhattan, all the other partners will be held equally responsible for his actions. Even if their personal partnership agreement limited the liabilities of each of the partners, a creditor can still move to attach the assets of all or any members of the partnership, and even the assets of partners' spouses.

Regardless of how honest, fair and well-meaning the partners may be with each other, the unlimited liability feature of a partnership structure is a very serious disadvantage. A bit of bad luck on the part of one partner could cost all the others their life savings.

Don't even think about entering into a partnership arrangement without talking to your insurance agent to help reduce the potential risks.

2. Stability. Like a sole proprietorship, a partnership is very unstable legally. The loss of any one of the partners automatically dissolves the entire partnership structure. In some states, such as California, where there are community property laws, even a divorce could spell the end of the business. Once again, look to your insurance agent and your lawyer to help you deal with these potential problems.

3. Freedom of decision. A partnership structure, by its very nature, restricts the ability of each partner to make decisions without regard to the wishes of other partners. This limitation on freedom of choice even extends to partners' spouses. Whether you like it or not, when your partners are married, their spouses have also become your partners. Not only will you have to make sure you can tolerate your partners, you also have to make sure you can get along with your partners' spouses. Even if you manage to keep the personal lives of the partners separated from their business relationships, which you should, you may not be able to shield your business entirely from a spouse who is a determined and persistent meddler. Spouses can also create serious legal problems.

If either the partner or the partner's spouse dies, problems created by the disbursement of the estate and the estate taxes could completely wreck the financial structure of the firm and all the surviving partners. Before you enter into a partnership agreement I strongly recommend extreme caution. Don't ever enter a partnership with family or close friends—if you value their friendship. Before forming any partnership make certain you've asked yourself some tough questions, such as:

1. Is the partner capable of carrying his own weight, seeking and servicing design projects on his own, or will he be too dependent upon your reputation or abilities? If the latter is the case, you can be sure that problems will develop in short order.

2. Are the personalities of the partnership compatible? Have you worked together long enough to test this under all conditions?

3. Do the partners' spouses get along? Are the spouses the kind who might be a problem later?

4. Do the partners have similar long-range goals? Are their attitudes similar toward their work and their business goals?

5. How do the partners handle disagreements?

If the answers to all these questions are encouraging and all the partners wish to go ahead with the partnership arrangement, then each should get a lawyer to begin drawing up a partnership agreement. The items which must be addressed and on which the partners must reach an agreement are:

1. How much money each of the partners is going to contribute to the establishment of the business and when these contributions will be made.

2. What will be the name of the business.

3. How the profits or losses will be shared.

4. What the partners will be paid and how they will receive the money, by salary, draw, commission, etc. Whether or not there are to be any expense allowances, automobiles, health insurance or other "perks."

5. What will be expected from each partner in the way of performance, degree of responsibility, managerial control, decision making, employee management.

6. How long the partnership agreement will last.

7. How the partnership will handle the problems of death, retirement, disability, and merely the desire to dissolve.

8. How the partnership will handle disagreements. Will there be a stated arbitration policy?

9. What kind of behavior would be absolutely forbidden or absolutely required.

10. What will be the accounting method of record? How will the company administer the books? Which of the partners will be responsible to do this?

11. How will the partnership deal with violations of the agreement?

These issues are just a few of the many problems that must be faced and settled. There will probably be many others that will surface as the matters are discussed and thought through. The partners should settle each issue one by one, put it on paper, sign it and put it away.

The knowledge that the agreement exists at all will go a long way towards making the partnership more secure.

CORPORATION

The corporation is a marvel of abstract thinking. In the eyes of the law, a corporation is a completely separate entity from the people who comprise it. What the corporation does and what each of the owners do personally have no relationship to each other. In most states, a corporation can consist of one person or an unlimited number.

Getting incorporated is more complex than creating a sole proprietorship or a partnership, but with the help of a lawyer it isn't too complicated, and it isn't expensive. A fee in the $250 range is not unusual for drawing up the necessary papers. For this fee, your lawyer will check to see if the corporation name you have chosen can be used; help you issue the necessary stock and set a value on it; write up a document of incorporation and file the necessary papers. In all likelihood, he will also advise you about how best to handle your corporate taxes.

Once the state grants you permission to incorporate, you are required to have regular stockholders meetings, have your books audited every year, produce an annual balance sheet, pay taxes on corporate earnings, and generally do business in a formal manner.

ADVANTAGES

There are many distinct advantages to be gained by forming a corporation. Among them:

1. Liability. The greatest advantage to the corporate structure is that it limits the liability of the individual owners—or stockholders, in this case. The investor will lose only the money invested. He doesn't have to worry about losing his personal belongings if the business goes belly up.

2. Performance. The corporation can be set up to last indefinitely. Should one of the founders die, the corporation will not die with him. This is comforting not only to the surviving stockholders, but to potential creditors and lenders as well (although the latter may still require stockholders to pledge their personal assets as collateral for loans).

3. Taxes. Corporations get many tax benefits that are not available to a sole proprietorship or partnership. Your accountant can give you advice on your specific situation. To give just one example, though, pension and profit-sharing options available to corporations are excellent ways for the stockholders of a corporation to put aside and accumulate tax-free income; they also provide excellent incentives to attract and keep employees in a firm.

4. Transferability. If more capital is needed, the corporation merely has to issue more stock and find someone to buy it (which is not always easy).

DISADVANTAGES

The main problem with the corporate form is that it must pay taxes on any profits before it can distribute them in the form of dividends; then the stockholders must pay personal income taxes on those same dividends. In other words, the same money is taxed twice. This is not a major difficulty for most small design offices, however, since practically all profits are paid to the stockholders in the form of salaries and bonuses.

THE SUBCHAPTER S CORPORATION

This choice is available to stockholders before any stock is issued. By choosing to organize as a Subchapter S corporation, the stockholders get all the advantages of incorporation—limitations to liability, pension and profit-sharing plans, etc.—while sidestepping the double taxation problem of the regular corporation. There are stricter limits for organizing a Subchapter S corporation, which differ from state to state: for example, in some states a maximum of ten shareholders is allowed, all of them residents of the state in which the business is incorporated; only one class of outstanding stock may be issued; and a specified portion of the corporation's income must be generated from the business itself rather than from investments. But these are relatively minor and easily accommodated.

Most small design firms will find that the Subchapter S corporation structure accommodates their needs very nicely. But, once again, don't even think about making a final decision without some long and serious discussions with your four best friends—your lawyer, your accountant, your insurance agent, and your banker.

Estimating Your Costs

Many design firms use a very simple formula for calculating the price to charge for their services: "Figure out what the client will pay, and tell him that's what it will cost." This is also known as getting "the going rate." While this system isn't a bad way to get business it's not a very good way to stay in business.

The major problem with focusing completely on the going rate is that it is only part of the story. It may establish what a client will pay, but it doesn't tell you whether you can make any money at that selling price. Ideally, the price of a job should reflect both factors.

Simplistic though it may sound, if you intend to make money, you must set a price that brings in more than you spend. So the first step in setting your price is computing your actual costs. *This is the single most important tool in setting design fees.*

When you know your costs for doing a job, you've established your "floor"—the minimum below which you cannot go and still make any money. At the other extreme, prices can reach a "ceiling," the point at which a firm has priced itself out of its market. It is vitally important that a design firm know where these points are at all times.

To arrive at your "floor," you have to calculate the true cost of an hour of your design firm's time. Once that cost is clearly established, it should be reviewed once or twice a year and adjusted (more likely, upwards) to remain useful.

HOW TO CALCULATE
THE HOURLY RATE

There is no universally accepted way to compute the hourly rate. The most often-cited formula is three times salaries, a rough estimate based on about one-third for salary, one-third for overhead, and one-third for profit.

This formula, like certain methods of birth control, is simple but not very reliable, as many design firms have discovered to their regret.

A slightly more complex, but also more realistic, formula for the hourly fee is actual and anticipated total salaries, plus actual and anticipated total overhead cost, plus desired profit.

To illustrate how to apply the formula, we'll create a hypothetical design firm, which we'll call WGDF (which stands for The World's Greatest Design Firm, Inc.).

SALARIES

The first step in defining WGDF's proper hourly fee is to add up the cost of all salaries, which represents the largest expense in the design business—labor. For this illustration, let's give our hypothetical design firm five people: a principal, or owner, who is paid a salary of $50,000 a year; a senior designer, who is paid a salary of $30,000; two junior designers/production assistants, who are each paid salaries of $20,000 a year; a bookkeeper/receptionist, earning $15,000 a year. The total combined salaries—$135,000.

Added to this should be all other costs associated with labor: taxes, benefits, FICA, insurance, bonuses (if predetermined), etc. As a rule of thumb, tack on about 25 percent, or about $35,000. The total of both would then be $170,000:

Total salaries	$135,000
Total additional labor cost (25%)	35,000
	$170,000

Next, figure the total number of man-hours that the firm could charge in a year. Assume 8 hours a day times 5 days a week, times 52 weeks, times 4 people (the bookkeeper/receptionist represents nonchargeable time).

Total chargeable hours possible: $8 \times 5 \times 52 \times 4 = 8,320$ hours But, obviously, no designer can be expected to charge every hour of his time. Allowances have to be made for vacations, legal holidays, illness, etc.

7 legal holidays	$8 \times 7 \times 4 =$	224 hours
2 weeks' vacation	$8 \times 10 \times 4 =$	320 hours
1 week's sick leave	$8 \times 5 \times 4 =$	160 hours
		704 hours

8,320 hours − 704 hours	= 7,616 hours

You must also make an allowance for nonbillable hours—time when the designer or principal might be cleaning up, filing, going over the books, etc. Allow approximately 25 percent for nonbillable hours.

7,616 hours × 25%	= 1,904 hours
7,616 hours − 1,904 hours	= 5,712 hours

Now divide the number of billable hours (5,712) into the annual cost of salaries ($170,000) to arrive at the per-hour cost of labor.

$170,000 ÷ 5,712	= $29.76 per hour.

(We'll round it off to $30 per hour)

OVERHEAD

Overhead represents what it costs to be in business, as opposed to labor, which is what it costs to do the work. Overhead costs include such things as rent, gas and electricity, insurance, telephone, cleaning services, postage, stationery, art supplies, magazine subscriptions, accounting fees, advertising, and marketing costs. These are expenses which are passed on to a client indirectly by building an add-on percentage into the billable time.

For the sake of this illustration let's assume these costs total $75,000 per year. That equals 44 percent of the total salary cost.

$75,000 ÷ $170,000	= 44%
$30 per hour (labor costs)	
× 44% (overhead percentage)	= $13.20
$30 + $13.20	= $43.20

(rounded to $43.50)

This is the price per hour to recover the cost of salaries plus overhead expenses.

PROFIT

If the design firm sold every possible billable hour for this rate ($43.50) it would only be breaking even. It also needs to make a profit. Too many design firm principals operate on the short-sighted premise that anything left over after paying expenses is theirs to spend. But the firm needs profits too, as surely as the principals. Profits get the firm through the rainy days, without firing employees; they replace old equipment or buy new furniture; they provide the funds for pay raises or bonuses; they can help secure a line of credit that can finance growth. In short, profits simply make life easier for all so they can go about doing their jobs. They buy the freedom to say no, and the freedom to say yes, at the appropriate moments.

A minimum profit margin of 10 percent should be added to the price per hour; 20 percent is preferable.

$43.50 × 20%	= $8.70
$43.50 + $8.70	= $52.20
(rounded out to $52.50)	

The hourly rate of $52.50 represents the minimum rate our hypothetical firm can charge to cover its cost of labor and overhead, with a profit margin of 20 percent. This is its floor price.

You can apply this formula to your own situation, substituting your own figures, to determine the "floor" price for an hour of your firm's time. This figure becomes your basic tool for calculating all estimates.

TIME VERSUS VALUE

The per-hour figure is not, however, the last word on pricing. True, it represents costs and profit. It accurately reflects the time involved in producing a job. But it does not reflect VALUE.

VALUE is complex, and not as easily reduced to formula. It can be approached from several perspectives.

VALUE is what the finished product means to your client's bottom line. Clients buy design services because they have a problem or a need; their ultimate concern is for how well you solve their problem. They will care, in other words, about the results, not about how you get there.

It is critical that you try to define for your clients the value your work will represent to them. Designers must try to help clients understand the direct connection between design and increased sales or awareness of a product or service; to demonstrate how appropriate design will enable a client to charge higher prices; to translate a more defined and positive identity into dollars for a client.

VALUE is also what the finished product means to your own firm's bottom line. Printed samples are a design firm's primary sales tools. If handling a particular job represents an opportunity with long-term value to the firm—because of the prestige of the client, the potential to create a spectacular showpiece, or the chance to enter a new market or a new type of service—then this value to you tomorrow may override the need for a healthy profit today.

VALUE is your firm's reputation for outstanding concepts and performance. It is easy to measure the time and ultimate value of "hand skills," such as mechanicals and paste-ups. Putting a real value on creative or conceptual work is more difficult. What a design firm sells, essentially, is its combined thinking, training, experience and talents. The better a firm's track record for original solutions and quality work, as well as the more experience it can draw on, the greater its potential value to the client.

Not only is it difficult to put a value on creative efforts, it is also very difficult to predict with any degree of accuracy how long it will take to solve a design problem. And there is no direct relationship between value and time spent on a design problem.

The late Herb Lubalin would generate an enormous number of brilliant sketches in bursts of quick energy. Each idea would only take him a few minutes to come up with. If he merely charged for the time spent on each job it would hardly be a reflection of the true value of his thinking. Yet there were times when even Herb would labor for days over a job, and when it was finally done, it still wasn't something he was really satisfied with. He once submitted something like 24 different sketches for a cover to a publisher. When asked which one he liked best, he replied, "None."

VALUE is the demand for your service, relative to the supply of competent competitors. If you're the only design firm in town and the client is desperate, your value is higher than if dozens of designers are swarming the business community begging for table scraps.

The actual quoted price, then, is likely to be a combination of many complex factors. However it is actually computed, it should reflect the floor price plus a weighing of the various components of value.

As a rule, value is factored into the equation by adjusting your profit margin upward or downward.

PRICING STRATEGY GOALS

Regardless of how you arrive at a price, the final objectives of pricing are the same:

1. To establish a clear and definitive price which the client understands, can plug into his budget, and is willing to pay.

2. To place the design firm in a reasonable position relative to its competition.

3. To allow the design firm enough flexibility to adjust its fees depending on the situation.

4. To pay the design firm a fair price relative to its talent, experience and efficiency, as well as relative to its total contribution to the client's ultimate profits.

DETERMINING PRICE

There are six basic methods a design firm can use to determine a final quoted price. They are:

1. Average hourly rate.

2. Individual hourly rate.

3. Per-page rate.

4. Past results.

5. Sales price.

6. Total cost plus.

Each of these methods has advantages and disadvantages and is best applied in certain situations.

AVERAGE HOURLY RATE

With this method, you arrive at a budget and a price by breaking the job down into its component pieces, estimating the man-hours needed for each piece, and multiplying the total hours by your per-hour rate (your "floor" price). Then out-of-pocket cost items are added on.

The key is answering one simple question: "How long will it take to do the work?" Getting the answer, unfortunately, is seldom that simple.

Many variables can affect the number of man-hours spent on a job. Different individuals work at different speeds; one individual's performance may vary from day to day; the firm's prior experience with a similar project may make the work proceed faster; jobs vary in their complexity.

But there is one thing you can almost always depend on: You will underestimate the time it takes. A good rule of thumb would be to always add 50 percent more to the total estimated time.

EXAMPLE: Your firm is asked to prepare an estimate for design and mechanical of a small 6-page folder, all type, 2 colors, 4 by 9 inches folded size.

Broken down into its various tasks, the time spent on the job looks like this:

1.	Read the copy for content, point of view, style of writing, length, "feel":	½ hour
2.	Drawing board time, preparing designs:	12 hours
	Add 50 percent contingency:	6 hours
3.	Mounting designs:	½ hour
4.	Write covering letter:	¼ hour
5.	Telephone call to set up appointment:	¼ hour
6.	Travel to client and back:	1 hour
7.	Meet with client:	1 hour
8.	Specify type:	½ hour
9.	Review galleys, make style changes:	1 hour
10.	Review repros:	½ hour
11.	Prepare mechanical boards:	2½ hours
12.	Mount boards:	½ hour
13.	Write instructions to printer, covering letter:	½ hour
14.	Call delivery service, prepare package to send to printer:	½ hour
	TOTAL TIME:	27½ hours

HOURLY RATE: $52.50 × 27½ = $1,443.75

To this hourly cost must be added any out-of-pocket costs. Most design firms add a 15 percent to 25 percent mark-up to their out-of-pocket costs. In this example we'll assume these costs include one delivery charge of $25 and typesetting charges of $250 for a total of $275.

$275 × 20%	=	$55
$275 + $55	= $	330.00
TOTAL ESTIMATE:		
$1,443.75 + $330	=	$1,773.75

ADVANTAGES

1. In organizing your estimate, you also create a plan for implementing the job once the estimate is approved.

2. This method breaks the job down into mini-budgets and schedules, which help in project management.

3. It identifies areas where changes may be negotiated. If the final estimate is too high, you might get the client to agree to approve the concept from rough thumbnails only, or to save on travel time by coming to your office.

DISADVANTAGES

1. The more complex the job, the longer it takes to break it down into all its mini-tasks.

2. Since each task is estimated separately, there is great potential for bad guesses. Underestimating could make the job a money-loser. Overestimating could cost you the job at the outset if the client chooses a lower priced competitor.

INDIVIDUAL HOURLY RATE

This method is a variation on the average hourly rate. The difference is that you use a different per-hour fee for each task, based on the salary of the individual who will actually perform the task. The $52.50 per hour figure (the "floor"), in other words, is replaced by one figure for a senior designer, another for a junior designer, another for the part-time mechanical artist.

ADVANTAGES

1. The estimate tends to be more precise than the average per-hour method.

2. All the other advantages of the average hourly rate method also apply.

DISADVANTAGES

1. It adds another layer of complexity, which makes estimating more time-consuming.

2. If for any reason the people who actually end up doing the work are not paid the same salaries as the people on whom the estimate was based, actual costs could be far above or below the quoted price.

This type of estimating forces a choice between accurate pricing and flexibility in using personnel. If salaries are not interchangeable, then personnel become locked in by the way the job is priced.

PER-PAGE RATE

This method uses the firm's own historical data plus a knowledge of what competitors are charging to arrive at a price per page that should cover costs plus a fair profit.

If the firm has carefully tracked its costs per project and the number of total pages it has designed, it merely has to divide the total man-hours by the total pages to reach an average figure which reflects man-hours per page.

Total man-hours billed per year	5,712
Total pages designed for year	1,200
5,712 ÷ 1,200	= 4.75 hours per page
4.75 hours × $52.50 per hour	= $249.38
(rounded out to $250 per page)	

Different design firms contract their per-page fee proposals in different ways. Many firms using this method tell the client that, as long as the criteria under which they are designing haven't changed, the total price paid by the client will not vary, regardless of how many design revisions are required. Other firms using this method will put a cap on the number of revisions they will do for the per-page price.

For purposes of estimating, all covers are regarded as pages. All illustrations, graphs, and the like are billed as additional items at specified costs.

EXAMPLE: (Taking the same example we used to illustrate the average hour rate method)

6-page folder: 6 pages × $250 per page	= $1500
Out-of-pocket costs:	330
Total price	$1830

ADVANTAGES

1. It is extremely simple, quick, and easy for a client to grasp. There are no hidden costs or contingencies. The entire process of negotiation is quickly disposed of, enabling you and your client to get on with the job.

2. Because you need not negotiate every project individually, this method encourages long-term client relationships.

3. Since it is based on average man-hours per page for all the firm's projects, it automatically compensates for individual designers' variations in experience and speed.

DISADVANTAGES

1. Regardless of similarities, each project is different. There will always be some that will require more design time than the average. Too many of these could get a firm in trouble financially.

2. While a per-page rate works well for publications, it is difficult to apply it to projects such as posters, identity programs, environmental projects, or packaging.

3. This method, because it is based on past history, is slower to keep up with changing conditions, which might drastically affect the average per-page rate.

PAST RESULTS

Like the per-page rate, this method bases its price quote on actual historical costs for similar work. The difference is that this method attempts to break down its historical data base more distinctly.

A design firm using this method would look at its records and define jobs by category and subcategory. For example, you might have a category for folders, with subcategories for 6-page folders, 4-page folders, etc.

In each category or subcategory, you would add up the total design charges and divide them by the number of jobs to get an average price.

EXAMPLE:

Total number of 6-page folders	10
Total charges, 6-page folders	$15,000
$15,000 ÷ 10	= $1500 average per folder

ADVANTAGES

1. It more precisely compensates for the differences in types of jobs than does the per-page method.

2. If properly tracked, it is self-adjusting as conditions and costs change.

3. It is quick and simple, enabling the design firm to respond to clients' requests for estimates quickly.

DISADVANTAGES

1. Like the per-page rate, it presumes that all projects that are alike physically are also alike in the creative problems they represent. This assumption isn't true. The averaging factor helps to compensate somewhat, but it wouldn't take too many complex and more time-consuming assignments than usual to get the design firm in trouble.

2. A computer becomes necessary to simplify this effort. Without one, the data gathering and computation can be rather exhausting.

3. As with per-page pricing, basing prices on past averages means prices are likely to lag behind new costs.

SALES PRICE

This method involves what may be referred to as "going-rate pricing." First the design firm identifies a sales price that seems to be what the client is willing to pay. Then it works backward, allocating man-hours, overhead and profit to bring the job in line with the budget.

EXAMPLE: You determine that your client is willing to pay in the neighborhood of $1,500 for a simple all-type, 6-page folder. By subtracting the profit margin and operating expenses, you arrive at the budget for labor charges.

$1500	Selling price
−300	(20% profit margin)
$1200	Total labor and overhead

Current overhead ratio: 44%

$1,200 ÷ 1.44	= 833 (labor)
$833 ÷ $30 per hour	= 27.8 hours
(rounded out to 27.5 hours)	

ADVANTAGES

1. If enough information is available from either the client, in the form of a budget, or from knowledge of competitors' prices, the highest priority is put on getting the most for the job.

2. It clearly identifies to the design staff man-hour goals for them to work towards. Most designers feel more comfortable working within clearly defined schedules and budgets, although they don't like to feel that these are the only goals for which they are to shoot.

3. Since the firm's profit margin is the first item allocated, it is assured of this profit almost immediately—if labor charges stay within budget.

DISADVANTAGES

1. The budgeted man-hours may not be enough to do the job properly. Either the job is done poorly or not to the client's liking (unwise) or overtime is required to maintain the schedule and reduce the losses.

NOTE: Overtime is the preferred method to make up underestimated jobs (if staff is paid on a straight time basis, rather than 1½ times salary) because, while it increases the salaries paid to staff, it maintains approximately the same overhead costs. The effect is a reduction in the percentage of overhead, which absorbs some of the extra labor costs.

EXAMPLE

We'll work with the same $75,000 overhead figure and $170,000 total salary figure from our example (page 31). With overtime, both increase

No Overtime	With Overtime
100 × $75,000	100 × $76,000
divided by	divided by
$170,000 = 44%	$185,000 = 41%

$1500	Selling price
−300	(20% profit margin)
$1200	Total labor and overhead

Adjusted overhead ratio: 41%

$1200 ÷ 1.41	= $851 (labor)
$851 ÷ $30 per hour	= 28.4
(rounded to 28.5 hours)	

The effect is that an additional hour can be allocated to the job without affecting the profit of the firm.

2. The design firm is not forced to plan the various steps involved in the production of a job and, hence, runs the risk of encouraging loose project-management controls.

3. It puts the emphasis on giving the client what he wants, rather than what he may need—on projects, rather than programs.

TOTAL COST PLUS

This is a method seldom used by design firms, but seen quite often in manufacturing and industry. In it the bulk of the profits are shifted from a labor-intensive base to a material and production base. The design firm contracts to deliver a completed printed job for a flat fee. All costs including design are added up, and overhead and profit are added to the total cost of the job.

EXAMPLE

Design:	27.5 hours × $20.50 ($170,000 divided by 8,320 max. chargeable hours = $20.43, rounded to $20.50)	= $ 563.75
Composition		$ 250.00
Printing of 1,000 copies of a 6-page, 2-color folder		2000.00
Delivery charges		25.00
SUBTOTAL		2838.75
Overhead: 44%		+$1249.05
		$4087.80
Profit 20%		+$ 817.56
TOTAL		$4905.36

ADVANTAGE

Since creative costs are the most unpredictable to estimate and since production costs are the most predictable, the bulk of the profit responsibility is placed on the most measurable and, therefore, most accurate part of the estimate.

DISADVANTAGES

1. It can only be used for a flat-fee contract.

2. It might cause a job to be overpriced and thus you may lose the contract.

3. It can only be used when creative work is involved, not for reprints, since the ratio of overhead to costs would be skewed.

4. Since the bulk of the profits made by the design firm come from the markup on printing, there is a danger that the design firm would be tempted to shift its focus away from creative work and become a volume factory.

WHICH METHOD TO USE?

Each of these methods has its advantages and disadvantages. You must use your judgment in deciding which method applies best in a specific situation. You may feel more comfortable with one method than another. Still, there is no requirement that you use one method exclusively. No method will be perfect for all situations.

It is important to remember that any of these methods, if followed properly and if based on accurate per-hour costs and overhead costs, can be used to create an estimate that will assure your firm an operating profit.

Proposals, Contracts, Letters of Agreement

By figuring out what your cost per man-hour is and by determining your overhead percentage and desired profit, you have given yourself some basic tools for estimating the cost of projects you are billing for.

In the preceding chapter, six ways of calculating prices were outlined. Regardless of which method you choose, you should view the resulting sales price as only a starting point. There are still several decisions yet to be made before you are ready to present a price to a prospective client.

Now that you know how much you SHOULD charge a client for your services, you must figure out what you WANT to charge, HOW you want to charge for the work you will perform and, finally, how best to inform your prospective client of your decisions.

Unlike advertising agencies, which have managed to establish a "fair" percentage the client expects to pay for their services — currently 17.65 percent of the price paid for media placement—design firms have no agreed upon formula for compensation that clients can refer to. Therefore, deciding how much to charge a client for work becomes more an art than a science. The design firm has to balance its desire for getting the highest possible price for its work against the realities of what it probably can get for its work. It has to assess the factors that determine value.

These are the same questions you had to confront in developing your business plans. They have to do with demand for your services, competition, and the kinds of jobs you seek. (For a complete discussion of these factors, refer to the section on The Business Plan in the chapter titled, "Planning Ahead," beginning on page 17.)

HOW TO CHARGE

Once you've decided what to charge, you must select the form in which you will present your price to the client.

There are two decisions to be made.

1. Should the price be quoted as an hourly rate or as a flat, fixed fee for the project?

2. Should the price be presented in a letter of agreement, a formal, printed contract, or in some other form? The basis for a price can—and should—take many forms, but the form it takes should always be consistent with the specific requirements and circumstances of the client.

HOURLY RATE OR TOTAL PRICE?

Regardless of what the client may tell you, he really wants you to propose a total, lump-sum price. If he asks you for an "estimate" of costs, he does not regard your reply as a best guess; he considers it a final quote. If you quote an hourly rate, he will want you to put a "not-to-exceed" figure in your proposal. This amounts to a no-win situation for you: If the job requires more work than you expected, you won't be paid for it; if it takes less, the client expects you to bill him less.

In addition, by putting the emphasis in the wrong place—on individual units of time, rather than on solving a problem—the client is encouraged to see the design firm's contributions as hand skills rather than creative thinking. And clients can get very nervous with hourly rate proposals. They view them as open checkbooks. But if the problem to be solved is so vague that it's impossible to predict creative time accurately; or if the number and kind of applications or adaptations can't be specified, then an hourly rate basis for payment is the only way the design firm can sensibly submit its proposal.

So why not merely quote all jobs on a fixed-fee basis? Because, in many cases, a fixed-fee can create more difficulties.

1. If the scope of the work the design firm is being asked to do is too vague, the firm could end up doing far more work than it expected to, with no way to get paid for the additional work.

2. When a client knows that there is no meter running he has a tendency to ask for a lot more adaptations and alternatives then he would if he knew he had to pay for each one.

3. Little allowance is usually made for slip-ups. Unless the job has been very well planned, the estimates carefully prepared, the project well managed and the team of designers efficient in their handling of the job, the firm stands to lose money on the job.

The system that seems to work best is quoting a lump sum price for a project but breaking the job down into phases, with each phase clearly and precisely described in great detail. A kicker paragraph inserted into the letter of agreement should spell out that any additional work not specified, described, or outlined already would be charged at a specific hourly rate. If your client balks at this last item and insists on a flat fee for everything, try to quote a flat fee per application. Work out the flat fee by figuring out how much time it would take for an average application times your basic hourly rate plus a 20 percent to 50 percent contingency.

CONTRACTS AND LETTERS OF AGREEMENT

No subject sparks more disagreement among design firm principals than the matter of contracts. Many designers insist that contracts are an absolute necessity, the single most important thing a design studio should incorporate into its method of doing business. Just as many designers not only have no use for contracts, but also insist that contracts scare the hell out of clients: they bring clients' lawyers into the picture—and with them more delays—and that even signed contracts cannot be enforced.

So the question is, "Should graphic designers rely on contracts, and, if so, what should the contracts say?"

A contract does not have to rival a Russian novel in length or density. It doesn't even have to be written, although any designer who runs a business entirely based on verbal contracts must also still believe in Santa Claus.

A contract is an agreement between two or more parties that something will be done by one or both. The key word is agreement. Until both or all parties agree to the terms of the contract, there is no contract—only what might be called a first offer.

Furthermore, until there is some evidence to suggest that both parties willingly agreed to the terms of the contract, the law must assume that there was no contract. Suppose, for example, that you and your client agree that you are to design a brochure for him for X dollars, and you go ahead and do it and send it to him with a bill. Within a few days you get an angry call from the client saying, "Not only is this nothing like what we asked for, but your bill is outrageous. We're not going to pay you a penny!" If you can't resolve the problem between the two of you, you might find yourself standing in front of a judge with little on your side except your word against his. Without any letters of confirmation spelling out the terms of the assignment, without any documented meetings in which the job was discussed, implying understanding and acceptance, without any previous bills upon which the terms were restated, what can a judge conclude except that the parties never came to any agreement?

Many designers will say that if a client really wants to get out of paying a bill, he will, contract or no contract. That, even if you do take him to court and win, it will cost you more than it's worth, and the client is a lost cause anyway.

Other designers will say that the mere presentation of a contract to a client appears to be insulting their honesty. In fact, designers have told me that some clients have even said to them that they have always done business on a handshake and always will.

These are weak arguments against the hard evidence of many naive designers who have been stung by clients with highly selective memories, executors acting on behalf of widows who view the designer as just another creditor trying to take her money away with no proof the deceased spouse ever even hired him; or new executives at the client firm who find no record in the files that their predecessors ever made a deal for a design job.

If a client refuses to sign some kind of document which spells out what he is buying and for how much, you have every reason to wonder, "Why not?" If he really intends for you to do the work for the price you are asking, what does he have to lose by putting it in writing?

One explanation for all the suspicion of contracts is poor contracting. Too many designers structure a document that is either confusing, intimidating, or simply too one-sided.

Contracts or letters of agreement do not have to be ponderous or full of technical terms. Quite the contrary; the shorter and simpler, the better. If the proper foundation has been laid, most jobs can be handled in very simple forms and short letters of agreement. (See page 47 for a typical example).

The important things to remember are:

1. The letter should contain no surprises for the client.

2. It should serve as a means of continuing the process of closing the sale, not shutting it off.

3. It should leave absolutely no margin for misunderstanding. Any reference that could in any way be considered vague or ambiguous should be rewritten.

The contract or letter-of-agreement should serve the purposes of both client and design firm. The client primarily wants to feel secure. He wants the reassurance that the design firm has understood the problem, that the price is within his budget, and that the work will be completed on time. The contract or letter should reinforce the client's feelings that he made the right choice in selecting your firm.

The tone of the letter should be professionally enthusiastic, not dry and dull. If the design firm isn't excited about the prospects of working on the job, how can they be expected to bring any fire to the job? The letter should be logical and organized, indicating a well-run and disciplined firm—one that won't miss deadlines or drop the ball during the course of the job. There should be absolutely no spelling errors, corrections, incorrect client names or titles, or any other indications of sloppiness and lack of control and supervision.

NEGOTIABLE ITEMS

The design firm obviously would like to sell the job for a profit. If the firm has properly estimated the time the job will take, it should have a good idea of what it will need to be paid to show a profit on the job. To sell the job at that price might take some negotiating, however. So, one of the most important things to build into a letter of agreement is items which are negotiable. If the client is quoted a simple flat price, the individual basis for this price should be spelled out in such detail that the price will look low. Even more important, by spelling the scope of the job out in such detail the design firm has given itself a tool to negotiate with, should the client balk at the price.

By giving itself the flexibility to reduce the amount of work to be done, the design firm is able to reduce the final cost of the job without reducing either the quality of its work or the profit in the job.

By suggesting to the client that the price could be reduced by doing only roughs, instead of comps, by doing fewer alternative solutions, or by eliminating some items altogether, the design firm demonstrates to the client that it really wants to do the work, and that it is willing to make some concessions in order to do it. But the firm should never indicate to the client that it will EVER make concessions which place a lower value on either itself or the quality of the job. As soon as a client learns that the firm can be pushed about so easily, it's only a matter of time before the relationship will turn sour.

It's far better, if the design firm can afford it, to lose the job. Even in losing, the firm will win the respect of the client. The client may continue to ask for proposals from the design firm, or at the very least, refer the firm for other assignments.

IDEAL CONTRACTING PROCESS

Obviously, there is no one best way to contract with clients, since all clients are different and all contractual arrangements should be tailored as precisely as possible to the specific situation.

Nevertheless, there are certain items which should be included in all contracts and letters of agreement and a certain procedure to be followed which seems to work best for graphic design firms.

THE NEW CLIENT

The first time the design firm is asked to submit a proposal for a new client is by far the most critical time for the design firm. If handled sensibly and well, it could serve not only to get the firm hired at a price that's right for both sides, but could serve as a strong base for all future assignments.

In the flush of the possibility of new work from a new client the design firm mustn't be tempted to abandon sensible business practices. Doing so could mean a lot of wasted time, not to mention a sizeable loss of income to the firm.

There will be two kinds of clients—those you've heard of and those you haven't. Just because you've heard of them doesn't make them any less a business risk. Conversely, just because you personally haven't heard of them doesn't mean they can't or won't be able to pay their bills.

Before accepting an assignment to do any work for a new client, make certain you run a credit check. This can be done discreetly by checking with your local credit bureau. If the information received is too incomplete, it doesn't hurt to ask for references and begin the assignment only after these references have been checked out. You must be very careful to treat any new client very delicately, but you also should be completely satisfied that they will not be a credit risk before you start doing any work for them.

IF THERE ARE DANGER SIGNS

For some reason brand new firms seem to feel that just because they don't have a lot of capital everybody they deal with should share their risks. Why this is so, I don't know, but an awful lot of design firms that should know better play Santa Claus to these new businesses. Perhaps they believe that because they've agreed to accept the job at bargain rates, they'll be allowed the freedom to do exciting work. An interesting theory, which has proven wrong 95 percent of the time. Cheap rates do not make a client any less demanding. If anything, new businesses are even more involved because their emotional stake in their enterprise is intense.

If you just can't resist taking an assignment from a brand new company, or any other client that may be unreliable about paying its bills, at least try to adhere to some basic, sensible ground rules in dealing with them.

1. Get everything in writing and all agreements signed by the client. If the client is a corporation you will need a personal guarantee of payment not from the business, but from the owner, in order to have a chance of getting paid should the business declare bankruptcy.

2. Make certain that you get some money up front and the balance in scheduled payments. By doing this you can deposit the money and get the cash working for you in case the client is slow in paying the second invoice. If any of the payments aren't paid according to the terms of the contract or signed letter of agreement, simply stop doing any more work and politely let the client know you've done so. Chances are very good that, if you haven't been paid yet, you won't be. Don't throw good money (your time) after bad.

3. Never go into debt for the client. Have printers or photographers bill the client directly or get the cash in advance to pay them. Don't risk ruining your relationship with a good supplier because of a bad debt.

4. If the client absolutely can't pay now, but you have great hopes for a bonanza in the future, don't be afraid to spell out this bonanza in writing. If, for instance, you decide to accept an identity program for a new business because you feel it would add something worthwhile to your portfolio, and the client can't afford your normal rates at the moment, you can structure a contract which pays you X now and X times X in the future, should the program still be in use. You might even decide to accept some stock in the firm in lieu of cash. Remember, a contract can be anything you would like it to be as long as two consenting adults are involved.

IF THE SIGNS LOOK GOOD

When the feedback indicates that the new client is definitely one you wish to work for, it is even more important that you proceed carefully. Most design firms only have to be burned once before they learn to stay away from bad credit risks; but some firms never do develop sensible procedures for dealing with the firms that will form the backbone of their business.

CONTRACTS OR LETTERS OF AGREEMENT?

Many designers never use a formal contract, but the weight of the evidence suggests that formal contracts should be an integral part of client relationships. The best time to send the client a contract is the first time you do a job for that client. At that point in the relationship the client is most likely to view it as a perfectly normal business procedure and will not be intimidated by it. A suggested approach: a contract that refers to terms generally, a letter of agreement covering the specific assignment you are estimating on, and a cover letter explaining that it is your normal procedure to send clients a contract only once, when starting to work on their first project. On future assignments you will use only a letter of agreement, or even just a purchase order.

Ask the client to sign one copy of the contract and return it to you while keeping another copy in his files. Don't worry if the client objects to some of the terms. It's better that these problems be faced early on, rather than later. Try to get each problem solved by negotiation as best you can so that all the legalities can be behind you.

The content of both the letter of agreement as well as the first (and only) contract should not come as a surprise to a client. In the very first meeting with the client, all points should be covered, with the exception of the final price. That will come in the letter of agreement.

Many design firms feel the need for several contracts, since the nature of the work can vary so much. Certainly the problems a designer confronts when estimating on environmental work—which might require enormous subcontracting fees and totally unpredictable numbers of signing applications—are nothing like those faced by the designer estimating a simple 2-color letterhead.

But basic terms which can apply to all design jobs can be covered in a simple, printed contract. Terms which only apply to a narrow range of situations should be covered by printed attachments to the proposal letter. These attachments should also be sent just once, to be held in the client's files. (This will necessitate keeping a file of all contracts which have been sent to each client and checking it when you are asked to estimate on new projects for that client.)

ITEMS TO INCLUDE

In addition to being written in simple, direct language, without errors, and in a tone that conveys enthusiasm, on stationery that looks good, every letter and/or contract must contain certain basic elements if they are to serve their purpose—sell the job at a price and on terms that are right for both the client and the design firm. Every letter and/or contract should:

1. Spell out as precisely as possible exactly what you are going to do.

2. Tell the client how long you expect it to take you to do this.

3. Clarify who's going to do what at your firm and at the client's.

4. State how much it's going to cost and how you expect to be paid for the work.

5. Have a place for the client to sign it.

(Even if the client doesn't sign the letter, if he behaves in a manner which appears to be in accordance with accepting the terms of the letter, such as approving designs in writing, he will have a hard time proving he never accepted the terms of the letter.)

Somewhere in either the overall contract or the letter of agreement these points should be addressed:

1. You want to protect yourself from getting too far into a job without getting paid. You also want to set up what amounts to a kill fee, should the job get sidetracked permanently. Start with a paragraph which describes your general working relationship and the fact that you will be doing your work in phases, which you will describe in detail, and that these phases will be billed as they get done or in monthly billings measured against the total for each phase.

2. You want to protect yourself against nonpayment. So you include a sentence which gives you the right to stop all work or not deliver the completed work until you get paid.

3. You want to get written evidence of the fact that you've been hired to do the project, so you should include a paragraph which states that you won't start any work until either written or oral approval is received.
 (The reason to mention oral authorization is this: you don't want the approval sitting there

waiting to be signed and possibly causing the job to not get started at all. If you *do* receive oral approval, send out a letter to that effect, thanking Mr. X for calling on X day and giving you the go-ahead, and announcing that you have begun the work.)

4. You want to get the payment terms in contract form, but since the payment terms vary from job to job you merely include a sentence which states that payment will be made according to terms described in proposal letters submitted for each project.

5. You will be billing out-of-pocket expenses in addition to the estimate, so include a section which describes what you consider these out-of-pocket expenses to be and what your mark up will be. Some clients incorrectly feel that they aren't subject to sales taxes. You should also mention the conditions under which items will be taxed.

6. Most of your payment problems arise from attempts to get paid for corrections, additions and alterations which you consider outside or in addition to the original estimated job. You should deal very directly with these situations by describing precisely what you consider this additional work to be. You also want to protect yourself from those times when the specifications on a job change so radically that the original estimated price no longer applies. To cover that, include a sentence stating that in such cases, a new estimate must be submitted and agreed to by both parties before work can continue.

7. Most estimates are submitted with the assumption that the work will be done on normal schedules, but all too often the actual schedule is much tighter, requiring overtime costs. You should include a paragraph which states that you have the right to revise your estimate to compensate for "rush" requests. (Incidentally, since the profitability of your firm is based on both quality *and* volume, volume can be increased by tighter schedules.)

8. Sometimes you will be asked to deliver a finished, printed product. At other times you will merely be requested to supervise the production of the final pieces. You will need a paragraph that tells what you do in each circumstance and how you charge for these services.

9. You do not want yourself included in a lawsuit with your client, so you will need a paragraph which gives you the right to refuse to publish any material which could get you in trouble.

10. You also want to transfer as much of the legal responsibilities as possible to your client, so you should have a paragraph which states that the client is responsible for all claims made, all trademarks, copyrighted materials, and clearances.

11. You want to protect yourself from those situations in which the client has a copyright problem and blames you, claiming he automatically expected you to get your material copyrighted for him. Include a sentence which offers the client the option of engaging you to do this. You should also mention that you would be willing, if requested, and for a fee, to help secure copyright protection for the client.

12. On occasion you will be asked to place ads for a client. Detail how you will charge for this service.

13. You don't want your clients dropping in any time demanding to see your books. On the other hand, you want them to know that you run an honest business and have nothing to hide. Include a statement to the effect that any information, correspondence, accounts, etc., relating to their business is available for inspection, *if* it is done in your office—you don't want these things taken out—*and* during usual business hours *with* reasonable notice given and arranged for.

14. You don't want to have to pay because a printer lost a slide or a piece of artwork, so you should include a paragraph that disclaims all responsibility for loss or damage to the client's property by others.

15. You will need to put a date on the contract when it goes into effect. You also want to leave yourself the opportunity to change it or get out of it, so include a sentence which states that the contract can be terminated by either party upon 30 days' written notice.

16. Along with this, you want to protect yourself from costs already incurred in jobs which are terminated if and when the contract is terminated, so you will need a paragraph to the effect that, in such an event, you won't be held responsible for any such costs.

17. Also in the event the contract is terminated, you will want to retain ownership of all materials and/or design ideas which haven't been paid for. Say so.

18. You want to be able to use your work as a marketing tool. Reserve the right to reproduce it for this purpose.

19. You want to be repaid for any losses that may come as a result of claims or suits made against you for work done on behalf of the client.

20. Mention the legal basis for this contract—the state laws you are operating under.

21. You will need to establish a reasonable range in your estimates and quantities delivered—15 percent is an acceptable standard.

22. You will need to set some time limit on how long your estimates will hold for.

23. If you do have to take a client to court to collect a bill, you will want the client to pay the legal fees and interest costs. Say so.

24. Mention that this agreement can't be changed except by signed agreement.

25. Finally, leave a line or two for it to be signed.

SUPPOSE YOU GET A CONTRACT
FROM A CLIENT
Try to remember that he's done the same thing you've done—protected himself from you as much as possible. If there's anything in the contract that bothers you, simply cross it out. Let him come back to you with a better offer.

Other items to consider: royalties or additional fees for identity programs used for a long time or extended beyond a certain geographical border.

Be careful not to give away rights you don't own. The law says that all original photos and illustrations are owned by the photographers or artists who created the work unless SPECIFICALLY signed away by them. Don't let your client think he is buying more than he is. Specify exactly what he owns—if only the reproduction rights to a particular use, spell it out. Mention that all original art and photos are to be returned to the photographer and illustrator by a certain time. But reassure the client that the work will not be sold to a competitor or used in any way which would be embarrassing to him. In order to do this you will need to secure these assurances, in writing, from your suppliers.

SHOULD A CONTRACT BE
PRINTED OR TYPEWRITTEN?
There is a difference of opinion here among designers. Those who prefer the typewritten form claim it looks less threatening, can be easily adapted to different uses on a word processor, and doesn't invite close scrutiny. Those who prefer printed contracts claim the appearance of finality lends more weight to it, therefore it inhibits changes, it's no big problem to adapt the same contract to many different uses and gang-print all of them and, finally, they look more professional and give the firm credibility. My vote is cast on the side of printed contracts, if used properly.

TYPICAL CHARGES

PAGE RATES:	LOW RANGE	AVERAGE RANGE	HIGH RANGE
Up to 12 pages	$400–$500	$600–$800	$1,200–$1,500
Over 12 pages	$250–$400	$500–$750	$1,000–$1,200

Note: In addition to their page-rate-based total fee, most design firms quote such items as charts, graphs and maps on a per-piece basis, usually in the range of from $200 for a simple chart to $500 for more complicated ones. Production (mechanicals) is also usually quoted as a separate charge on an hourly basis. In the lower page rate ranges most major design firms will usually provide roughs only, not comps.

IDENTITY PROGRAMS:	LOW RANGE	AVERAGE RANGE	HIGH RANGE
Simple program	$ 2,500–$ 5,000	$10,000–$15,000	$25,000 up
Large program	$10,000–$20,000	$25,000–$35,000	$50,000 up
Manual	$15,000	$25,000	$40,000 up

Note: Simple identity programs usually involve only one or two symbols or logotypes, usually presented as roughs only. Larger programs usually require elaborate presentations and/or research.

One package	$10,000–$15,000	$18,000–$25,000	$30,000 up

HOURLY RATES:	LOW RANGE	AVERAGE RANGE	HIGH RANGE
Principals	$55–$75	$100–$150	$200–$300
Sr. Designers	$50–$70	$ 75–$ 90	$100–$135
Jr. Designers	$35–$50	$ 55–$ 70	$ 75–$ 85
Production	$35–$45	$ 50–$ 65	$ 70–$ 80

Note: Printing and photographic supervision, research and writing are usually charged for as additional costs in either flat rates or on a per diem basis.

MARK UP ON OUT-OF-POCKET COSTS:	LOW RANGE	AVERAGE RANGE	HIGH RANGE
	15%	17.65%–20%	25%

Note: Although most design firms will mark up some out-of-pocket costs, there appears to be a wide difference among design firms as to which costs will be marked up and which will not. Half the design firms include printing as a marked-up item, while half only charge a flat supervisory fee. Many mark up all out-of-pocket costs, while many exclude all costs outside of typography charges. Those who do not mark up their costs believe it makes them appear more professional, since they benefit in no way from money spent on anything other than their own labor efforts. Those who do mark up all out-of-pocket costs argue that, since they have in effect advanced the money for their client they are entitled to recover at least the interest they have lost on their money during the period the money was being used by their client.

AGREEMENT BETWEEN WGDF, INC.

AND _____

1. GENERAL WORKING AGREEMENT

This paper, when signed by you with a copy returned to us, will constitute a working agreement between our firms. All projects or services which WGDF, Inc. may be contracted to produce or provide for your firm will be subject to the general provisions spelled out in this agreement. It will not be necessary, therefore, for any other further agreement or agreements to be entered into between our firms until such time as these general agreements should change.

2. SPECIFIC TERMS

Terms for specific projects and/or services will be detailed in either a "Letter of Agreement" for such products or services or a simple purchase order. We will not begin to start work on a project until such letters or purchase orders are approved (written or oral). Such approvals would constitute an agreement between us in accordance with the terms specified in such letters or purchase orders.

Unless otherwise specified, all our "Letters of Agreement" or purchase orders will be based on reasonable time schedules. In those cases when the work eventually performed requires the work to be done on a RUSH or overtime basis any additional costs incurred due to such circumstances will be reflected in our billings.

3. FEES

The specific fees and billing sequences for each project or service will be described in the previously mentioned "Letters of Agreement" or purchase orders. We reserve the right to refuse to begin, complete or deliver any work until the appropriate fees agreed upon are paid according to the billing sequence specified.

Since it is impossible to predict with absolute accuracy either final total fees or, in the case of printed material, final total quantities, a 15% contingency should be allowed for in each case.

Should any of our invoices not be paid within 60 days we reserve the right to charge interest at the maximum rate permitted by law.

Should we be forced to retain attorneys to collect our invoices such fees and court costs that may be reasonable and necessary, as well as any interest charges incurred, will be paid by you.

Unless otherwise specified our fees do not include such items as photographs, photostats, photo prints, typesetting, illustrations and other such contracted for artwork, copywriting, retouching, color separations, printing, paper, messenger services, shipping, postage and long-distance telephone calls. These items will be regarded as out-of-pocket expenses and will be billed in addition to our quoted fee.

Such out-of-pocket expenses will be itemized on each invoice and are subject to the then current standard agency service charge. They are also subject to applicable State Sales Tax unless: (1) you are a non-profit organization; (2) the contracted work is for resale and you have furnished us with a valid resale number; or, (3) your offices are not in (fill in State _____).

If we are required by the nature of the assignment to travel to out of town locations, any out-of-pocket expenses incurred for transportation, meals and lodging will be billed at cost. Reimbursement for mileage will be calculated according to the then current allowable government rates.

4. REVISIONS AND ALTERATIONS

Any work requested by you and performed by us after a "Letter of Agreement" or purchase order has been approved, and which was not included in such a letter or purchase order, such as Author's Alterations (AA's) or changes requested after typesetting, will be considered to be "new work" and will be billed in addition to the original letter or purchase order.

If the scope or nature of the job changes to such an extent that the original "Letter of Agreement" or purchase order is no longer applicable, a new letter or purchase order will be submitted and must be agreed to by both parties before any further work can proceed.

5. LEGAL MATTERS

A. We reserve the right to refuse to be a party to any project which, in our judgement, would be illegal, fraudulent, or in some other way harmful to the best interests of our firm.

We will not be responsible for any claims made by you or for any legal clearance incumbent upon you to receive. However, should you request it, we will, at your expense, take all necessary steps to secure such legal clearances.

B. We will do everything we can to protect any property or materials you entrust to us and to guard against any loss to you. However, in the absence of gross negligence on our part, we are not responsible for the loss, damage, destruction or unauthorized use by others of such property nor are we responsible for the failure of other suppliers or vendors, such as printers, photographers or media.

C. We will also make every effort to return to you as promptly as possible all material and property which belong to you or for which you have paid. However, we are not authorized to release to you any property or material which may be owned by others. This includes any photographs, illustrations, lettering or other such artwork which is specifically owned by the artists or photographers. Any transfer of ownership can only be signed away by these suppliers directly. Should such ownership rights be desired or should you wish unlimited use of a particular piece of artwork or photography, inform us of these desires before we contract for such work and we will be happy to negotiate for such rights on your behalf.

D. We reserve the right to use any work we may produce for you as samples, which we may use or reproduce in any reasonable way for our marketing needs.

E. Any design ideas which are not accepted and paid for by you become our property and we will be free to use such designs in any way we may desire.

F. In the event that we sustain a loss as a result of a claim, suit or proceeding brought against you as a result of the publication of material which you approved of and authorized us to produce for you, you agree to indemnify us for any such losses.

6. INSPECTION OF DATA

If at any time you wish to examine any contracts, correspondence, books, accounts or other data relating to your projects, these will be made available for inspection in our offices during normal business hours by either you or your authorized representative. You merely have to give us reasonable notice of your desire to do such so that we can get the desired material together.

7. AGREEMENT VALIDITY

The validity and enforceability of this agreement is based on the laws of the State of (State) which are applicable to such agreements entered into and performed within the State of (State).

This general agreement forms the basis for our entire working relationship and shall not be modified or altered in any respect except by mutual agreement in writing.

_____ _____
Client name and title for WGDF, Inc.

_____ _____
Date Date

Sales
and
Marketing

Of all the words in the English language, none strikes more fear in the hearts of young graphic designers than SALES. Designers are not alone. Most people seem to believe that salesmen are despicable people and selling is an unsavory activity, to be avoided at whatever cost.

This is an attitude deeply ingrained in the artistic tradition, which defines fine art and commercial success as mutually exclusive. It is reinforced in school and permanently sealed for most designers by jobs that are totally divorced from sales and marketing concerns. This aversion to selling is a normal feeling, and it is harmless for any type of designer except one—the designer who wants to succeed in business.

Like it or not, the simple fact is that once you hang out your shingle, you're in a real business. You're not hidden away in a garret churning out masterpieces of pure artistry; you are in the thick of a difficult, highly competitive, sometimes even cutthroat business environment.

Your capability of doing excellent work is not enough to survive in business. You also must find ways to let potential clients know about your ability. This requires MARKETING. And you must learn to transform potential clients into actual paying clients. That requires SELLING.

Almost all designers interviewed for this book told me that they rely on referrals for 100 percent of their work. Does that mean they don't have to knock on doors making sales calls? Perhaps. (Most of them admitted to trying cold calls at one time, but without success.) Does it mean they don't have to sell? Wrong. If you believe clients will come running into your office, waving their checkbooks and begging you to take their projects and their money, it's time to pinch yourself and wake up.

Clients do not buy design on impulse. They seldom make up their minds to do business with a designer without prompting. Clients buy design because a designer convinces them they will benefit from doing so. Clients buy design because a designer persuades them that his firm can solve their problems better than any competing firms. He does this by describing how the firm has successfully solved problems for other clients.

That doesn't sound so terrible, does it? In fact, it serves two rather noble purposes. It enables the client to obtain a service of genuine value to his business. And it enables the designer to eat.

Looked at in those terms, selling isn't quite so reprehensible. For, in fact, much of people's discomfort with sales has to do with unfair stereotyping. SALES and SELLING automatically call up visions of used-car lots and late-night TV pitches for Veg-O-Matics. These are the worst cases, the grotesque extremes. They are not models that must be followed. Selling is not a synonym for exaggeration, exploitation, or deceit. The fact that you must persuade a client to buy your services is not degrading; it is a fact of life. Selling is not lying; it is expressing convincingly what you surely believe: that you can help a client achieve his goals.

Every successful design firm, without exception, sells its services.

Most successful designers also market themselves. Marketing is not the same as selling. Sales is focused on today; it is persuading today's clients, usually in face-to-face contact, to use the design firm's services. Marketing is focused on the future; it creates awareness of the firm's presence and its abilities among targeted prospects that are the most promising potential customers. Effective marketing creates a desire for your firm's services. It softens up the marketplace, making later sales efforts that much easier. Most design firms that rely almost wholly on referrals are reaping the fruits of seeds sown by their own continuous marketing efforts.

Both sales and marketing are vital to the growth and health of the design firm.

THE MARKETING PLAN

Word of mouth is a wonderful way to bring in business. But it is risky to rely on referrals exclusively—and when you're first beginning a business, it's a sure formula for failure. Building a solid reputation takes months—sometimes years. In the meantime, bills, rents, and salaries still have to be paid. Depending on referrals for new business also takes the control out of your hands and entrusts it to luck.

The design firm has to find a way to keep work coming in at a steady and controllable pace. When the economy is booming, a well-established design firm can usually get along by relying on referrals for all its work. It's in slower times that problems begin to surface.

When a studio develops a well-thought-out, practical marketing plan—a plan unique to its own particular goals, needs, strengths, weaknesses and interests—it begins to commit itself to staying in business.

You begin a marketing plan by taking a hard look at your business. No two design firms will have exactly the same strengths, weaknesses, interests or goals, simply because no two people are alike. It is important to identify the range of differences before planning the future of the firm. A goal of growing into a very large firm will require a totally different marketing plan than one which merely seeks to maintain present size or seeks moderate growth.

There are three questions you want to ask yourself:

1. What is your business like today?

2. What would you want your business to be like tomorrow, if you had your preference?

3. What would be the best way to get there?

The answer to the first question requires information gathering and analysis. The answer to the second requires soul-searching and the weighing of pros and cons. The answer to the third question requires strategic thinking.

What is your business like today? You need to know a number of things, such as: Who are your major clients? What industries do they represent? Where are they located? How difficult are they to work with? How profitable are they? What services and products do they ask you to provide? How much money do you make from your business? How do your products and prices compare to your competitors'? Get as complete a picture of your present situation as possible. With this information you can then begin to evaluate the information in personal terms.

What do you want it to be? Are you working in the place you want to work? If not, where would you rather be working? Are you spending your days doing what you want to be doing? Are you, for instance, doing paperwork when you'd rather be designing? Do you want more of the same kind of clients you have now, or do you want to go after a different market? Are you getting paid to provide the services you think you should be providing? From the answers to these questions, you arrive at a set of business goals.

How can you get from Point A to Point B? To change what you are doing, do you need to hire assistants, an office manager, another designer? How can you increase your volume and profit to afford increased overhead? What are effective ways to win business in a new segment of the market? The answers should take the form of a plan for achieving your business goals.

In most cases, achieving these goals will require a deliberate effort to increase your sales.

Most designers have no trouble recognizing the point at which they have enough work to enable them to hire assistants. Few designers know how to accelerate the process, or work actively to maintain volume levels high enough to keep additional employees full-time.

Waiting for referrals is a passive approach. At best, it leaves you at the mercy of fate and circumstance; at worst, it leaves you coughing in the dust while more aggressive competitors go after the most attractive clients.

Marketing and selling are the active approaches to being in business. They are techniques for taking control of your own destiny.

Suppose, for example, you look at the work you are doing and conclude that your clients, at best, allow you only to do mediocre work and, at worst, are low payers, slow payers or nonpayers. If you thrive on masochism, fine; let it be. If you don't, you have to take action to change the situation.

Many issues are totally within your control, if you choose to exercise it: Where you live and work. How you spend your time. Who you work for. Once you accept this fact, and the responsibility that goes with it, you can gain control of your life and control of your business.

When Ellen Shapiro of Shapiro Design, New York, analyzed her business, she found herself working on too many tiny jobs for too little money. She decided to get some corporate annual report projects, but she had to find a way to win them despite having not a single annual report in her portfolio.

First she got a list of *Inc.* magazine's fastest growing companies and sent away for the annual reports of all the companies within a reasonable geographical area. She studied the annual reports and narrowed her list of target companies down to about a hundred. There were three industries that she felt held the most promise for her—consumer products, computer hardware and software, and the biomedical field. In each field, she created comps for an imaginary firm's annual report.

She had the comps printed in a simple four-page booklet and started making calls. The first year she landed three reports; the second year she won five. In a short time, through intelligent planning and aggressive marketing, Ellen has managed to change her client base from low payers to high payers.

MARKETING: LAYING THE GROUNDWORK

Most designers make some effort to create sales indirectly. They enter shows and exhibitions, make speeches, write some articles, join some local clubs. They work up a capabilities brochure for their firm. All of these are tools for marketing.

In fact, every action you take that places your name and your firm's name in the public eye is an act of marketing: The name you select, the logo you use for stationery and cards, the location you select, the office decor you select, the promotional materials you produce, the clubs you join, the competitions you enter, the awards you win, the classes you teach. All of these create awareness of your firm. More importantly, they affect how your firm is perceived among potential clients.

These actions are most effective when they fit within the framework of your overall marketing plan. Ideally, they should supplement and support—not replace—direct selling efforts.

When it is handled correctly, marketing lays the groundwork for sales. It softens up the marketplace; it makes prospective clients more receptive, so that a direct selling effort is not a cold call, but a warm call. And if you are very, very fortunate, the marketing alone will bring clients right to your doorstep. (Warning: Don't count on it.)

In naming your firm, designing your stationery, or decorating your office, you should be asking yourself, "What effect will this have on a client? What will this say to a client about my firm?" Too often, design firms give themselves esoteric artsy names that turn off business clients or fail to convey what sort of work the firm really does.

A very talented designer once produced a business card for himself that featured a beautifully rendered illustration of a face on a lightbulb. He was trying to say that he was imaginative; but instead, the card gave the impression that he was merely an illustrator. He was surprised to find himself getting few design projects but lots of illustration assignments. Only after he changed his business card to a far more typographic design did he begin to attract the kind of clients he wanted.

Marketing is also talking to businessmen in informal settings. It is making contacts. Too many designers limit their social and professional activities to a small circle of fellow artists and designers. This may be reinforcing for personal morale, but it does nothing for the bottom line. There is probably no better marketing tool than a reputation as an expert. You build such a reputation by making appearances, giving talks, joining clubs. You also, at the same time, have opportunities to meet prospective clients. There are other advantages to increasing your exposure to the world beyond the artistic set. The more business people you meet informally, the more exposure you have to the concerns and world view of the people you hope to do projects for. The better your understanding of clients' problems and mind-sets, the more successful you will be at persuading a client that you can solve his problems.

(Along the same lines is the question of winning awards. Does a string of prizes help attract business or merely affect your reputation among your peers? My own sense of things is that young designers are wise to enter as many shows as they can before they go into business. It helps the designer just starting out to establish credibility. It is the cheapest advertising available. Once in business, though, it seems to have very little impact on clients; results mean more than design awards.)

Contacts are everywhere. Don't be hesitant to let your friends, relatives, and business acquaintances know that you're in business and would appreciate any leads they can give you. Practically every designer I interviewed got his first free-lance jobs this way.

Make friends with your colleagues in advertising agencies and public relations firms, even if you don't do any work for them. They often have the ear of the client and will play a large role in determining which design firm gets what.

Make an effort to cultivate your suppliers. Suppliers can be one of your strongest allies in getting work indirectly. Suppliers work with a tremendous number of potential clients and have many opportunities to recommend design firms. You want them to recommend you. Be good to them. Send them notes when they do a good job for you. Send them presents at Christmas. And, especially, pay your bills quickly. Try to work with the biggest and the best. They'll have the biggest and best clients.

YOU CAN'T ESCAPE SALES!
YOU CAN'T ESCAPE SALES!
YOU CAN'T ESCAPE SALES!

Even if your marketing efforts have brought the client to you, you still haven't got his assignment. You still have to persuade him that, indeed, he has made no mistake, you are the one who can provide him value for his money. You can call that charm, you can call that luck, you can call that gentle persuasion. I call that selling. Whatever label it wears, it cannot be ignored, willed out of existence, or escaped. Not if you are serious about being in business and staying in business. And most clients do not come self-propelled to your door. You must find them, court them, and win them over. But it pays off. Hour for hour, the effort spent in creating sales through indirect channels will never produce as much as the same efforts in direct, face-to-face sales.

When a studio sends out a mailing, it is marketing. When it makes a presentation to a client it is selling. When the principal of a design firm makes a speech, he is marketing. When he gets on the phone and persuades a potential client to let him make a slide show presentation of his firm's capability, he is selling.

I am not suggesting that deep in the psyche of every designer lies a natural salesman. Far from it. Designers tend to be people who enjoy sitting alone and thinking deeply. They tend to prefer communicating by what they do than by what they say. Successful salesmen, by and large, are the opposite personality type. But I do know that the world's most successful designers tend to be charismatic and incredibly persuasive, energetic and competitive, as well as highly creative. And I know, from personal experience, that sales are essential to staying in business.

My first job after graduating from art school was in a small studio, where most of the business came from one account. This one account kept three people busy full-time. So busy, in fact, that the owner of the firm hardly had time to do any other work, much less seek it. One day the major client called to say he was getting out of the business. The bottom had suddenly dropped out. To his credit, my boss didn't fall apart or fire his two assistants immediately, although he must have been feeling somewhat panicky. Who wouldn't? He simply hunched up his shoulders and started making sales calls. Before too long he was bringing in enough work to keep the place going. His studio is still going today—and he's never stopped selling since the day he got that phone call.

WHO DOES THE SELLING?

There are various approaches to building sales directly. One way a designer can approach direct selling is to hire a salesman. Every designer I've talked to who has tried this approach said that it doesn't work. Although I'm sure there are exceptions, most of the time the person who is selling doesn't understand the needs and desires of the designers and sooner or later the relationship sours.

A second alternative—better, but potentially costly in a lot of ways—is a partnership between a designer and a salesman, especially one with a strong background in printing. One of the outstanding examples of this kind of relationship is the partnership between Bennett Robinson and Michael Watras of Corporate Graphics, Inc. Although Bennett Robinson had had his own design firm for many years, it was only when he joined forces with Michael Watras that the business really took off.

The keys here, obviously, are that the two partners are highly compatible, that they share common goals, and that the salesman partner has a real understanding of design principles. Considering what it takes to be successful in each discipline, this is a tall order.

The best way to handle sales, by and large, is to learn to do it yourself. It's the least costly; you don't have to increase your overhead or share your profits. It's the most efficient; you don't have to speak through someone else's mouth or hear through someone else's ears. It's also the most effective. It has been proven time and time again that clients prefer to deal directly with the person who will actually do the work. They feel uncomfortable buying design services from people who are clearly only selling, not designing. At the very least they need assurance that the person who is selling the firm's services will be heavily involved in the production of the client's job.

IDENTIFIED FLYING OBSTACLES

In order to create an effective direct sales approach, you should first recognize the obstacles that must be overcome.

The insecure client. First of all, you have to remember that design isn't something that can be picked up and examined, like a banana. A shopper can tell at a glance if a banana is ripe, too ripe, or not ripe enough; he can compare prices easily from one supermarket to another; and one bite will tell whether the product was good or bad. Clients have no comparable way to evaluate design, before buying it or after it has been produced. Furthermore, few clients understand design principles or how to use them to serve their own marketing purposes.

Even when a client is aware that he needs professional design services, he seldom has a clear idea of how much it will cost. If he gets competitive bids from three or four design firms, he has no way to measure value against price. He really doesn't know how to make any choice at all, much less an educated one. Finally, he has virtually no way to measure accurately whether the design firm's work was successful.

In short, the client is full of tremendous uncertainty. The single most important thing a design firm has to do in its dealings with its clients, both potential as well as current, is to reduce this uncertainty—to make a client feel safe, secure and comfortable. Every single contact that the design firm has with its clients—known and unknown—should be carefully measured as to whether or not the contact either increases or decreases the client's uncertainty.

How do your firm's promotion materials look and read? Are they directed towards the client, towards other designers, or, even worse, only towards the design firm itself? Do the brochures concentrate on procedures or on results? Do they talk more about HOW your firm works or the benefits to a client? Clients need to be educated on the VALUE of design for THEIR purposes. They need to be TAUGHT what they can expect design to do for them.

What do your offices look like? Are they decorated in such a way to make clients more comfortable or are they likely to make clients feel out of place? Do you have all your awards on display? Will the client be impressed by your reputation, or see the display as evidence that you're more interested in what he can do for you than in what you can do for him?

How do you dress when you call on a client? Does your dress say you're different or does it say you understand the client?

What kind of car do you drive up in when you call on a client? Dave Goodman, a business consultant for design firms, tells of one designer who owns a Porsche but rents an American compact to call on clients that he believes aren't making enough money to afford a foreign sports car.

The need to feel wanted. Clients that are insecure about dealing with design firms want constant reassurance that their interests are the most important thing in the world to the design firm. They get very irritated when they can't get through on the phone or when their calls are not returned promptly, or at all. They want to stay posted on every twist and turn in their jobs. It is impossible to give them TOO much information on the progress of their jobs.

If they've hired you and they're willing to pay your "obviously exorbitant" charges, they are usually in some kind of trouble. The last thing they need is to feel that you're too busy for them or that they're one of a crowd. Make them feel they're the most important thing in the world to you, and prove it by doing the job for them better than anyone else has ever done it before.

Experience, experience. Because of the scarcity of guidelines for evaluating design firms, most clients tend to lean heavily on how much experience the firm has had and how closely this experience matches their needs. The closer, the better. The bank client wants to work with a designer who has worked with banks. The cookie company isn't satisfied that your firm has designed packages; it wants a firm that has designed food packages at the very least, cookie company experience preferred.

The bigger the client firm, the stiffer the experience requirement. The buyer of design services in a large corporation has supervisors looking over his shoulder. This buyer wants to protect himself as much as possible. The greater the design firm's experience, the less risk for the buyer.

The client's insistence on experience leaves your design firm with several marketing choices:

1. Specialize, so that you can narrowly focus your marketing efforts on a market that would be most likely to use your firm.

2. Bring in a designer or a partner with considerable experience in the industry you want to target.

3. Charge fees significantly lower than your competitors' in an attempt to gain entry to the industry you want to target.

(Be aware, however, that the third option could cause problems later. It will be difficult to raise fees later without losing existing clients. And the firm might acquire a reputation for producing low quality work for its low fees.)

The positioning problem. As difficult as it is for clients to evaluate the quality of design solutions, it is doubly difficult for them to distinguish differences among design firms. Unless a firm manages to position itself in a way that clearly distinguishes its work from that of its competitors, it faces the difficult task of convincing a client to give it work on the basis of faith and trust alone (translation: without experience and reputation) commodities which are unavailable to the young firm just getting into the field.

Arriving at a distinctive design look may be an answer—if, of course, that look is flexible enough to be useful for a broad range of design problems. While having such a style poses the risk of narrowing the market for a design firm's services, on balance it seems to be more helpful than harmful.

The graphic design works of Paul Rand, Milton Glaser, Kit Hinrichs, the late Herb Lubalin and dozens of others are not only brilliant in conception and execution, but also have distinct and recognizable looks. It is unlikely that any of these designers consciously tried to create a look or style for themselves; more likely, their styles evolved from a complex combination of influences, such as philosophy and training. Nevertheless, the recognizable look of each designer's work multiplied its impact and influence on the design world and solidified its commercial success.

Do not misunderstand. I am not suggesting that all young designers should run out and manufacture a look when one doesn't exist. Quite the reverse. What I'm saying is that designers should work hard to find within themselves their own unique way of dealing with design problems, not just because by doing this they become better designers—which I happen to think they will—but because it makes more sense for their business.

THE DIRECT APPROACH

The direct approach to sales can be broken down into five steps:

1. Identifying prospects

2. Contacting prospects

3. Making sales presentations to prospects

4. Closing

5. Follow-up

IDENTIFYING PROSPECTS

Whom do you approach for new business? Your first logical step is identifying likely prospects and qualifying them. If you have been in business for a period of time, you have two immediate sources to look to: present clients and past clients.

Present clients are by far the easiest to sell more work to. They already know you. There is already an existing element of trust (however slim it may appear to be at times). The challenge is to make them aware that you can provide more services than you are providing now. At large companies, this may mean making a pitch to a different division or department. Asking your present contact to set up a meeting for you with one of his associates is a commonly accepted practice; if your contact is willing, his associate will rarely refuse such a meeting. If your contact can't or won't, you might ask to use his name as a reference instead; this is usually enough to get you an appointment to make a presentation.

It is very important to treat all present clients as if they were future clients. Pay attention to them. Keep calling them, even when you're not actively working on one of their jobs.

Every time you finish a project for a client, you are theoretically fired. You don't want to change theory into practice.

Past clients are worth considering also. Whether they can become active clients again may depend on why they stopped sending you work in the first place. If it was because they thought you were too expensive at the time, perhaps their perception has changed, perhaps their budgets have, or, perhaps the people who objected to your prices before have been replaced by people more willing to pay higher design fees.

In any case, the real barometer is not price but value. Go back to your clients and try to find out the results of your work for them. Were sales increased? Was money raised? Were goals met? Don't be afraid to ask. The worst they can say is "No." Or they could tell you what you want to know. If the answers to your questions are mixed or don't help you, you're under no obligation to use them. But if they do, get the client to allow you to quote him in your sales material.

Never just take a client's word alone. Sometimes they won't tell you the truth, and sometimes they're wrong. Check other sources. In the case of annual reports, for instance, check the stockbrokers. Has their perception of the client's image changed?

There's no good way to deal with a bad experience with a client, unless the people you worked with have changed. The best way to deal with a previous bad experience is to admit that it was bad, assert that whatever conditions caused the problem originally have been taken care of, and ask for a chance to prove it. This approach doesn't always work, but it does work occasionally.

New prospects represent the smallest percentage return for the greatest effort. (Although in total dollars, of course, they represent a much larger universe than the clients you've already worked for.) Be aware, going in, that you will be facing lots of rejection. A typical ratio for direct selling is 50 to 5 to 1. That is, every 50 cold calls result in invitations to make 5 presentations, which result in 1 sale.

If after a year you're doing better, adjust your ratios for what is normal to you. If you're doing worse, look hard at your telephone techniques and your presentation methods and materials. You may need to sharpen any or all of these. If an honest effort to improve these still doesn't improve your percentages, perhaps your market environment is just too difficult for the moment and your ratios must be adjusted downward.

The actual ratio is not terribly important. What IS important is that you know with some accuracy what a certain level of sales effort will net you in increased business volume.

Let's assume, for example, that your average profit per client is $10,000, and your goal for the next year is to add $50,000 in profit, or roughly 5 new sales (with adjustments to compensate for increased overhead to handle the additional work). At a ratio of 50 to 5 to 1, you could expect 250 cold calls to generate 25 presentations, which would result in the 5 sales you seek.

The figures may not work out, but by forcing yourself to create definable sales goals, and by constantly measuring and evaluating the results, you virtually guarantee that you will make more sales. Your track record should constantly improve as your confidence in yourself and your material builds.

Remember, every sale you make is a sale you never would have had if you had done nothing.

Where do you begin to find the 250 prospective clients to call? You start by looking for companies or institutions in fields related to those in which you have had the most experience. These clients are likely to have problems similar to those you have already dealt with. Your work will have the most credibility with these kinds of firms.

Say, for example, most of your projects have been done for furniture manufacturers. How do you find the names of other furniture manufacturers? Well, for one thing, you can go to furniture stores. You can make a note of every manufacturer of furniture you see in the stores. Look in magazines and newspapers for ads from furniture manufacturers.

Go to trade shows. Every industry has them, and there's probably no better way to get a handle on who your prospects are. You get a chance to talk to some of the reps, which gives you a feel for how the people in the field feel about their support material. You also get a good background on the individual manufacturers and their problems. This is invaluable when you make presentations, for you want to talk about your client's problems first, not your own firm's capabilities.

Most industries also have their own trade publications. These will not only give you the names of your prospects, but most of them also have a column or section which helps you track the movement of people within the industry. A trip to your local library will give you the names and addresses of these publications.

That same library trip will also allow you to look at the various directories where you can find the names and addresses of most of your prospects. There's a directory for practically everything now.

To name a few: *Thomas' Register of Manufacturers; Standard and Poor's Register of Corporations, Directors and Executives; The Directory of Corporations; the Encyclopedia of Publications; the Encyclopedia of Associations.* There's even a *Directory of Directories,* which is probably where you'll want to start.

Once you've identified a list of possible prospects, you'll next want to zoom in on the most promising targets. Write for the annual reports of the public companies; most companies will send a report to anyone who requests one. Also send for catalogs, facilities brochures, even recruitment materials. What you're trying to find out is whether or not you can help them. Can you make a strong case for how much they need you? Concentrate on companies whose materials appear to need help, yet are not without redeeming graces. These could be companies that are willing to spend for good work but aren't getting it yet. Your toughest sells will be the best and worst—the firms who already use good professional designers, and those who look like they'll never spend the money for quality design work. Put these in a lower category of prospects—ones to be contacted later.

Read an annual report for clues about whether the company is growing and how quickly. The best kind of client to contact is the company that is on its way up but hasn't yet arrived. These firms go through many transitions along the way, and each transition usually requires a great deal of communication with their public and employees. Often they require identity programs with numerous applications.

Narrow your basic list of prospects to those that are most easily accessible to you. Start with your own city, then expand to your state or nearby states. Staying closer to home keeps down travel expenses, as well as time spent away from the board.

But on the other hand, whenever an out-of-town client calls to invite you to see them about a possible job, treat it as a golden opportunity for prospecting. Try to postpone setting up a date as long as possible without getting your client upset. Then get on the phone and attempt to line up at least one or two other prospect presentations with clients near the one who called you. Don't waste an opportunity to cluster calls when it's given to you.

Once you've narrowed your list of prospects you're almost ready to start contacting them. But not quite. First, make certain the information you have is accurate and current. Nothing makes for a worse start than talking to the wrong person, misspelling the name of the person you're writing to, or sending a letter to the wrong address. Double-check first to save embarrassment.

Be careful that you contact the right person at the prospect company. In some cases, depending on the size and structure of the company, it will be the president, in some it will be a vice-president, in other cases it might be a manager.

The larger the program you're trying to sell, the higher you'll eventually have to go. But you might not be able to start at the top. In fact, it is usually counter-productive to try, unless the person you seek happens to be a personal friend. Although the president of the company may get involved in selecting a design firm, usually a lower level of management is responsible for. taking these concerns off his shoulders. You don't want to make these people look bad in front of the president, nor do you want them to feel that you went over their heads to try to get work. They won't appreciate it and neither will the president. Try to identify the proper channels to go through, and let your client call the shots as to where it goes from there.

The names and titles that you get out of directories will indicate generally who is the right person to contact in a company, but, if the directories are no help, call the company and tell them your problem. Sooner or later you'll be given someone's secretary who will help you identify the right person to talk to.

CONTACTING PROSPECTS

It doesn't make any difference if you call immediately or write first and follow up by telephone. Both work equally well. Do it whichever way you feel most comfortable.

If you write first, keep the letter short, clear and direct. Tell who you are and what kind of business your firm is in. As soon as possible, mention a name or a company they will recognize: a name, if someone has suggested you write to this person; a project, if it's going to be an absolutely cold call. Don't try to sell them on using you at this point. Merely mention that you'll be calling them next week to set up a date when you could show your work.

PHONE-CALL TECHNIQUE

Making cold calls isn't easy for anyone, but it seems to be especially hard for designers. They're not prepared to deal with the barrage of rejections that cold calls produce. More often than not, they're just waiting for the first negative response to provide the excuse to hang up the phone and dispense with this unpleasant chore.

The key to successful telephone cold calls is absolute confidence in what you want, how you intend to get it and what your expectations are. You get this confidence by planning your calls carefully, even to the point of rehearsing with spouses or friends until you think you've got it down.

Remember: Your goal is merely to get your prospect to agree to a meeting, at which time you will make a presentation of your firm's capabilities—nothing more, nothing less. You're NOT trying to do any selling at this point.

If you even begin to sell your firm over the phone you're going to lose before you've even started. You don't want to be thought of by your prospect as a salesman. Instead your objective is a short, friendly conversation which helps your prospective client understand who you are, what your firm does, and why it might not be bad to let you provide more details in person. That's it.

Next, remember to keep your expectations low. A ratio of 50 to 5 to 1 is all you should be trying for, for the moment. Keep reminding yourself of this when you are turned down, as you will be most of the time. Don't get discouraged. Just meditate briefly on the law of averages, and pick up the phone again. Remember as you go through your list of prospects that as each one turns you down, your odds improve on the next call's being a success.

Because you're going to be less experienced and more nervous in the beginning, make your first calls to clients when success or failure won't be critical to your self-esteem. Try to make your calls when you feel ready to deal with them. It's tough work, so you must be in your most positive mental state. Don't call when you're likely to communicate the wrong impression to your prospect. Since the phone can only allow you to communicate with your voice, you have to rely on it to do all the work.

Before calling, make sure you relax for a few minutes. A tense person often speaks too quickly or too aggressively on the telephone. Try to speak more slowly than normal for you. Lower the volume of your voice.

Close the door to your office to shut out as much noise as possible and discourage visitors. Tell your secretary to hold all your calls.

Be prepared. Have in front of you everything you might need in the course of the conversation. For example, your appointment calendar. If the prospect should, by some slight chance, take you up on your request for an appointment, you should be ready immediately to offer alternative dates and times. Give him two choices to pick from. If you already know which one you want him to take, make sure that one of the choices is clearly less likely to be accepted than the other. If, for instance, you have an open calendar next Tuesday at 10:30, say, "Would you prefer Tuesday at 10:30 or Friday at 4:00?" Since it would be unlikely that a busy executive would prefer Friday afternoon, when he's probably trying to get away early, he's more likely to choose Tuesday at 10:30. If not, take Friday and rearrange your schedule, if you must.

If he can't see you at either time, don't say you'll call back later to set up a time. Wait. Ask your prospect for a date convenient to him. Take it, whenever it is.

Also have before you a list of your major projects and clients and perhaps some references. You don't want to hem and haw if a prospect asks about other clients or projects, or wants to check out whether you are really a designer or Jack the Ripper. It may even be a good idea to have a map of the city to which you have to go to in front of you, so that you can pin down directions then and there. You don't want to call again to either confirm your appointment or get directions.

Don't give them a second chance to cancel your appointment! If it turns out that you show up and they can't see you then, see if they'll see you later that day. If they can't or they're not even there, they'll probably be feeling so guilty about you're having schlepped yourself out to them fruitlessly that they'll be more than willing to reschedule the meeting for another date.

Start out by identifying yourself. If you sent a letter in advance, mention it. Don't go too far yet in trying to tell too much about yourself. Next, let them know that you're aware that they are probably very busy and that you won't take too much time. Don't get off the track with personal or friendly remarks which are obviously designed to set them at ease. Get to the point first and then try to get the conversation on a friendly basis. People resist having to deal with orchestrated chit-chat. Ask them if they've had time to read your letter. If they say yes, tell them that you would really like to be able to set up a date to show the work of your firm. If they say no, they haven't had time to read it yet, summarize the letter, emphasizing the clients and projects you've worked on that you think they will recognize.

Chances are that this is when you'll begin to get some resistance. Be prepared for it. Take notes so that each negative response you hear and each counterargument you make is documented, so that you can keep track of what works for you and what doesn't. What works for one person won't always work for another. You have to find what you, personally, feel comfortable with. Go over this "response book" before you make your call, and keep it in front of you when you call so that you're prepared to handle anything that might come up easily and gracefully. If you keep your goal firmly in mind—just getting an appointment—if you're not put off by rejection and evasion, and, if you're determined to keep at it with each prospect until there is a definite, absolute yes or no, sooner or later your ratio of success will improve to the point where it is working for you. This is not speculation. It is a proven fact, borne out by the experiences of hundreds of salesmen and dozens of design studios who have tried it.

"NO" IS NOT THE LAST WORD

Although each prospect will be unique and each designer will have to find his own way of handling negative responses, here are some possible rebuttals to a few typical prospect responses.

1. Mr. X's secretary: "Mr. X got your letter and told me to give you the message that he's not interested (or "our needs are already being taken care of" or some other response).

Possible responses: This is a tricky one. At this point you have no idea what Mr. X has really said or even if he saw your letter. You also have no idea whether Mr. X's secretary has his ear or not. The best way to handle this situation is to shift the selling from Mr. X to his secretary. Show her respect for her position and try to make a friend of her. "Well, we can understand that, but we really feel that we have something to offer that's not typical of other design studios. Let me explain . . ."

2. "We already use a design studio, and we're happy with them."

Possible responses: "We're happy to hear that. It shows that you recognize the value of using professional designers. Many companies haven't even gotten to this point. But every design firm is different, and you really owe it to yourself to look at the capabilities of other studios. After all, your situation may change."

3. "Our advertising agency handles all our work."

Possible responses: "We're happy to hear that. Agencies know how to work with designers, which makes our job a lot easier. We work with lots of agencies (name some here) through our clients, and there's no problem. Agencies quite frequently farm work out to designers (plant seed of doubt). We would like to show you what we do so that you could see for yourself how we work together with other agencies for the benefit of a client."

4. "I want to know more about you before making a decision. Can you send me some literature?"

Possible responses: "Sure. I'll get it off today. (Do it!) Suppose I call you next Thursday after you've had a chance to go through it?" (Do it!)

5. "We have no work to give out at present."

Possible responses: "Fine, but it's a good idea to have a number of suppliers who you feel confident you can call on when there is a project that needs to be done quickly."

6. "We've heard you're too expensive."

Possible responses: "Really? There have been an awful lot of times when I was sure we weren't expensive enough. But, seriously, design is such a custom business that it's practically impossible to compare prices easily. We realize this, and we make it our policy to deal with our clients in such a way that they will never be surprised. Every job is estimated precisely before we start it, and we never do any work without a direct approval of costs by the client. If you haven't expressly approved the price before we do the work, you don't pay for it. So, if our price isn't in line with your budget, we can talk about what can be done to reduce the costs."

7. "What's different about you?"

Possible responses: The client is asking you to sell him over the phone so that he can turn you down without having to see you. Don't fall into the trap. Keep in mind that all you're trying to do is get a chance to make a presentation. One possible tack: "We approach design strictly from a marketing standpoint. So really, until you have a chance to look at the specific client problems we have worked on and seen our visual solutions, you can't evaluate our work. We'd be happy to arrange for you to see some of our projects for other clients. We plan to be in your area this coming Tuesday and again on Friday. Would either of these dates fit in your schedule?"

8. "I got your literature, but I haven't had a chance to read it yet."

Possible responses: "Do you think you'll be able to look it over this week?" (Don't say "today." Expect to have to call a couple of times before he finally agrees to read it.) "I'll call you next week after you've looked it over."

9. "Mr. Y is the fellow here who has to make these kinds of decisions, not me."

Possible responses: Either Mr. Y is there, in which case, ask to speak to him, or he's not there, in which case find out when you should call back.

10. "I'm too busy to think about it now. You'll have to call me back another time."

Possible responses: "Fine. How about if I call next Tuesday. Suppose I call at the same time or would another time be better?"

11. "You should have called last week. We just hired a design firm to do a whole identity program."

Possible responses: "Gee, I wish I <u>had</u> called last week. That sounds like something we could have helped you with. Suppose I call you back in about three months, just in case things aren't working out as you planned, and you want to look at some options."

12. "We've used our entire budget for the year. We won't be able to spend any more the rest of the year."

Possible responses: "When will your next year's budget be set? January? Fine. I'll call you then. How about January 10th?"

TIPS ON TELEPHONE TECHNIQUE

1. <u>Listen more than you talk.</u> Be alert to where the conversation is going. Let the client lead you to where you want to go. He may not know who you are or what you can do, but he knows what he wants.

2. <u>Give your prospect time to speak.</u> Some people speak quickly. Some speak slowly, pausing to consider their words carefully. Don't assume that just because there's a long pause your prospect is finished speaking. Give him a chance to complete his thoughts.

3. <u>Don't anticipate.</u> Don't finish your prospect's sentences for him, just to show how quick-witted you are. Even if you're right he won't appreciate the implication that he's wasting your time.

4. <u>Don't be afraid to try to clarify points.</u> If you don't understand something or you're not certain what you heard, ask your prospect for clarification. This won't make you appear stupid, but it will convince him you're interested and serious. It will also avoid problems later, in case you really did misunderstand something.

5. <u>Don't argue.</u> Regardless of how rude the other person is, don't show by your tone or your words that you're irritated. Remember, you called him and you want something from him. It won't do you any good to argue with him. He has the power. Just say something like, "I guess I caught you at a bad time, didn't I?" Who knows? He might have just had a real trying morning and is dying to unburden himself to someone. The worst that can happen is that you set up a time to call him back when he is not so harried.

6. <u>Put yourself in your prospect's shoes.</u> Evaluate what you're saying from his point of view. You want to serve his needs, not yours.

7. <u>Learn to hear between the lines.</u> People communicate almost as much by the way they say things as by what they say. Be alert to the nuances in a conversation. When someone is saying "no" but what you hear is a "no, but . . ." you've got a chance to turn it to a "yes" if you're alert.

8. <u>Take notes while your prospect is speaking.</u> Don't interrupt, but wait until he's finished to clarify any points he's raised or answer any questions or reservations he has expressed. But be careful not to try to write down everything he's saying. You won't be able to keep up with the conversation. Just write the key points.

FOLLOW-UP
If your call succeeds in landing a firm appointment, DON'T send a confirming letter. The date is set. You should have directions. Don't offer the prospect a chance to cancel out. Just show up on the appointed day and time.

If, however, a prospect has agreed to give you an appointment at an unspecified later time, send a polite letter of appreciation. Thank the prospect for his time, and say that you'll be calling him again at such-and-such a time. Say this even if it hasn't been agreed that you will. What have you got to lose? Include something in your letter which you think would help make your next call more productive, such as a list of clients which you know would impress him, or a printed piece which, based on your telephone conversation, you feel certain he would like to see. DON'T send him your capabilities brochure, unless he's specifically asked for it. You don't know yet whether this would appear to be more than he needs to know.

In summary, the cold-call process consists of:

1. Developing a list of possible prospects to whom you feel you can offer something of real value.

2. Confirming your information on the prospects. Making certain that names, addresses are correct.

3. Contacting the prospects by phone, either preceded by a letter or not.

4. Following up on the calls.

Remember, the cold-call telephone contact has one purpose only: To set up a meeting at which you may make a presentation and THERE convince the prospect to give you a project. That's it. Don't try for too much, too soon. It will backfire.

The Presentation

Your first objective was getting an appointment to make a presentation of your firm's capabilities. Now your task will be to make a presentation that will land you a specific project, or earn your firm consideration for handling the prospect's next project.

The initial presentation may be your one and only chance to win the prospect's trust and convince him that your firm can do his work better than anyone else. If there ever was a time to pull out all stops, this is it.

On the other hand, remember that it normally takes five presentations to make one sale, so don't be too surprised or depressed that four out of five presentations yield no sales. As your confidence and presentation techniques improve, so too will your percentage of sales.

CONVICTION AND TRUST

The heart of any successful presentation is your absolute conviction that what you have to offer will truly help the prospect. You must truly believe in your firm's ability to deliver real value. Most problems in presentations grow out of lack of belief—in your firm, in its services, in the benefits of working with you, or in yourself.

A good presentation deals directly with the prospect's expectations. He wants to know what's in it for him. What can you do for him? He has a problem somewhere or he wouldn't even be talking to you. But, before you can solve his problem, you will first have to win his trust and confidence in you personally. After you've done this, you can transfer those feelings of trust to your firm.

The best way to do this is to understand clearly the prospect's concerns before you go in, and to construct a dramatic presentation which you KNOW deals with these concerns in every way.

As a designer, you also need not be reminded that form is at least as important as function. Don't weaken your dynamic message by sending contradictory signals in your speech, dress, or behavior.

The prospect will assume that how you behave in the presentation will indicate the way your firm will behave in its client dealings. If you arrive late, how credible is your claim that your firm will make its deadlines? If you dress sloppily, make a disorganized presentation, and show inattention to details, why should he believe that you are a precise, careful project manager? If you are vague and confusing in communicating the strengths of your own company, are you likely to be extraordinary at communicating the client's message? If your samples are amateurishly photographed or old, dirty and torn—indicating that not even you regard them with respect and esteem—why should your prospects be impressed?

In short, a carefully prepared presentation, with attention both to appearances and content, delivered with the self-confidence and conviction of a true believer, will be a presentation that will be difficult for your prospects to forget.

THE PROSPECT'S CONCERNS

Several questions will be on the prospect's mind as he evaluates your firm.

The primary question will be the depth of your experience, and whether it is in a closely related field. A financial institution will probably feel less secure about your experience if you've only designed annual reports for heavy equipment manufacturers. A competitor with a portfolio of annual reports for banks will have an edge on you. This is why your primary prospects should be in industries quite closely related to those you have already worked with.

Nevertheless, there are ways to turn a lack of experience in a specific field to your advantage. If you are making a presentation to a prospect in a field that is new to you, try to convince the prospect that you can bring a fresh, objective new approach to their problems. Don't directly criticize the work that has been done; instead try subtly to find an ally on the prospect's side. You can be certain that someone to whom you're making the presentation will be dissatisfied with some aspect of their current work—no client ever is totally satisfied. If you can make a compelling case for a fresh approach, you might be able to remove the stigma of your lack of related experience.

Another issue for prospects is how creative you are. This is the area which is hardest to define and sell. While a lot of the judgments of this creativity will be reactions to your decoration skills, it is better to emphasize the nondecorative, problem-solving aspects of your projects and let the look of the work speak for itself.

Prospects will want to know the size of your staff. They're seeking reassurance that you can be depended upon to stick to schedules and stay within budgets. (Don't talk specific prices at large presentations; hold these discussions for your specific proposal.)

Talk about and perhaps demonstrate a typical job as it moves through your project management system. The fact that you have a system at all may impress the prospect, since design firms are often stereotyped as creative but disorganized and a bit flaky. While most clients accept the fact that most design firms have a number of designers, they will want some reassurance that they'll be getting a lot of attention from the design firm's principal.

They will be very interested in your geographical proximity. If you're far away, you'll be expected to tell them why they should choose you over a firm that's closer. If you're nearby you'll have to emphasize how much of an advantage this is.

Finally, they will expect you to demonstrate that you have many satisfied past and present clients, at least some of whose names they should recognize. Show a partial list of clients—labeled as such. Even if you've only done one small job for a client some years ago, use his name. There's nothing unethical or wrong about doing this. You did the work for the client; you can say you did. You have no obligation, unless asked, to explain what it was you did. Of course, don't list a client if you had a bad experience with him.

PROBLEM-SOLUTION-RESULT

There is a right way and a wrong way to show a prospect the work you have done for other clients. The most common way is to hold out the cover of a printed piece and announce, "This is a piece I did for XYZ Company. It won a silver medal in our local art directors exhibition."

That also happens to be the wrong way.

What does it tell the prospect? That you're an award-winning designer? No, that you're a designer who cares about winning awards. Which may be good for you, but what does it do for him?

Show not what the client can do for you. Show what you can do for the client.

How? There's a simple formula: Problem-Solution-Result. Tell the story behind your previous assignments in that order. What was the client's problem? How did you work with the client to solve it? How well did it work for the client?

Example: "Here's an example of a leasing brochure we produced for XYZ Company. This shopping center had heavy competition from several established centers. We sat down with the developer and established several points to emphasize in the design—factors that made this project distinctive . . . We were pleased with the solution, and so was XYZ. The center was fully leased four months before the target date."

Sometimes the results are not going to be quantifiable. In that case use a "satisfied customer" quotation: "John Jones at XYZ says the salesmen call this the most useful sales piece they have."

The point is obvious but it cannot be emphasized enough. Your client doesn't give a flip how many design awards you win with his piece. He does care about getting results for his dollar. Show him that you understand that. Show him that good design can solve problems and get results, and that you've done it.

SUPPORT MATERIALS

The ideal presentation is custom-fitted to the unique needs of a specific prospect. But a good presentation might take two to three months to create, and rarely does a design firm have the luxury of spending that much time. Instead, smart firms create several flexible marketing pieces which can be adapted quickly and easily to different prospect types.

There are basic tools which will have to be created in advance:

1. A slide show

2. A capabilities brochure and/or

3. A capabilities folder.

In addition, one more tool should be created during the actual presentation: a flip chart.

THE SLIDE SHOW

Slide shows, admittedly, present many problems as a selling tool. They are cumbersome to carry around, especially on airplanes. They can only be presented in a darkened room. Electrical problems and equipment failures present hazards. Many clients don't like them. Other clients give the clear impression that they find them intimidating.

All these are valid concerns that must be considered by a firm that chooses to create a slide show. But all pale beside the obvious fact that there is no more powerful, more flexible, and more useful tool for presentations to new prospects than a well-constructed, dramatically presented slide show. Design firms whose new business comes presold on using them may feel little need for a slide show to make sales, but for firms doing aggressive cold-call marketing, slide shows are indispensable.

A slide show is a tool, no more and no less. In some situations it may be the wrong tool—and it is foolish to use a hammer when a socket wrench would be more appropriate. If it is clear that the client is going to be very uneasy with a slide show, or if the physical environment is absolutely wrong for showing it, DON'T. Put it aside and proceed as if it never existed. And work out a contingency plan to cover yourself in such circumstances.

Generally, a slide show should be no more than 15 to 20 minutes long, which is about the right length for a presentation. It should include, in no particular order:

1. **Identification of the design firm and some broad descriptive line telling what you do.** Keep this description as broad and general as possible (let the prospect fill in the blanks): "Marketing through Design," "Visual Communications," etc.

2. **A section which broadly describes your firm's design philosophy.** Emphasize the problem-solving approach to design—which sets the stage for . . .

3. **Case studies, using the problem-solution-result approach to tell about the firm's work.** For best results, arrange products in coherent, understandable categories. For example, in dealing with college admissions materials, group together slides that show how the design firm used the excellent location of one college as its basic message while another college with a less attractive location was handled in a different way.

Where it strongly emphasizes the design improvements made by your firm, show what a client's products looked like before you were hired and what it looked like after you did your work.
To emphasize client satisfaction, show a whole program or what is clearly work done over a number of years. If the client kept coming back to you, you must have been doing something right!

4. **A practical and selective client list.** These could be grouped one category to a slide to make it easy to custom-tailor a slide show.
Clients whose names are self-explanatory, such as IBM or Xerox (should you be fortunate enough to have a few like this on your list), need no other words to describe who they are, but any clients whose name means nothing to your audience should be identified by who they are: "XYZ Company, a manufacturer of aircraft widgets."

5. **Optional slides: photos of your offices, equipment, and people.** These should only be used if they would help to strengthen feelings of security in your client. If you have nice offices, show them, especially to corporate clients. If you have a large staff and this will be seen as an advantage by your prospect, fine. But don't let your prospect get to the point where he expects to see these terrific professional offices peopled by lots of busy designers and then show him three people in a space the size of a cupboard. Similarly, don't allow photographs of designers amidst their cute, artsy office decorations widen the gulf that already is seen to exist between corporate America and artists. The client expects, even wants, to see some evidence that the design firm is creative, but within tasteful and acceptable limits.

6. **A slide which signals that the slide show has ended.** It doesn't have to be the name of your firm but usually is. This doesn't mean the name has be just type or a logo. If the name or logo appears on a door or a window or a wall this, too, can be an effective ending slide.

The ingredients and structure of the show, while important, are no more important than the style and quality of the slides. Among other things, a design firm is selling its knowledge of what is or is not quality photography, and its ability to get it. If it can't even demonstrate this ability in its own slide show, clients are not likely to be impressed.
The slide show should be reviewed at least every couple of years and updated, if necessary.

THE CAPABILITIES BROCHURE AND/OR FOLDER

Just like the shoemaker's children who never have shoes, an amazing number of design firms never get around to producing a capabilities brochure for themselves. Most manage somehow to get out a small folder, which tides them over for a while.

But, sooner or later, if a design firm ever wants to be considered truly professional, it will have to publish a good capabilities brochure.

Capabilities brochures take many forms, sizes, and price ranges. Some, like Pentagram's *Living By Design* publication (Watson-Guptill, 1978), are as long and elaborate as books and are even sold as such.

How large, elaborate, or expensive they should be depends largely on the size and wealth of the clients the firm works with and wants to attract. If the present clients and prospective clients are huge corporations, the brochure has to reflect this. It has to be large and lavish and have a look of permanence.

One of the most important characteristics of a capabilities brochure is its flexibility and easy adaptability to different prospect needs. Brochures that are constructed more like packets or kits are usually less impressive than those which are permanent, yet they may be more suitable to a design firm's general needs.

The material covered in the brochure is similar to the content of the slide show, but generally it is more detailed. A list of possible ingredients:

1. The firm's design philosophy. Don't dwell too long on procedure, but do spend time establishing the proper professional tone. Strive to create a common ground between your firm and the client—to reduce the feeling that the design firm is only concerned with decoration.

2. The principals and staff. Who are they? What are their credentials? The principals probably won't change, but the staff list might, so design it in such a way that it could easily be updated.

3. The work of the firm. Once again, the focus should be on benefits, not procedures. The client has little interest in how the design firm does its job. The client is more interested in the results of those procedures. Spell out clearly the PROBLEMS posed by the job, the design firm's SOLUTION to those problems, and the positive RESULTS for the client. The benefits to the client can be quantifiable, qualitative, or both. Use figures, charts, quotations or whatever it takes to make the point.

4. A list of clients. They should be grouped by categories and identified by type of business if not immediately recognizable. As with the staff list, this should be designed for easy updating.

5. A list of references. Be sure to ask for permission before printing them, as many will be called.

6. Special inserts. These might be reprints of articles about the firm, press releases, speeches made by principals, or other such material that might help the client understand the firm.

The capabilities brochure should be used as a leave-behind, distributed as part of the closing remarks of the presentation. It is also used to send to clients in response to specific requests for information about the firm.

THE FLIP CHART

After the slide show, the spokesman for the design firm should ask for questions from the prospect group. Whether there are questions or not he should try to steer the discussion in the direction he wants it to go, which is the design firm's project management system. If there are questions, this shouldn't be too difficult, since sooner or later someone will ask a question which will naturally lead to this subject. For example: "The last designer we worked with gave us what we thought was a firm price, but when we got the bill he had added on enough to double his bill. How do we know you won't do the same?"

If there are no questions, just raise one yourself. "A lot of clients are concerned that a designer will quote them one price, but try to bill them something more. We don't work that way. Let me show you exactly how we would work together." At this point move to the flip chart, which consists of a collapsible easel with a large blank newsprint pad on it. Then diagram exactly how you intend to work with the client, right before their eyes. By doing this you set up a counter to the slide show, which often has a slightly canned effect.

This two-pronged presentation technique gives you the advantage of showing the work of your firm at its most beautiful and powerful, orchestrating the message so that the emphasis is on creativity and results, while at the same time allowing you to get into a direct and personal discussion of budget and schedule management, which is difficult to do in a slide show without boring the audience.

It also allows you to end the presentation on an up note, rather than a downer. Putting on the lights after a slide show is no way to end a presentation, nor is a question and answer discussion a better way. You want to end the presentation by passing out your leave-behind material and telling them directly that they are very important to you and you want to work with them—now!

TIPS FOR "ON-THE-SPOT" FLIP CHARTS

1. Use a large newsprint pad, but be sure the size of the pad is appropriate to the size and distance of the audience. It should be large enough to be seen in the back of a big room, but go to a smaller size if you're talking to a handful of people seated only a few feet from the easel.

2. Test all your equipment and materials. Make sure your markers are fresh and will write. Test to see that your easel won't fall apart or tip over. Make sure there are enough sheets in the pad to tell your story. Make sure the area you'll be standing in is well lit.

3. Don't turn over the cover sheet until you are ready to write on it. When you do, get to it; don't waste time talking. Get the information down, discuss it, tear it off or flip it over. Don't leave it out while you talk about the next point. You don't want your audience staring at one thing while you talk about another.

4. Don't be sloppy. Don't make errors in spelling or grammar.

5. Don't turn your back completely to the audience. Stand to the side of the easel to write.

6. Try to make the information you present on the flip chart as graphic, spontaneous, and personal as possible. Don't use the generic terms "client" and "design firm" when discussing how information will flow back and forth; use the prospect's real name and your firm's name. Use lots of boxes, circles, arrows and dingbats. Check things off, cross things out. Put action into your presentation.

7. Be enthusiastic. A prospect will want to give work to a firm that appears to be eager and excited to do the work, not blasé and bored.

CLOSING

Don't be afraid to close. When you sense the client is really trying to find a way to give you a project, ask for it.

FOLLOW—UP

Don't forget to follow up the presentation with a brief thank-you note. Use your note as another opportunity to ask for a specific job, if one is ready to be awarded. If there is no job to be given for the time being, tell them you look forward to working with them on a future job and STAY IN CONTACT.

If you were allowed to tape record the presentation, review it to see what worked and what didn't.

If you find out from the prospect that you didn't get the job you were trying for, don't be bashful about asking him why. He may not always tell you the truth, but he won't be offended if approached tactfully.

Managing Projects

It's an all-too-typical day for our hero, the owner of his own design studio. He has just returned from an important presentation, which took longer than expected and went badly. He needs to finish a design for an annual report which is due tomorrow (the rough sketches for which are hidden somewhere in his office under a pile of other papers). However, one of his junior designers is impatiently waiting to show him some sketches for a major corporation's logotype. There are five phone calls waiting to be returned; two seem to be from prospects he has been wooing for a year. Either or both may require him to fly to presentations, at which it would have been nice to have had ready his leave-behind brochure that has been in the works for two years but is, unfortunately, still in the early rough design stage. There is also a message on his desk from his bookkeeper: Estimated taxes will have to be paid next month, and there isn't enough cash on hand to pay them. This means either he must call up several clients and get them to pay their overdue bills, or talk to his banker about a loan to tide him over. He's not getting enough sleep, exercise or relaxation. His children are starting to call him by a name he's never heard before. His best designer has just given him two weeks notice (and he suspects that she will probably take one of his best accounts with her). Worst of all, some of the work leaving his office is embarrassingly slipshod; two years ago he would never have let work like that see the light of day. He feels his business is out of control.

It is easy to understand how our hero found himself in this uncomfortable position. For most of his adult life he focused on learning to be the best possible designer he could be. Now, suddenly, he is having to learn something entirely different—to take control of himself and other people.

He doesn't exactly want to be disorganized. But of course, his whole life has been devoted to being creative, not to arriving at organized systems. He is intuitive, not an unimaginative, rigid, bureaucratic superorganizer.

CONTROL VS. CREATIVITY

Being successful in business does not require you to make a choice between control and creativity. There is no choice to be made; you need both. Creativity's dirty little secret is that control is not the enemy; control is a necessary ingredient that makes creativity possible. The greatest creative thinkers are, in some sense, the most disciplined, focused thinkers. And the most consistently high quality design work tends to come from well organized, well managed shops.

Control doesn't mean having clean desks or a quiet, unharried office. Clean desks don't necessarily prove that work is getting done—only that it is being put out of sight. On the other hand, a busy, noisy office isn't necessarily a symptom of chaos and lack of productivity.

Being in control means creating management systems that match your style of working with the specific needs of your business—systems that succeed because they get the work done well, on time, and at a profit.

The critical first step toward gaining control is accepting the fact that it should be done at all. It takes a recognition on your part, as the design principal, that you must make an effort. Lifelong habits may have to be changed or relearned. You must invest time in analyzing, planning, and testing different approaches, not all of which will work.

Gaining control means accepting the necessity of being decisive and delegating responsibility well. It means having an information system which keeps you aware of what must be done, when it must be done, how it will be done and for how much. It means creating a follow-up system to help you stay on top of schedules and budgets, phone calls that must be made, opportunites worth pursuing, and details that otherwise might fall through the cracks. It means advance planning that anticipates emergencies and minimizes crises.

Gaining control is mastering day-to-day management of five things: projects, people, time, paper, and money. It is an interactive process. The better one gets at managing one, the better one is able to manage the others.

A graphic design business is project based. It lives and dies in direct proportion to how successfully the principals bring projects in and get them out. Firms can only remain in business by managing projects in a way that satisfies the clients, yet permits the firm a fair profit.

WHAT CLIENTS WANT

It isn't too difficult to figure out what it will take to make a client happy:

1. He wants his work produced within an agreed-upon budget.

2. He wants his job delivered on schedule.

3. He wants the job to satisfy all its goals.

4. He wants these things accomplished with the least amount of hassle.

5. He wants his job produced up to what he recognizes as an acceptable level of design excellence.

But these requirements are rather broad. What is more difficult is understanding, in specifics, what an individual client really wants. What is his idea of design excellence? At what points does he expect to be consulted, and at what points will he consider it a nuisance? What is the reason for the schedule? How much flexibility does the budget have? What are the goals for the project?

It's amazing how many design firms make virtually no real effort to pin down the client to specific answers about what he really expects for his money. Of course they arrive at a price and a deadline, but all too often the other, more hidden, objectives remain vague and undefined. Most often it is these same ill-defined but equally important goals that cause problems in designer-client relationships.

For example, a design firm is hired to design an annual report for a corporation that produces widgets. Because of poor interviewing techniques, the firm begins work on concepts which are product oriented, only to learn later that this year the client really wants to emphasize its management skills. Not only has a lot of time been wasted—time which may not be billable—but the client has lost just a little bit of trust in the design firm. A tiny seed of doubt has been planted. Plant enough seeds during a project, and you may find yourself with a garden of weeds choking the entire business relationship.

The best way to prevent this sort of fatal faux pas is a project management system that works by setting up the standards, performing the work according to those standards, monitoring the work so that adjustments can be made as needed, and following up and evaluating the results when the project is complete.

There are four phases or steps to managing a project:

1. DEFINING THE CRITERIA

Depending on the kind of design project, there may be different objectives and parameters to deal with. It is important that the design firm identify them all.

Most of this information can only come from the client. Typical of the kind of information that the design firm has to dig out of the client are such things as:

What is the total budget? How would the client prefer to be billed?

When is the final job to be delivered? Is the client expecting an advance delivery? When is the client expecting to see the first roughs? Does the client expect to see comps? If so, when? Who will be the writer? When is final copy going to be ready?

Who is the ultimate audience for the job? Is the job going to be directed more towards one sex than the other? More to one specific age group than another? More to one income level than another? Is the appeal more regional than national?

What is the feeling or mood to be? One of elegance and luxury? Of utility and practicality?

How many pieces are included in the total design contract? If it is an identity program, does the client expect the design firm to design applications as well as logos or logotypes?

How much text has to be accommodated? What is the character and texture of the text? Are the paragraphs short or long? Are there a lot of heads and subheads?

Are there any graphics that must be accommodated? Tables? Charts? Photographs or illustrations? How many?

Does the client have any market research which is relevant? Is market research needed?

How is the job to be delivered into the hands of its ultimate audience? Will this require unusual packaging?

Are there color preferences?

Does the job have to be consistent with other materials or with the client's advertising?

Is there an existing trademark or logo which has to be accommodated?

Are there size, color, or production limitations?

Does the client want the design firm to select and supervise the printing? What is the quantity desired?

What are the major points to be made?

Who will make the final approvals of the designs?

Will the client be at the printer to approve the press sheets?

These are just a few of the dozens of questions that might be asked. Often you must ask the questions of several different people in the client's office before you can grasp firmly what's needed or desired.

When the criteria appear to be clear, the design firm should send a letter to the client, spelling out how it understands the ground rules and assumptions. On a small, low-budget job, a short note might do it. If the project is complex and multifaceted, a detailed letter is a good idea. In either case, the objective is to be certain client and design firm begin from a clear, shared understanding.

2. BREAKING THE PROJECT DOWN INTO TASKS AND MINITASKS

To get the job done, each step of the process is identified, assigned, and scheduled. Doing this puts controls into place—controls to assure that no task is forgotten, left unassigned, or given an infinite amount of time for its completion. It also creates a series of checkpoints; these afford the project manager chances to catch a job that is beginning to veer off on a wrong tack, wasting valuable time and energy. Some tasks will be sequential—that is, one task cannot proceed until another is completed. Some tasks can be accomplished concurrently with other tasks.

Many design firms create a job jacket which follows the job through its various stages. Into the job jacket go all the specifications. As size, paper stocks, type styles, grid sizes, and so forth are identified and agreed to, they are written down and inserted in the job jacket. The schedule is often affixed to the outside of the jacket. On it are checkpoint dates by which various components are to be completed or approved. Someone in the design firm is given the task of monitoring the project to see if the components are in place by the due dates.

In making assignments, whether to employees or to outside suppliers, consultants or free-lancers, be certain to establish definite areas of responsibility and clear lines of authority. This is the one area that seems to cause the most problems in project management. A project almost always gets into trouble when the people working on it do not understand clearly what their objectives are, what their responsibility is, how much authority and control they have, or whom they report to for approvals.

There are many approaches to defining and scheduling tasks, depending on the complexity of the project. These include milestone charts, bar charts, and flowcharts (see illustration, pages 70 and 71). It doesn't make a lot of difference which system is used, as long as it is compatible with the firm's style and available resources, and as long as tracking a job doesn't take more time than doing the job.

MILESTONE CHARTS

This type of chart merely lists each task in order of expected completion. It may or may not also include budgets for each task, individuals responsible, actual completion dates and actual costs.

Advantages: Easy to prepare and monitor.
Disadvantages: Difficulty of tracking simultaneous activities.

BAR CHARTS

A bar chart lists each task, with attendant budgets, responsibility, projected budgets and actual budgets. It also uses a series of horizontal bars to identify the schedule for each of the tasks individually.

Advantages: Bar charts more precisely identify when each task will begin and end, which is very useful in a project where there are many simultaneous tasks being performed.

Disadvantages: It is a little more difficult to prepare than a milestone chart, and doesn't clearly show links between various activities.

FLOWCHARTS

These are sometimes called PERT charts (for Program Evaluation and Review Technique) or CPM charts (for Critical Path Method). A flowchart is a series of interconnected circles or rectangles which track the path of each task and how it flows into other tasks.

Advantages: Flowcharts indentify the relationship between tasks on a very sophisticated level. Not only do they show when a task is to begin and end, but they also show which tasks are dependent on each other and how tasks develop along simultaneous tracks.

Disadvantages: Flow charts are most difficult to prepare and are often confusing to an uneducated eye.

MILESTONE CHART:

Schedule

WGDF, Inc.

1 MAIN STREET, EVERYTOWN, USA 10000 100-123-4567

PROJECT: FOLDER DATE: MAY 1, 1985

CLIENT: ABC CORP.

CONTACT: JD

PROJECT MANAGER: EG

Activity:		Date:	Comments:
Design:	Planning meeting	May 1	
	Submit preliminary cost estimate	May 3	
	Receive copy	May 10	
	Present preliminary designs and schedule	May 15	
	Select photographer/illustrator		
	Revisions	May 20	
Photography:	Complete photography (illustration) schedule		
	Begin photography (illustration)		
	Complete photography (illustration)		
	Edit photography		
	Present finished dummy with photos (illustration) in place		
	Release color (art) to printer		
	Correct color proofs		
Typesetting:	Release copy to typeset	May 22	
	First galleys	May 24	
	Second galleys	May 29	
	Third galleys		
	Repro	May 29	
Mechanicals:	Begin mechanicals	May 30	
	Complete mechanicals	May 30	
	Client sign-off on mechanicals and release to printer	May 31	
Printing:	Blueline for client approval	June 3	
	Final corrections approved	June 5	
	Revised blueline for client approval	June 7	
	Project on press	June 7	
	Sample copies to client	June 11	
	Start delivery	June 12	
	Complete delivery	June 13	

BAR CHART

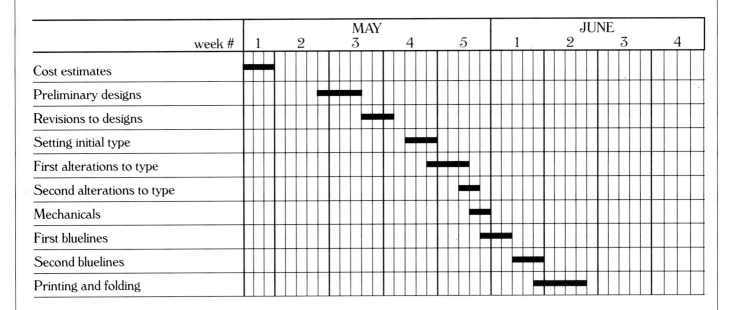

	week #	MAY					JUNE			
		1	2	3	4	5	1	2	3	4
Cost estimates		▬								
Preliminary designs			▬							
Revisions to designs				▬						
Setting initial type					▬					
First alterations to type						▬				
Second alterations to type						▬				
Mechanicals						▬				
First bluelines							▬			
Second bluelines							▬			
Printing and folding								▬		

FLOWCHART

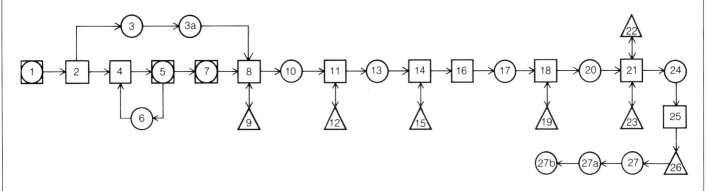

⬜ Designer-action points ◨ Client-Designer check points ◯ Client-action points △ Supplier-action points

1. Planning meeting, 5/1
2. Prepare preliminary cost estimate, 5/2
3. Preliminary cost estimate sent to client, 5/3
3a. Client writing copy, 5/3–5/22
4. Designers receive copy, prepare preliminary designs, 5/10–5/15
5. Present preliminary designs, 5/15
6. Make revisions to designs, 5/15–5/20
7. Present revised designs, 5/20
8. Receive released copy, typespec, send to typesetters, 5/22
9. Typesetter setting copy, 5/22–5/23
10. First galleys to client, 5/24
11. Alterations received from client, out to T.S., 5/27
12. Typesetter making aa's, 5/27–5/29
13. Second galleys to client, 5/29
14. Second galleys returned with alterations, out for repros, 5/29

15. Typesetter setting and pulling repros, 5/29–5/30
16. Mech's prepared, 5/30
17. Mech's to client for final check, 5/31
18. Mech's returned to designer, released for press, 5/31
19. Mech's to printer, 5/31
20. First blueline to client, 6/3
21. First blueline returned with alterations, 6/5
22. Alterations being set, 6/5–6/6
23. Alterations to printer, second blueline being pulled, 6/6
24. Second blueline to client, 6/7
25. Job released for press by client, 6/7
26. Job on press, 6/7
27. Sample copies to client, 6/11
27a. Begin delivery of job, 6/12
27b. Complete delivery, 6/13

3. DOING AND MONITORING THE WORK

In addition to tracking tasks as they relate to schedules and due dates, projects must also be tracked as they relate to estimated and actual costs.

Most design firms use some form of job-order cards on which all labor and out-of-pocket costs are entered. Attached to this card might be a schedule, an estimate sheet, and a letter of agreement. Taken together, these pieces of paper give all the information needed to help the design firm manage its projects, but in an unstructured and disparate form. They make the system a complicated and time-consuming job to keep up with, especially if the firm is handling a large volume of work.

While it is possible to bring together these various pieces of paper into one or two forms, it could turn out to be a full-time job.

COMPUTER-AIDED DESIGN FIRMS

Computer graphics software and hardware are still a few years away from being of much practical design use to the average graphic design studio. But microcomputers are proving to be ideal for design firms as a project management tool.

The needs of most firms can easily be accommodated by relatively inexpensive hardware and, quite often, by off-the-shelf software. Relational programs, such as dBASEIII and Lotus 1-2-3, which can run on moderately priced microcomputers, permit design firms to create sophisticated project-management systems that meet their needs quickly, efficiently, and cheaply. There are new programs coming out every day which have even more features ideally suited for project management.

The ideal project-management system should have these capabilities:

1. It should have a listing of all tasks called for.

2. It should have an estimate of all time, associated costs and out-of-pocket expenses built in.

3. It should have a schedule of dates and target dates built in.

4. It should be very flexible, so that it can easily be adapted to various kinds of projects.

5. It should generate information fast, so that the information is available when needed, not when ready.

6. It should be capable of providing the information in many visual forms and in large or small chunks, as needed. If, for example, the design firm would like to plug in the information and then pull out a portion of the information in the form of a bar chart to send the client, it should be capable of doing so.

7. It should be capable of using the same information in a variety of ways. For example, as bills come in from typesetters or photographers, they could be typed into the system once and automatically be distributed into accounts payable files, individual job-order files, total supplier files, estimate files, and perhaps a variety of other files. This eliminates considerable duplication.

8. It should be capable of a variety of measurements in response to inquiries. These should be for individual jobs: for example, in X job, how do the actual costs compare to the estimated costs? How does the estimated time compare to the actual time? What percentage of the work that needs to be done has been done? And for several jobs collectively, for example, What current projects are now 10 percent over budget or 10 percent behind schedule? What bills need to be paid this week to preserve available discounts?

The first step in constructing a system is sitting down with the company accountant and making a "wish list." On the list is all the information the accountant needs to pay bills, set up accounts receivable files, create profit and loss statements, pay taxes, meet the payroll, etc. Also on the list are the things the principal of the firm and any other project managers would like the system to do.

Armed with this wish list, the firm should contact a number of nearby computer software companies. (They can usually be found in the *Yellow Pages* under "Computers-Software and Services." Let them know your needs and ask them to get back to you with proposals. Be patient and be skeptical. Don't let the jargon put you off or fool you. Be prepared for widely differing costs and opinions. Many companies that design software programs also sell specific brands of hardware and will try to sell these, too. Be as cautious in hiring a firm to develop a software package for you as you would in hiring an architect.

If your computer needs are minimal, you could expect to spend between $5,000 and $15,000. If your needs are more complex, the sky's the limit. By making certain that you get plenty of competitive proposals you should be able to determine what you will probably have to spend to get the system designed and installed.

COST-EFFECTIVENESS

With the proposals in hand, the cost of installing a system can be estimated. This total price should include the cost of the hardware, the software, service contracts, financing or leasing costs, additional electrical and installations costs, training, and possibly additional personnel to run the system.

Calculate the total number of hours presently being spent in a year doing tasks which will be computerized. Multiply the hours by an appropriate per-hour cost for employees, and compare the result to the estimated cost of installing a computer system. If your current costs per year are equal to or more than half the cost of the projected system, then the system will pay for itself in two years or less, which makes it cost-effective. If present costs are less than one-half the pro-

jected costs, then perhaps it's time to take a closer look at what new capabilities and kinds of information a computerized system can provide you that your present system cannot. If these added capabilities could provide the tools to increase your volume, get your bills out faster or more accurately, measure and collect for overages more easily, or monitor projects more effectively, then installing the system might still be cost-effective.

CHOOSING A SUPPLIER

If you decide to proceed with a computerized system, you'll need to select a supplier from those who submitted proposals. Place all your emphasis on service and dependability. Make certain that the supplier you choose will be around to service you, not only to install and get the bugs out of the system (and rest assured, there will be plenty of these), but also to upgrade and refine your system over the next few years as your business changes and develops different needs. (Choose hardware, likewise, that can easily grow with your growing needs, without forcing you to pay for expensive modifications to the software.)

Select a supplier who is willing to promise a service call response time of no more than 24 hours. Get references and call them to check how well the supplier has lived up to his promises.

4. FOLLOW-UP

An ideal project management system includes follow-up after a job is complete. One part of follow-up is assessing whether each project came in on budget and on schedule. Measuring what happened, in comparison to what was expected in time and cost, gives the firm information to use in refining its estimates and expectations on new jobs.

A second part is continued contact with the client. Since former clients are the most easily cultivated source of new sales, it's in the design firm's best interests to maintain contact with the client. Its goal is not merely to produce projects, but also to build strong relationships.

Managing People

L eslie Smolan, a partner in the firm of Carbone Smolan, tells of the day that she and partner Ken Carbone hired their first employee. A client of theirs, upon hearing of this, told them, "Things will never be the same for you. You will never be as efficient as you were when you had no employees." Says Smolan, "He was absolutely right." A designer who has learned his craft well and starts his own business determined to do the very best work he can on every project will find it difficult NOT to grow. But growth is at best a mixed blessing that brings with it added problems. To many designers, the biggest problem is added people.

MANAGING CREATIVE PEOPLE

Persuading people, reading people, communicating with people and managing people are at the heart of most businesses. Nowhere is this more true than in design firms. The firm's dependence on its ability to persuade clients to buy is obvious. More to the point, the product to be sold is totally dependent upon the talent, conscientiousness, and the productivity of individual employees. The assets of a design firm are not machinery, or capital, or raw materials, or inventory; its only assets are its people.

No project-management system is better than the persons doing the managing or the persons being managed. Firms larger than one person can succeed only by effectively harnessing and harmonizing the efforts and talents of several individuals. That takes effective management of people.

Sad to say, even professional, trained managers have a difficult time attracting, supervising and, when necessary, replacing employees. Design firm principals, typically untrained, inexperienced, uninterested in, and even a little intimidated by dealing with personnel management, can hardly be expected to do better than professional managers.

Managing people in graphic design is further complicated by the nature of the people attracted to the field. Graphic design appeals to a certain kind of personality which doesn't respond well to managerial techniques that work well in other businesses.

Creativity is an unpredictable process which cannot be easily programmed. It can't be turned on or off like a faucet. Sometimes the tap will bring forth a trickle of water, sometimes a torrent. Sometimes the torrent is brackish and unpleasant, while the trickle is sweet and clear.

Furthermore, designers themselves tend to be perfectionists who will, if given the time, tickle and refine a design forever. Some designers work slowly, some fast. Some designers feel more comfortable working on one kind of job while others work better on another. Often, because of the pressure of deadlines, a design firm can't always make a perfect match.

WHAT TO LOOK FOR IN EMPLOYEES

The personnel of a graphic design business should always reflect two parallel demands—the clients' needs and the design firm's needs.

Clients need the design firm

to be creative and imaginative;

to be experienced and dependable;

to be responsive and flexible.

The design firm needs

to give the clients what they expect;

to make a profit;

to produce materials that will attract more clients;

to create a working environment for employees that is pleasant and also creatively and financially satisfying.

These needs should guide the selection of employees. In order to have a creative, imaginative staff, obviously you must hire creative, imaginative individuals. Yet even more important, they have to be managed in a way which will encourage them to use their talents. Fortunately creativity and imagination show up in a portfolio and an interview more clearly than other factors—such as work habits.

You can't have an experienced, dependable staff if most of your people are entry-level designers. Entry-level employees pose other difficulties aside from inexperience: Their potential is difficult to evaluate, they need a lot of supervision and training (which cuts into the productivity of those supervising and training), and they tend to come and go quickly.

Nevertheless, for the health of the profession, even small design firms should make an effort to have at least one or two entry-level employees on their staff at all times, not merely because it is good for the industry to have a constant stream of new blood infused into it each year, but because it is also good business.

An aggressive search for talented entry-level employees forces a design firm to maintain contacts with the two best resources for experienced good designers—design-school teachers and young designers themselves. These contacts become valuable when a design firm needs to find and hire a good experienced designer quickly. They will be aware of those young designers who are looking around and ready to move on. A large number of your best prospects will come from this group.

Entry-level employees also tend to keep the rest of the staff on its toes. The mere act of having to train and supervise people forces employees to learn to communicate, persuade, and articulate—to grow in managerial skills.

It will be this growth that will enable the design principals to delegate more and to gain more time to concentrate on other areas.

To be responsive and flexible, a design firm must have a staff that is skilled in a variety of design specialties, large enough to be able to withstand the loss, whether temporary or permanent, of key people, and savvy enough to understand what clients are saying and to give clients the kind of advice which is tuned into the client's desires.

This requires the design firm to hire those designers who exhibit skills which go beyond having a good portfolio. They must also demonstrate that they have enough social skills to be able to work well with co-workers and clients.

GOOD MANAGEMENT BEGINS WITH GOOD HIRING

To perform well and to grow, a design firm must be able to attract and manage the best young talent in the field.

There are many ways to find talent. Ads, employment firms, and word-of-mouth all work. Most firms maintain a file of promising applicants who have shown their portfolios.

But a design firm shouldn't wait until the hour of need to begin looking for talented designers. Desperation often forces a firm to hire the best AVAILABLE DESIGNER instead of the best DESIGNER AVAILABLE— and there is a difference.

To find the best designer available, a firm needs a network of contacts which gives it instant access to the best young talent out there. It also needs a reputation in the field as a good place to work.

Contacts will come from a variety of sources, including some unlikely ones, such as clients and competitors. But the best sources will be your own staff and their friends in the field, design-school placement officers and teachers, and professional employment counselors—in that order.

It is wise to remember that your staff and their friends are also the best sources of contacts for other design firms—designers talk a lot to other designers—and therefore the way you treat your employees and applicants has direct impact on the long-term health of your firm.

If your firm consistently produces good work, it will always attract a certain number of good entry-level designers. But if word gets out that your firm doesn't allow a designer to grow, uses designers only as extra hands for the principals, is unfair or discriminating in its pay or employment policies, or is only interested in what it can get out of an employee, not what it can give, it won't be long before the firm finds its sources of experienced talent drying up and its best people leaving for greener fields.

A good recruiting program should include:

1. A continuous, active dialogue with design schools and design school teachers. Teach a course in a local design school. Make friends with teachers and students *and maintain those friendships*.
 Get involved in portfolio reviews and seminars. Be *visible* in the community.

2. Hiring interns, co-op students, and entry-level designers.

3. Making sure your own staff understands your personnel policies and goals. Don't inspire an atmosphere of fear and insecurity which would encourage them to sabotage any attempts to bring in strong co-workers. Build pride in themselves and their co-workers.

THE SELECTION PROCESS

Once a number of candidates have been identified, the selection process involves four steps:

1. Portfolio review

2. Reference check

3. Personal interview

4. Follow-up interviews

It is smart to treat each step as separate and distinct. There may be rare occasions when a firm might choose to make an offer without going through each stage separately. Nine times out of ten, however, there is more to be gained by the slow, conservative approach than by rushing to make an offer.

1. Portfolio review. One good thing about the graphic design field is that so much of what a designer does can be seen, so it is relatively easy to evaluate a candidate's level of design talent. Design principals need no instruction on evaluating the quality of a portfolio. But there are some guidelines to bear in mind relative to the portfolio review:

Remember that the portfolio review is only step one in screening CANDIDATES for a job; it is NOT the time to make an offer, or even to do much in the way of a personal interview. Ask only those questions which pertain to the portfolio itself. Ask questions if you need information to explain what it is you are looking at, but try to limit your questions to those that help you evaluate what the applicant actually did or did not do on the pieces shown. Once you are satisfied that the candidate looks like he or she has the translation skills to do the work, then move to the next stage: checking references.

The portfolio only shows what the candidate has DONE, not necessarily what the candidate is CAPABLE OF DOING, given the right training and environment. This information can best be evaluated in the next stages, the obtaining of references and the direct interviews.

The portfolio review is the time to have the candidate fill out an employment application. This way you will have information to use in checking references. Most applicants will provide you with a resume when they show you their portfolios. Resumes are useful; they should be attached to your own application form, but they should not replace it. By asking each candidate to fill in your own application, you set your own priorities of information. And you have a consistent way to review the information and compare candidates.

If a job IS available and you decide, based on the portfolio review, not to consider the applicant for it, avoid the strong temptation to tell him right then and there. Always ask the candidate to fill out an application and politely and graciously tell him that you will let him know in a few days—and do so. Have some standard letters ready for just such occasions.

This is not only good ethics but the best legal protection against charges of discrimination. In your letter you should always say that the job to be filled didn't match up well, in your opinion, with the applicant's samples. NEVER say that the applicant wasn't suitable for your needs.

If there is NO job open at the time, but you would be interested in the candidate should a job open up later, tell him this. Encourage him to stay in touch and let you know where he can be reached in the future.

If there is NO job open at the time, and the candidate doesn't appear to be one you would ever be interested in, merely tell him right away that there is no job open at the present time, but should a suitable one be open later you'll be in touch. Under no circumstances say any more, regardless of how hard the applicant presses for more information. DON'T pass judgments on either the work or the person. Don't be tempted to give advice. It can't do you any good and can get you in trouble if handled poorly.

2. Reference check. After an applicant is identified as a good candidate, you should check at least three references before granting a personal interview. You need to do a lot of research if you expect to be able to conduct a good interview.

What you're trying to find out from the references is how well the candidate will fit into YOUR situation, not how he fit into THEIRS. You can't assume just because they may say the person was terrific for them he will be equally good for you. On the other hand, just because he didn't fit in well at one place doesn't necessarily mean he won't fit in well at another.

Most personnel problems stem not from hiring people who can't do the design work up to standard, but from hiring people who are psychologically incapable of working well with others. Few personnel problems are harder to handle than an employee who is competent on the boards but who constantly angers his co-workers, clients, and bosses. It is far better to identify these kinds of workers in advance and not hire them, regardless of how good their portfolios may look.

When questioning a former employer you should be trying to learn almost as much about that employer as you do about the candidate. What kind of work do they try to do? What is their approach to design? What is the work environment like? Ask yourself, "If I were in the candidate's shoes, would I have been happy and productive?" Other things you should be trying to find out from references are such things as how the candidate handled pressure situations. Did he get more or less productive? Did he panic? Did the work suffer? How does he respond to criticism? Is he subject to great mood swings? Does he hold things in and harbor resentments or is he direct and eager to get things off his chest? Is he basically pleasant and good-natured, or will he be grouchy and difficult for others to work next to?

3. Initial personal interview. Following the reference check, the initial interview is the next place to weed out those candidates who will be troublemakers, whose long-term interests don't match yours, or who merely don't match up well with your present needs.

The key to a good interview is getting them to open up, to do most of the talking. The more you talk, the less you'll learn about them. Keep your remarks limited to asking questions, not pontificating about your design philosophy or describing the job in detail. That will come later. Ask them questions which will require them to express personal points of view and which reveal their own experiences and attitudes. Answers like "yes," "no," or "I like to do posters" don't tell you what you need to know. Build your interviewing vocabulary on phrases like "Tell me about . . . " "What do you think of . . . " "Why was . . . " "What if . . . " etc.

You want to find out if their long-term goals match up well with yours—for their sake as well as yours.

You should also be examining them for possible personality problems. Are they unusually tense? Everyone will be nervous to some extent in an interview, but is their nervousness out of proportion to the situation? Are they unrealistically and perhaps dishonestly enthusiastic? Could this indicate a personality subject to extreme shifts of mood? Are they too wooden? Do they listen well? Make a statement calculated to elicit an emotional response, and make a statement you know they'll disagree with. Do they disagree politely and matter-of-factly? Do they disagree at all? Save these questions until the interview has reached a level of easy, relaxed discussion. Otherwise the answer might only indicate the candidate's need of a job and his unwillingness to jeopardize the chances of getting it.

Try to avoid answering questions about the available position until the later stages of the interview. If an interviewee proves to be promising, you'll want to glean from him as much as possible to determine what part of the job would be most appealing to him—and it's best to get the information before you outline the position to him. In adddition, you'll be wasting time describing the job should you decide not to move the interviewee into your final group of candidates.

Toward the end of the interview you'll decide whether the candidate belongs in the prime group. Should you decide not to consider the candidate for the job that is open, follow the same procedure as you did at the portfolio review stage—send a letter in the mail. If there is no job open at present, politely tell the candidate right away that you will get back to him if a suitable opening developed.

If you are interested in an interviewee, the end of the interview is the time to give some information about the job available. Make sure, before starting the interview, that you have all your facts together about your firm and the job itelf.

Obviously the candidate will want to know what his tasks and salary will be. In all likelihood he will also want to know something about your firm's benefits, what kind of growth he can expect, what will be expected of him, how many people he will be working with, and whom he will be responsible to. He might also like to see what the place looks like and where he might be working.

4. Follow-up interviews. If there is a mutual interest in pursuing the process further, you should then offer to set up some appointments for the candidate to meet other people in your firm. Try to arrange these as soon as possible. Furnish each person meeting the candidate with a complete summary of the candidate's qualifications, the job he is to fill, your own impressions and those of the people who gave references. You are not obliged to mention any salary or benefit details to those doing the interviews, unless you want these details to become common knowledge, as they surely will. Try to fit the interview sessions into strict—and short—time frames. Urge each interviewer to concentrate on his own range of likely interaction with the candidate, to spare the candidate having to answer the same questions over and over.

Make clear to those conducting the interviews that they are not to use the interviews to wash dirty laundry or make speeches about how they would prefer to see the firm operate. Their role is to listen, answer the candidate's questions politely, but carefully, and give you their impressions.

Schedule yourself for the last interview. Use this time to clear up any uncertainties or questions the candidate may have. Tell the candidate you will get back to him in writing in a few days.

Talk to your people and decide which of the candidates, if any, you wish to make an offer to. Then frame a letter to that candidate and that candidate only, which details as precisely as possible the job you are offering and the specific terms of the job.

If the candidate accepts your terms, this letter is, in effect, a valid contract. So be prepared to live with it. You might want to have your first job letters reviewed by your lawyer before you send them, as there are any number of tricky issues to address. For example, should you make an offer in which only a yearly salary is mentioned, with no review period or escape clause also mentioned, you could be held liable for an entire year's salary if you discover after several months that you've made a mistake.

If your firm has a work contract, the candidate should be informed of this in your letter. If you hire him and afterwards ask him to sign a work contract, it could be worthless, even if he did sign it, as the courts would probably recognize the conditions of duress it was signed under—the implied loss of a job already held.

Do not send a letter to your second or third choices until your first-choice candidate has either accepted or rejected your offer. If he has accepted, send a letter out promptly to the other candidates simply stating that, although they were among the final few candidates for the job, your people ultimately decided that the requirements of the job didn't match their skills quite as closely as did another candidate's. Add that they would certainly be strong candidates for a similar job in the future, should an opening occur, and for this reason you would like to stay in touch.

File their names away for future consideration.

GOOD MANAGEMENT ALSO INCLUDES THE NEED TO FIRE PEOPLE, WHEN NECESSARY.

Every business owner invariably has to fire someone someday, unless he is incredibly lucky, is always absolutely right in his judgment of both human beings and business shifts, or prefers to remain blind to the obvious.

For most of us, firing an employee is one of the most painful and difficult aspects of running a business. No one enjoys it. Small wonder most owners try to delay it as long as possible.

Too often, after a bad situation has gone on far too long, one action of the employee so infuriates the owner or manager that the employee is fired impulsively and in anger. This is the worst way to handle the separation, both for employee and employer. For the employee it can be devastating and unkind. For the employer it can cripple morale, by sending other staff members all the wrong messages. They will tend to perceive the owner as short-tempered, arbitrary, and immature, which will make them feel insecure. If the firm acquires a reputation as a place where people are often fired abruptly, it will be very hard to attract good people. Furthermore, an emotional firing exposes the owner to charges of discrimination, which can be expensive and time-consuming to defend against.

If someone must be fired, the firing must be done as fairly and as humanely as possible, for everyone's sake.

What is the right way to fire someone? Even more important, how do you know when you should fire someone?

To answer these questions you should have a clear understanding of what is expected of you as owner and what you should expect of yourself.

As owner/manager you have an obligation to all your employees, including yourself, to make their jobs as secure as possible; to assure their future and your own by guiding the firm surely and steadily in the right direction; and to give your employees the opportunity to make the most of their abilities and skills. Anything less would be wrong.

Your people expect you to reward good performance, not bad. By not rewarding good performance quickly and clearly, you encourage bad performance. By accepting bad performance, you reward it. Unrewarded good performers will soon leave to seek more promising opportunities, leaving you with only those who won't or can't perform.

If the deciding factor in who goes and who stays is to be performance, then it is incumbent upon the owner/manager to spell out clearly to his employees exactly what performance means.

Some measures of performance are true of all businesses and obvious—doing jobs correctly, meeting deadlines, working cooperatively with co-workers, giving a full day's work for a day's pay. In the graphic design business, however, performance can also be measured in purely aesthetic terms, which cannot be clearly defined. Often this is a more important measure of an employee's value. An employee who does everything else right but can't measure up to the aesthetic standards of the firm is a weak link and a serious threat to the firm's future.

When faced with an employee in that category, the owner/manager has three possible courses:

1. To educate the employee so that his work will improve and be brought up to standard. This should always be the first choice. The owner/manager should set some clear goals and definite time limits for reaching them, in order to have a way to measure progress.

2. To encourage the employee to pursue his own vision of what is good design until one of two things becomes clear: either that his interpretation is at odds with that of the design firm and he should pursue it elsewhere, or that his approach, while different, can nevertheless be useful to the firm. This course may be worth taking when it appears that a designer's solutions are not what yours would have been but are still professional and do the job.

3. To fire the employee. This course should be taken only after it is crystal clear to the employee himself that every effort has been made over a reasonable length of time to both train him and to let him grow in his own way.

Long before any decision is made to fire someone, the owner must be very careful to keep a record of each and every meeting he has with his employees regarding their performance, including what was said and who was present. Send a copy of these notes to the employees and put copies in their personnel folders.

Should any problems arise which could necessitate firing an employee, you must have good documentation of the events leading up to the dismissal to protect yourself against charges of discrimination. If you have been meeting continuously with the employee, your dissatisfaction should come as no surprise to him, and neither should a decision to fire him. If your dissatisfaction is a surprise, you haven't been communicating as clearly as you should have been.

Once you make the decision, get the job over with as quickly and humanely as possible. Don't drag it out. Set some kind of policy regarding separation pay—the standard is two weeks minimum, but a week's pay for every year worked, with some maximum you think is reasonable, would be fairer for someone who's been working for the firm for a long time.

Bring the employee into your office. Tell him right up front what you are doing. Be considerate of his feelings. Discuss with him what he would prefer others be told. Don't get into disagreements over whether what you are doing is right or wrong, fair or unfair. Whichever it is, it is your decision to make and you've made it. You will never be able to convince the person it's for his own good, even if it is, so don't try.

Make sure that any benefits or opportunities due the employee are discussed with him, such as any profit-sharing or pension due him, any insurance or medical benefits that he could continue on his own, etc. Try to ease the economic blow on the employee and his family as much as possible. He didn't twist your arm to hire him. You share the blame for making a wrong decision in the first place. Don't make him shoulder all the penalties by himself.

You could let the fired employee continue on the job briefly to finish work he has started, if it won't cause too much of a problem with the other employees. As a general rule, however, a fired employee should leave as soon as possible. The others will have to be told, and it's better for you if they hear from you, not from the fired employee or via the grapevine.

GETTING GOOD PERFORMANCE

Managing a staff of creative people places design firm principals in the peculiar position of trying to predict the unpredictable, to control the uncontrollable, to set a price on the priceless.

For this reason it is even more important that the design firm principal find ways to control and measure the performance of his staff.

There are certain basic guidelines to bear in mind when trying to manage a creative staff.

1. At some point in the process of being creative, a typical designer will have to revert to a childlike state of being emotional, impulsive, and intuitive. During this state he is likely to be a royal pain to those around him. Leave him alone. Don't force him to be a planner and an analyzer all the time. He will have to use his own judgment as to when to change roles.

2. Creative people need rewards and attention more than most people. Any attention at all is a reward. If they can't get these rewards by good performance, many will get them by bad performance. If your managerial style is to expect good performance as routine but to criticize bad performance strongly, you are rewarding only bad performance with your attention. Bad performance will continue because the attention it draws is better than no notice at all.

3. To improve performance you will have to define what performance you want to improve and be quick to reward any improvement in it, no matter how slight.

For each of your employees, identify which of their shortcomings you regard as the most important one to be worked on—and work only on that one. Give suggestions; be patient. Rejoice with him over percentages of progress. Help him measure his progress. Think of yourself as a coach, not a boss.

4. Keep people busy! Designers have a habit of working to the outer limits of any time restraints or budgets given them, so you're far better off being slightly understaffed than being slightly overstaffed. Get them to agree to deadlines and budgets for each minitask rather than for the overall job. Don't tell them they have 40 hours to do the whole job; ask them when they can get the preliminary roughs to you. If they say 4 hours, ask them if it's possible for them to do it in 3. Create a small sense of urgency on every task. Give them two or three projects to handle at one time. Don't let them get the idea that missed deadlines are what is expected, but tell yourself that an occasional missed deadline, when properly handled with the client, is not a monumental disaster.

5. Managing meetings: You will hold meetings for two reasons: to give or receive information, and to give or receive inspiration.

Information meetings tend to be most successful if kept small. In a large group of people, considerable time is wasted in role-playing—in trying to look smart (or at least trying not to look stupid). The human dynamics take precedence over conveying the hard facts you need to help make decisions.

On the other hand, there is probably no better instrument for creativity than a wild, fire-breathing, kick-down-the-doors, no-holds-barred brainstorming session. Throw a bunch of creative types into a room, throw in some food, tell them they've got three hours to come up with an answer to a problem, lock the door, and don't come back for three hours. I guarantee you the walls will be scorched with the creative fire generated during those three hours.

Try to use meetings of more than one person more as CREATIVE PLAYGROUNDS, not reporting instruments. Try to get information in private, one-to-one meetings. If you want to find out where a project stands or what went wrong, ask the same questions over and over again of different people within the company. They'll all give you different answers, but somewhere, hidden within the answers, you'll get the real truth.

Encourage your project managers to give you the bad news first. Make them understand that, for the most part, bad surprises will threaten your business most—and consequently their jobs. Don't discourage them from giving you the truth by trying to find someone to blame when things go wrong. Concentrate on looking for ways to fix the problem.

DELEGATING

Graphic designers, like most people, only have two arms and one head. Which means that the only way they can handle more than one job at a time is by delegating some of the work to others. The more they can delegate, the more they are free to work on other jobs and other problems.

So, it's for their own good that designers should learn how to develop good assistants. There are dozens of books that have been written on the subject of managing employees and most of them pretty much say the same thing: Give your people as much responsibility as they can handle and then keep giving them more.

There's nothing wrong with this advice, except it doesn't work very well for graphic design firms unless the design firm principal who is doing the delegating accepts some rather difficult truths.

Hand skills can be delegated. Project management—watching the budgets and the schedules—can be delegated. Even client contact can be delegated. But art and creative vision can't be delegated. If you hire designers to solve problems, don't hand them your solutions and also expect them to grow and be able to help you. Instead you'll have to turn over problems. You'll have to let them make decisions. Give them the freedom to work their way, not yours. Suggest methods, not answers.

Educate them to your objectives: serving the customer; making a profit. Set the example, and let them figure out the ways to follow your example.

Find ways for them to compete with each other, but make sure the competition stays focused on the jobs, not on the people themselves.

The bottom line is that by really having their best interests at heart, you'll be serving your own best interests.

Ask yourself, "How good is your word? Would you work for you?"

Managing Time and Paper

Most graphic designers put in long, tough and lonely hours. The 18-hour work day is not uncommon. Yet despite this hard work, most design firm principals are barely scratching out a living.

The reason is seldom lack of design ability. More often, it's the inability to manage time well. In most businesses, profitable performance and successful time management are closely linked. In the graphic design business, the linkage is as close as Siamese triplets in an airplane washroom.

Frankly, much of the inability to manage time is a self-induced affliction. Too many designers wear their disorganized, undisciplined behavior like a badge of honor, an official certification of their artistic credentials. They fall under the sway of the popular but totally false idea that control and creativity are mutually exclusive qualities, and that an obvious deficiency of one signals an abundance of the other. In a profession based upon tangible results and measurable performance, this notion is downright stupid.

In point of fact, graphic design studios make profits relative to how well they use or abuse their time. If the principals can estimate their time accurately, perform tasks in roughly the time allowed for, and track time accurately, their studios will show a profit.

The difficult part of time management is having to change bad personal habits. Most human beings would rather believe nonsensical ideas and dangerous myths than confront their own worst enemy — themselves.

Dangerous Myth #1: Using time well means putting in hard work and long hours. Wrong. Being effective has nothing to do with how fast you are pedaling the bike. It has more to do with whether or not the wheels are on the ground.

Dangerous Myth #2: Pressure is a necessary ingredient in quality work. Wrong again. There's nothing that a good designer can do under pressure that he couldn't do if he didn't put himself in a pressure cooker. The strong possibility of serious errors cropping up in the job are hardly worth the momentary high that the designer gets from performing at high-pressure level.

It's far easier to believe that you cannot change the way you are. Reforming bad habits is hard work that doesn't yield results easily. But the potential benefits, both emotionally and financially, are worth the pain and aggravation. When doubts set in, take hold of these truths, which happen to be self-evident.

Self-evident Truth #1: Time is precisely measurable and finite. You can't add hours to the day; but you can make the hours you have more productive.

Self-evident Truth #2: Every hour that isn't being used to make money is costing you money. This is not a case for sweatshops or personalized nose-grindstones. It IS a reminder that time really is money; that doing work yourself is wasteful if you can teach someone else to do it more cheaply; and that doing work that doesn't pay you what you're worth doesn't help you get work that will.

TOOLS AND SYSTEMS
The first step in time management, therefore, is the mental commitment to doing it. Once you've taken that step, there are a host of tools and tricks to help you do it. Although the tools and systems vary, all have certain common objectives.

The ideal system:

1. Helps you plan and prioritize your personal time.

2. Helps you plan and monitor the time and work of others.

3. Helps you deal with your mail.

To turn available time into productive time, you must develop a system to prioritize the tasks on your agenda.
The tools you will be needing to plan your personal time are:

1. A small "everything" notebook

2. A small tape recorder

3. A large planning book

4. A daily "to do" worksheet

THE SMALL "EVERYTHING" NOTEBOOK AND THE TAPE RECORDER
I used to be one of those people who walked around with dozens of odd-sized pieces of paper in every pocket. Any time I needed to make a note of something I would search through my pockets for a handy piece of paper and write the note down on whatéver I found. Needless to say, when it came time to retrieve and act on these notes I couldn't find half of them.
Then one day, while I was going through my paper-searching act in front of one of my friends, he asked me, with some amusement, why I put myself through all this. Why didn't I just carry one notebook instead of all those different pieces of paper? I looked at him for a moment, stunned and embarrassed. Finally I had to answer that it simply had never occurred to me.
I stopped in the next stationery store I passed and bought a small memo book. Using this memo book, and the dozens that followed it, did more to organize my time than anything else I have ever done. I carried it with me at all times—to work, to the bathroom, to the night table at bedtime. Anytime a thought occurred to me I immediately jotted it down. Anytime I was given an instruction or request I wrote it in the notebook. I always knew where to write a reminder. Even more important, I always knew exactly where to find what I had written.
Things improved for me dramatically and immediately. But there was still one problem in this area that I had to deal with. Like so many other businessmen, I spend a lot of time in my car, traveling back and forth to work and clients' offices. Since I'm one of those weird people who have a hard time driving and writing at the same time, I usually just tried to remember what it was I had thought of as soon as possible after I stopped the car and wrote it down in the notebook.
Naturally, my best thoughts somehow never made it into the notebook. Then, one day, I discovered the twentieth century. I bought a small tape recorder, along with a transcriber for our secretaries. I made it a habit, as soon as I got in my car, to remove the tape recorder from the glove compartment and place it on the seat next to me. Whenever I thought of something that I normally would have written into my small notebook, I recorded it on tape instead. Back in the office, I could either play back the tape and jot the words down myself in my planning book, or turn the tape over to one of our secretaries to be transcribed and typed, after which I transferred my notes to my planning book.

THE LARGE PLANNING BOOK

The small notebook and tape recorder help you retain and retrieve your thoughts and memos. By themselves they can't help you become more productive. You also need to plan ahead.

To help you, you will need a large planning book. It should have room enough to write numerous notes on each date, and scope enough to allow you to plan weeks and months ahead. Several such books are available. One of the best systems I've seen is called the Scancard system. It consists of a series of small cards which insert into pockets. Notes are written on the cards and the cards are inserted into the pockets in any order you wish, chronologically or by category. The cards are color-coded to help you assign the categories.

As plans change you merely have to move the cards about instead of creating new cards. When a task is completed you simply remove the card from its pocket. If you want to find out more about this system you can write to The Executive Gallery, 6480 Busch Boulevard, Suite 200, Columbus, OH 43229-9966.

THE DAILY "TO DO" WORKSHEET

The last tool for prioritizing your time is a worksheet of tasks to be done each day. The tasks should be divided into "must be done," "should be done," and, "would be nice if they were done" categories (or any other, 1,2,3/A,B,C, etc., designations you care to use).

HOW TO USE THE TOOLS

The four planning tools work interactively. I've already described how the small "everything" notebook and tape recorder work. They are used to help you record and retrieve information and ideas. The large planning book is not merely an appointment book, although it is also used to record appointments. The book is your complete planning instrument.

To use the planning book start by filling in all the tasks and times slots that are unbendable. I teach a class every Thursday evening from 5:30 to 8:00, for example. So these are time slots I start with.

Next I try to identify the most pivotal tasks or activities and add them to the schedule. Pivotal activities are those activities which you can do which will create work for many people, affect a small number of people for a very long time, or supply a crucial piece of information to your firm, such as what your overhead percentage is.

These pivotal activities are penciled in, along with the estimated time it will take you to do them. All other less crucial tasks are added to fill in the spaces. It's wise to add about a 25 percent contingency factor to the time allowed for each task. Don't forget to add in time for planning and time for resting.

Plan to do your most important jobs during those hours when you are most alert. If you are not sure which hours are your best, try different ones.

The bottom line is that if you haven't allowed any time in your schedule to do the work, it's a pretty good chance the work won't get done at all.

After you've identified the long-range tasks, set down those that must be done that day on your daily "to do" list, in order of priority.

Do the first one first, the second one next. If all of them don't get done by the end of the day, don't sweat it. By always concentrating on the most pivotal jobs first, at least the jobs that do get done will be the most productive ones.

When planning your schedule, try to identify those tasks that interest you most, that could possibly be delegated to others, or that are an unproductive use of your time.

SUPERVISING EMPLOYEES

There are only two ways a graphic design firm can make more money—by handling more jobs or by charging higher prices. The ability to command higher prices is dependent to a large extent on factors which the firm can't control, such as how much in demand the firm is. The ability to handle more jobs, on the other hand, is strictly within the power of the design firm itself to control.

Increasing the amount of work will require finding ways to increase sales. But it also means that the firm will have to find a way to spread the work load beyond the principals—they'll have to learn to train and to delegate.

As sensible as this simple fact of life seems to be, an awful lot of design firm principals resist delegating as hard as possible. They are afraid that the quality of their jobs will suffer. They are afraid that they'll lose control over their jobs and their business.

Good delegating begins with surrounding yourself with the right people. But even the best young designers need experience and training to provide you with real help. You must create systems and routines for them to work within that make life easier for you. You must specify precisely how you want your work to look. How you want your office to run. What your standards are. It doesn't make sense to reinvent the wheel for every task in your shop. Standard procedures help you avoid this.

Corporate Graphics, Inc., in New York, has a thick manual of procedures that spells out exactly how it wants each designer to operate. How it wants type specified. How it wants roughs and comps done. How it expects time to be logged. Everything.

Demanding strict adherence to these kinds of procedures must not be viewed as putting designers in strait-jackets. It is simply good communicating. Like it or not, in the long run their future growth in your firm will depend on how well they live up to your standards and how much you are willing to trust them. So it is only fair to them that they know what the ground rules will be from the outset.

TOOLS OF DELEGATING

In a previous chapter we discussed the techniques of delegating. In this chapter we want to focus on the tools of delegating.

The tools you will need to help you delegate and monitor the work of others are:

1. Individual folders for each person you work with

2. Individual jackets for each project

3. Your large planning book

4. Time sheets for each person

Anytime you think of anything that relates to one of the people you work with, make a note of it to be filed in his or her individual folder. If the note relates to a specific project, make a copy of the note and file it in the appropriate project folder. If the note refers to something you have to check or follow up on at a later date, log it in your planning book to serve as a "tickler file."

TIME SHEETS

Time sheets are monitoring tools which are very familiar to most designers. They are vital to the bottom line; a design firm's profits begin with time sheets. If a designer's time isn't recorded, is recorded sloppily, or is recorded too late to be billed, the firm will not be paid for the hours it has spent on a job. Worse, problems that may be occurring may go undetected until it is too late to correct them.

You must find a way to help your design staff attach real value to their time sheets. This cannot be emphasized too strongly. I've even been told of some design firms which hold their designers' car keys for ransom until completed time sheets are turned in. Perhaps that's a bit extreme, but somehow you must make your designers realize that profits help the designers, and that profits can't be earned unless the firm is paid for the designers' time.

Time sheets have another vital function. Good time records help build historical experience that improves your ability to estimate accurately on future projects—not only how much time a job may take, but what levels of experience should be involved, and who should be involved. Bad record-keeping, in contrast, could have disastrous results in estimating future jobs.

DEALING WITH THE MAIL

Handling incoming mail can be aggravating and time-consuming. Don't let it be.

There are only four things you can do with your mail:

1. Take action.

2. Pass it on to someone else.

3. File it.

4. Throw it out.

The first thing to do with your mail is separate it into those four categories, using four bins or baskets. The fourth basket, off course, is the circular file. A well-trained secretary could handle this sorting for you, saving you time.

It is best merely to sort, not to make decisions, on the initial pass-through. While it may seem like a waste of time to pick up the same papers twice, and while some people prefer to make these decisions as they go through the sorting process, I believe that sooner or later you'll reach a piece of paper which will get you involved, hang you up, and slow you down. One exception to this rule: If someone else's work is held up until you take action, do it right away and drop that item in the "pass on" basket.

A letter that requires an answer from you goes in the "act on" bin. If no reply is necessary, either pass it on for someone else's information, file it, or trash it. Put magazines and newsletters into the "act on" bin. Reading is an action.

Don't be afraid to be ruthless with junk mail. Junk mail provides a ready excuse for procrastination, but don't yield to temptation. Your time is your most precious resource. You charge your clients enough for it. Don't charge yourself less.

Before you read anything, junk mail or otherwise, decide whether it will be worth your time at all. If it can't inform you, make money for you, or relax you, don't bother with it.

Once your mail is sorted, return to the "pass on" and "file" bins again. Dump the entire contents of one bin on top of your desk and work your way down through the pile, piece by piece, putting the pieces back into their proper bin as you finish with them. Don't be afraid to change your mind about which bin they belong in. After you finish with one bin start on the other.

If you have a piece to be passed on, write the name of the person or persons who are to get it right on the front of the piece itself, with an appropriate note from you.

If it is something to be filed, write the category it is to be filed under right on it and toss it back into the "file" bin. Remember, you should be choosing the filing categories, not delegating this task to someone else to do. They are your files and you have to be able to retrieve things from them quickly.

After you have been through the "pass on" and "file" bins, ask your secretary to pick up the entire bins, distribute them or file them and return the bins to you when he or she is finished. If you have no secretary, pass out the "pass on" mail yourself—you owe it to others not to delay their ability to act on your requests too long. Wait for some later down time to do the filing.

Next deal with the "act on" bin. Dump it all out on your desk and separate the magazines, newsletters, and other such material from the pile. Put them on the bottom of the pile or in a holding area or bin. Work on all the rest of the mail first. Look through the mail with an eye to identifying all items that can be dealt with quickly and easily, such as thank you notes that have to be written and such. Do so immediately, right on the original sheet of paper. Next go through the pile to try to identify the most important tasks. Put all the rest of the papers back into the "act on" bin and put the important papers right on top.

Try to get rid of these first, then move on to the others. If you find you really can't act on something, either because you need more information or you have to meet with someone else who isn't available yet, keep putting it back in the "act on" bin until you can get rid of it later. Flag the piece of paper somehow so that it gets moved up into a higher-priority category.

If some piece of mail demands a very large chunk of your time to act on, such as a detailed compensation plan, for example, slip it into a "holding" bin reserved for such items. Make sure you block out some time in your planning schedule to take care of such items, based on when the item is due, so that working on it doesn't fall through the cracks.

After you've gone through the important items in the "act on" bin, or when you decide to take a break, tackle the reading material. Quickly skim the magazines. Look for articles that you want to read or file away for further reference. Tear these right out of the magazines or make photocopies of them. Put the tear sheets or photocopies in a folder and put the folder in your briefcase, which you should keep open by the side of your desk all day for just such a purpose. Anytime you get a few odd moments, pull out your "to read" folder and catch up on your reading.

Managing Money

W hat's the best way to show a profit in your business? The answer is simple. Some might even say simple minded: Spend less than you make.

That is easier said than done. To spend less than you make, you must know exactly how much you have *already made*, how much you can reasonably *expect to make* in the next days, weeks, and months, how much you have *already spent*, and what you are *obliged to spend* in the near future.

The process of keeping this financial history and making projections of your financial future is called accounting.

One compelling reason for accounting is simply to keep from going broke. A second, equally compelling, is that banks, the IRS, and other governmental or institutional bodies expect you to provide precise proof of your fiscal situation whenever you have to deal with them.

This is where your good friend, Mr. Accountant, comes in. He's the one to whom you must turn for advice on the best way to maintain your records.

In a previous chapter I advised you to find out which accountants were already working well with some design studios, and to find opportunities to try them out in small ways. If you have not yet begun to search, begin.

Your accountant will advise you on the details of setting up a good bookkeeping system for your business, but there are some general words of advice I would like to pass on.

1. CASH IS MORE IMPORTANT THAN PROFITS.
Which means bill your clients fast, bill them often, and get as much money up front as possible. Use your client's money to make money, don't let them use yours. They've got more of it than you do.

2. DON'T DO YOUR OWN BOOKKEEPING.
There are four people who could keep your books for you working either full or part-time:

A) A CPA (Certified Public Accountant)—someone who has been certified by the state to do this kind of work.

B) An accountant—an individual who can do the same work, but hasn't been certified by the state to do it. This usually means he costs less, but it doesn't necessarily mean he is less accurate.

C) A family member—preferably one who can get all the numbers right most of the time. A family member who has taken a bookkeeping course would be even more preferable.

D) A bookkeeper—someone who can get all the numbers right and also understand what an accountant says, which isn't always easy.

One person, you'll notice, is conspicuously absent from this list. *That is yourself.* Of course you should be deeply involved and interested in your firm's financial information, but you should not do your own bookkeeping. Your time is better spent as a profit center than as dead overhead.

Most designers know how to set a value on design and production services. But when it comes to financial services, they don't know how to measure what they need and what they get. Some designers may pay too little; as a result, they may not get enough information, or the right kind of information, or, even worse, totally inaccurate information. Others, recognizing how little they know about finance, will go to the other extreme and pay for far more information than they can possibly use.

Use your accountant or bookeeper as an adviser, as a detective, and as a critic. If your firm is large enough to need these services full time, then by all means hire one. Otherwise contract for on-call services only.

The first on-call service you could contract for with your accountant would be advice on how to set up your system. In order to do this your accountant will need a lot of information about you, your finances, your goals, and how you intend to operate your business. If you've already had the good sense to find a CPA who understands the needs of graphic design businesses the job will be easier, and, consequently, less costly.

Whichever system he recommends, it should be simple to use, easy to understand, accurate, and, above all, capable of providing you with the kind of information you need *when* you need it.

3. LET CHARLIE DO IT, BUT GET MARY TO WATCH CHARLIE—AND YOU WATCH THEM BOTH.

Remember, if something goes wrong, Charlie and Mary may lose their jobs, but you might lose everything you have, or even end up in jail.

For example, require two signatures on all checks. This reduces the chances of problems cropping up. Sign as many checks as possible personally. If you are out of the office a lot and can't sign every check, have a designated stand-in—but only if you first make it clear to that person exactly what you expect from him: A thorough understanding of the reason for every check he signs, and an instant alert of every problem he sees before letting the check go out. You might also consider making an arrangement with your bank that limits the amount that it will cash for your stand-in.

Also, don't forget to bond anyone who will be signing checks for you—anyone. Even the closest and most trusted people have been known to do some strange things where money is concerned.

4. ALWAYS KEEP YOUR MONEY IN SEPARATE POCKETS.

Your clients may think that you and your firm are one and the same, but you should never think of your money that way. Think of your firm as someone who is paying you a salary to handle his finances, and is holding your children hostage to see that you do it right. You wouldn't put your money into his checking account, would you? Don't do it! You would be extra careful and prudent with his money, wouldn't you? Do it!

5. DON'T LEAVE MONEY LYING AROUND, DOING NOTHING.

Put it to work as fast as possible. Every day you miss represents lost money to you.

6. IF YOU HAVE A NUMBER OF PROFIT CENTERS, THINK OF THEM AS INDIVIDUAL BUSINESSES.

Each of them should be monitored and measured by what they cost and bring in individually. If you lump them together you'll have a hard time evaluating their performances.

7. NEVER FORGET THAT YOUR ACCOUNTANTS WORK FOR YOU, YOU DON'T WORK FOR THEM.

If you can't understand the numbers, or if your reports aren't giving you the kind of information you need, don't be afraid to ask your accountants to change their system to accommodate your needs. That's what you're paying them for.

8. WATCH THE PENNIES AND THE DOLLARS WILL TAKE CARE OF THEMSELVES.

For a design firm, this means look less at the big picture and more at each project individually. A design firm lives and dies on whether or not it has enough projects to keep its employees busy, and, even more important, whether or not it makes a profit on each of those projects. You don't want to be in the position of losing a little bit on each job but making up for it in volume.

Design your accounting system to feed information back to you as fast as possible about the financial status of each project.

Make certain that your systems are structured to receive all records of time, things paid for already, and things *contracted* to be paid for in the future, as quickly and as accurately as possible. If the information doesn't get in fast or isn't accurate, either you won't get it out in time or it will be wrong.

Try to set up a system which automatically and quickly flags those projects that are 10 percent or 15 percent over their estimated budgets. If your system isn't structured to isolate and identify this information, it's probably wrong and needs to be revised.

If all project managers are consistently going over their budgets, the problem may lie in your firm's contracting procedures, your firm's estimating procedures, your firm's ability to track additional work requested by the client, or any number of basic internal procedures. If only a few are exceeding their budgets, the problem may lie in their lack of experience or knowledge of proper procedures, they may be overworked, or they themselves may be sloppy and disorganized.

9. IF YOU CAN'T PREDICT YOUR INCOME MORE THAN A MONTH OR TWO AHEAD, YOU'VE GOT A BAD SALES PROGRAM.

In order for a business to grow and be healthy it can't wait for trouble to jump up and bite it. It has to be able to anticipate and plan. Owners who operate by "feel" are usually owners whose business is running them. As long as industry and economic conditions are good, problems are hidden. When things turn bad these owners don't "feel" it until their competitors have already blindsided them.

It isn't too difficult to predict expenses. Income is harder—but just as necessary if you want to survive. You've got to work just as hard in setting up long-range sales projection procedures as in setting up historical number-counting procedures.

10. IF YOU KNOW THE DIFFERENCE BETWEEN "CASH BASIS" ACCOUNTING AND "ACCRUAL BASIS" ACCOUNTING, YOU PROBABLY SHOULD USE THE ACCRUAL METHOD. IF NOT, YOU SHOULD PROBABLY USE A CASH BASIS UNTIL YOU LEARN THE ACCRUAL METHOD.

A cash basis method is pretty simple. It is set up to keep track of only the actual physical dollars and checks you take in or pay out—just like your own personal checkbook.

Because most design firms do most of their business on *promises* to pay or be paid, a strictly cash basis doesn't really reflect the actual financial status of a company. An accrual basis does. It forces you to record each and every time you contract either to get paid for something or to pay for something, *as well as* the cash and checks you pay out or take in. These have to be recorded as either increases or decreases to the promised monies. You can already see, in this oversimplified description, that the accrual basis is a far more complicated process that will demand more of somebody's time to keep up with. But, if you have the money, it will be well worth it. It's the only way you'll be able truly to measure your firm's financial health.

11. TALK TO YOUR ACCOUNTANT ABOUT COMPUTERIZING YOUR ACCOUNTING SYSTEM—BUT BE SURE THE SYSTEM YOU USE IS DESIGNED TO WORK FOR YOU.

A computerized accounting system, by its very nature, is designed to apply to a lot of businesses in a general way. Until you understand how your system should work in order to give you the information you need, you're not ready to decide on software or programming. You want a business and a system that make you master of your fate, not a slave to it.

The standard advice once was to design a manual system first, then computerize it. That may be outdated today. Inexpensive software packages on the market today are simple to learn, and an individual without much accounting experience can operate them with more ease and speed than a manual system. Often these packages have safeguards that prevent you from making certain kinds of errors, and many guide you step by step through the necessary procedures. The better advice today might be to begin with a prepackaged software program, try it out, learn what you can do with it, then adapt it or another system specific to your needs.

THE BOTTOM LINE

When all is said and done, being in business revolves around one thing: making money. Profit may be only a means to an end—personal independence, perhaps, or the freedom to produce quality design—but that means is absolutely essential. Businesses make money or they do not remain in business. Period.

Your accounting system is your single most effective control over your entire business operation. It provides you valuable information about your anticipated income, which reflects on your pricing, your sales, and your marketing efforts. It keeps track of your expenses, which give you insights into the merits of your project management and time management systems and which in turn may reflect on people management in your firm.

Your accounting system cannot tell you whether you are succeeding as a designer. It cannot tell you whether your customers are satisfied. It cannot tell you whether you ought to be in the design business. But it can tell you whether your firm is succeeding as a business.

If you can succeed as a business all the other things are possible. If you cannot succeed as a business, all other measures of success become irrelevant. In the business of graphic design, that *is* the bottom line.

Primo Angeli studied design at Southern Illinois University, receiving a Masters in Communication degree. After graduation Angeli worked for a couple of years with Buckminster Fuller, and then, in 1959, he moved to the Palo Alto area, where he began freelancing.

In 1967 he and his family moved to San Francisco, where he opened Primo Angeli Graphics, which specializes in large packaging and corporate identity programs.

Primo Angeli designs have received international distinction and are included in exhibitions and museums throughout the world.

The Bauhaus school of design and my early experiences left me with the impression that I could solve anything. This attitude was as natural as breathing. I was always sure that there was an answer to any question, if one kept an open mind.

In my business's early years I only had to manage my design problems and a staff of two. An outside accountant handled the books, and my wife, Deanie, typed the bills. Simple.

High visibility assignments became a priority because of my interest in solving visual communications puzzles and my need for notoriety and a good portfolio. (No portfolio—no work.) My wife's salary as a schoolteacher allowed me four years to experiment with design solutions. When our first child arrived, my meal ticket disappeared, and for the first time in my fledgling career I knew the real meaning of the words, "pure white fear."

Two long-neglected elements had suddenly surfaced, time and money. Without them, design is mere decoration. Neither good design nor fine art.

My appraisal of each assignment in much greater detail eventually resulted in sensibly written proposals, and the ball finally started rolling. The assistants grew to seven or eight including my first full-time salesperson.

Larger, more comprehensive projects in packaging and corporate identity were the primary objectives of my new one-person sales department. And, as this goal was achieved, more support in design and production was required— and more space.

A move to larger quarters and eleven people later, I realized the full impact of the change as our volume of work doubled. No complaints. Profits increased too. However, Primo Angeli and eleven assistants were not my idea of ideal. Restructuring of personnel and creation of key positions of responsibility and authority became paramount.

My personal goal is that I wish to maintain my position as creative director and continue involvement with every project. Our overall objectives are to make certain our clients have an effective marketing program, with design solutions that are laser sharp and memorable, with the personality of each product or service clearly expressed. Perhaps ideal, but possible in *every* assignment.

How we are now structured is not much different than many other comprehensive design firms, I suppose. Corporate identity, brand identity, packaging and environmental graphics constitute our basic field of endeavor. Essentially permanent or long-term graphics.

Originally, all my jobs were acquired by referral. My past performances were my best salesmen. Today with a marketing and sales group of four people, over 50 percent of our assignments are still by referral.

The Christian Brothers: This represents one category. The complete design program includes varietals, generics, dessert wines and champagnes.

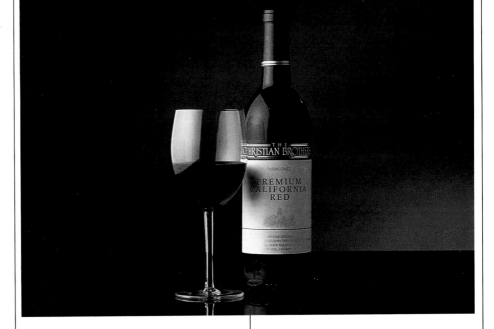

The Grand Canyon: Identity system for the national park which wraps up the Grand Canyon with the American flag.

Philippine Airlines: This corporate mark for Philippine Airlines has been implemented on everything from print materials through aircraft markings and signing throughout the world.

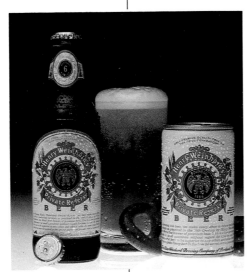

Molinari Salami: This limited edition salami container was designed to introduce a new packaging program for Molinari.

Henry Weinhard Beer: Designed to project those qualities of a super-premium beer that is brewed in a very special way in limited quantity.

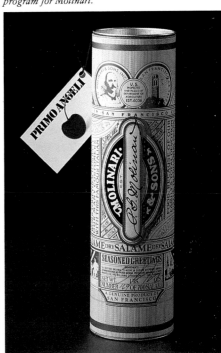

Airport Marina Hotel: This mark designed for Amfac Corporation's Airport Marina Hotels included all print materials, signage and vehicles for the hotels in Texas and California.

In acquiring a new account, we rely primarily on our track record and how we respond initially to establish our credibility. Our salespeople present a potential client with a slide show which documents where the product was before, what the problem is now, and what we understand the target to be. Design exploration and refinement sketches are exhibited down to the last two or three candidates, and, finally, our reasons why it should be this one specific idea become obvious.

After we have shown a convincing portfolio, we begin to deal with the client's specific problem, taking a hard look at his special marketing objectives. We reiterate them in our proposal, making it very clear that we understand them. We include all essential data so the client is aware that this proposal is more than boilerplate. He knows that we really understand the assignment and that we are going to take his job and company seriously.

Briefly, once our proposal has been accepted these are the steps we follow: 1. ORIENTATION, which constitutes firming up objectives, setting criteria, audits of competition, and interviews, 2. DESIGN DEVELOPMENT, 3. PRESENTATION, and 4. REFINEMENT. We gradually resolve the assignment into a successful solution for the production phase within a well-defined schedule and budget.

What one sells in these stages is confidence. The fact is, you are no longer trying to impress him or her with your grand knowledge of design in general. You are now dealing with the client's problem, not *your* problem. You have to sell trust, enthusiasm, responsibility, and results. Quite an order, but essential. The client must be made to feel you understand the assignment and can get right to the core of the problem. You are not selling design alone—nothing is alone. When it is good design, it is integrated with marketing and research and includes the all-important strategic plan.

We put together a design team from our firm which I think will work best with the client's people. This could mean anywhere from two to ten designers, including myself. Clients like to know that the principal is involved and what the design team is all about. The team must be compatible and dedicated to the discovery and development of the finest, most effective solution possible. Key to this, of course, is to create a condition for decision making in which individual authorship takes a back seat until the completion of the job, after which, all heroes are finally acknowledged. I don't care if the best idea comes from a junior member or the janitor.

Our efforts to understand the differences between the client's project and any other project make the client realize that we are concerned with its special personality and that we are also trying to help the client capture that market.

We keep reminding ourselves that although we are actually only the designers we must somehow magically transform ourselves into the consumers if we are ever going to solve the marketing problem well.

Every Monday morning, our design and production staff meet to check every job. The project directors and I go over all aspects of scheduling and budget. The computer readout tells us where each job is, how many hours of work are left in it, how much of the budget is left, which jobs are in trouble, who needs help—everything but how to accomplish it. This task goes to the most important person, to the center of the storm—the designer.

It is the project designer's responsibility to stay on budget. If there were changes asked for by the client, we will bill them for the changes. If the problem is ours, we get the job back on track by putting in night and weekend overtime.

An important thing to remember is that you can't afford to wreck those forty hours a week upon which all your costs are based. Those hours are what the business lives and dies on.

My general advice to the student designer and the young professional is the same, "Concern yourself with design." School is the best place to explore, make mistakes, design, and redesign.

Design is business, art, marketing, communication and integrity. More specifically, in the case of Primo Angeli, it's design for marketing and communication.

Shasta Beverages, Inc.: Corporate identity system.

Boudin Bakeries: A brand identity, packaging and environmental design system was created to communicate the old-world quality of San Francisco original sourdough French bread bakeries in their nationwide stores.

Snoopy's Ice Cream & Cookie Company: Retail identity program designed for Charles Schulz.

GardenAmerica Corporation: Formerly Leisure International, the new name and identity system better expresses this parent corporation for garden supplies and nursery products.

Shaklee Corporation: Brand identity and packaging design system for three lines. Shelf impact was not a consideration since Shaklee is a direct sales organization. Design was aimed at home environment suitability.

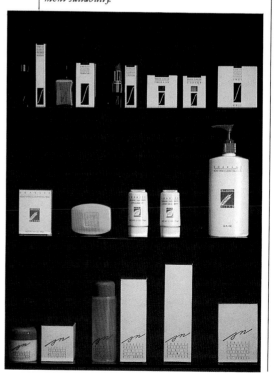

SmithKline Bioscience Laboratories: A worldwide laboratory service and testing center.

DHL Corporation: Corporate identity system for the world's largest international air courier service.

Aubrey Balkind brings a most unusual background to the design consultancy profession. He began his professional life abroad as a certified accountant and auditor. After receiving his MBA with honors from Columbia University, he joined Arthur Young & Company, where he designed organization structures, operating systems, and forecasting models. His interest in graphics led him to a partnership with Philip Gips in 1972.

Gips + Balkind + Associates is a full-service design and marketing communications firm and one of the leading designers of corporate and financial, entertainment and real estate communications.

Early in 1985 the GBA Group was formed—an "all-under-one-roof" total communications source. The Group includes: Gips + Balkind + Associates, Fearon / GBA Advertising, GBA Entertainment and Tony Silver Films.

Our organizational system is two-pronged: Designers and account executives always work together on projects. The account executive manages projects and, together with the designer, contributes to the projects creative direction. Budgeting, scheduling, production and day-to-day discussions between clients and our firm are handled by account executives. The designer, on the other hand, creates the look, structure and style for the project. Major client meetings are attended by both account executives and designers. Clients thus have at least two contact points within GBA.

There are more than 40 people on our staff right now, including four account executives, two junior account executives, and about seven designers. We also have people who handle production and traffic, write copy, do research, write computer programs, and develop promotion and publicity. This kind of specialization enables just a few designers to produce a great deal of work.

Diana Graham and Phil Gips spend almost all their time designing, while I spend most of my time managing. Most management decisions are made by me, although I consult with Phil and Diana on major questions. The result of having distinct areas of responsibility is that there are very few misunderstandings and arguments.

At GBA, we think of ourselves as professional communicators. This means we solve problems in an efficient and profitable manner. For example, creating an exceptional piece of work but losing money on it is only acceptable if we have made a prior conscious decision (e.g., for portfolio purposes) to do so.

We have a very sophisticated computer system to help us control jobs. It tracks our time and expenses by job, helps refine our billing rates, and tells us whether we are recovering our overhead and out-of-pocket expenses. Practically all our jobs are estimated in advance, usually based upon prior experience. We are seldom too far off target because for a long time we have had accurate financial feedback. Our present system is a far cry from our early days when time sheets weren't even kept.

Client contracts take many forms. Sometimes we ask clients to sign our proposal and sometimes we merely request a purchase order. At other times we have a more formal contract. It depends upon how work is done in that client's industry.

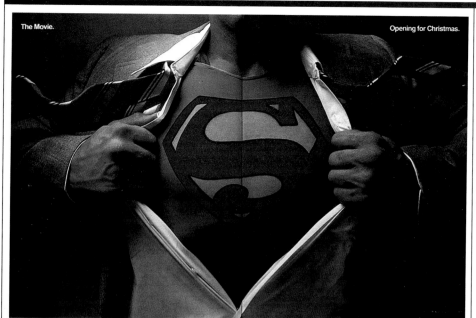

"Superman" movie ad campaign.

The Movie.

Opening for Christmas.

Columbia Pictures

Columbia Pictures corporate identity.

The New York Fire House museum identity and exhibit design.

"Alien" movie poster.

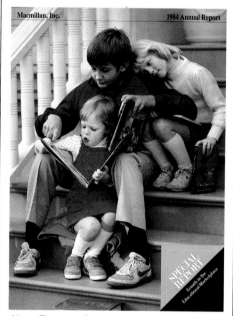

Macmillan annual report, 1984.

GE's Homeminder product identity and packaging system.

I have discovered that even with a signed contract serious problems can still develop. Say someone owes you $10,000 and they decide they only want to pay $7,000. The legal fees and delays involved in enforcing the contract often result in compromise arrangements. Contracts are best for spelling out what each parties' expectations are: Who is going to do what. How it is to be done. What it is going to cost. And what variables change the cost.

Our contracts with clients generally specify a fee plus reimbursement of out-of-pocket expenses. Some design firms split their fee into design, supervision of typesetting and printing. We prefer to break our fees down by phase. This aids us in billing and makes it easier to determine the fee if a project is prematurely terminated. We do our best to keep ourselves competitive. For example, we often go out-of-state for printing if our quality standards can be met at a lower cost and within the agreed-upon time deadline.

As for new business, at present we rely almost 100 percent on referrals. We are, however, getting to the point where we are growing too large to leave new business to chance. So we are beginning to build a marketing function in order to actively develop business. We envision making cold calls, instituting a public relations program, developing self-promotion materials and possibly even advertising within certain specialty industries.

We have two problems marketing our services. The first is that we are perceived as being very creative. This stems primarily from our philosophy to create an image that relates to our client and not our own firm. Since our clients are each unique, so are the projects we create. This means that when a prospective client looks at our portfolio, they have difficulty imagining what we will create for them. Thus, our market is limited to the more sophisticated client.

Our other marketing problem is that our work is very diverse. We create identity programs, package designs, annual reports, brochures, collateral materials, and advertising. We design exhibits and are becoming increasingly involved in film design. So while GBA is relatively large, we don't do that much of any one thing. We don't specialize. For example, when we are bidding on an annual report, we are often competing with other firms that specialize in annuals, which puts us at a slight disadvantage in some ways.

On the positive side, we find that some clients like the idea of our being able to do many different types of projects. This also enables us to market ourselves to different departments within a client company. Additionally, we are less vulnerable to declines in one sector and can usually maintain a steady flow of work year-round. We are not overloaded in annual report season and quiet the rest of the year.

I think a design firm should either be very small or very large. Being midsize is difficult. And it is getting to be even more difficult. Medium size firms have as high an overhead percentage as large firms but many less resources with which to compete. Small firms, on the other hand, have a lower overhead. Our industry is still in its infancy. Down the road I believe mergers and acquisitions will create larger design firms, just as they already have with advertising agencies.

GBA is now beginning to branch out into other areas. We have recently formed a full service advertising agency (Fearon/GBA Advertising) and have invested in a film production company that specializes in movie trailers, TV commercials, and corporate films. We have also consolidated all the work that we do for the entertainment industry in a subsidiary called GBA Entertainment. We have, in fact, become an all-under-one-roof total communications source.

A question that often comes up in our business is: "How do you get a group of creative people to work together?" I think the trick is to bring together the competitive egos that seem to exist between designers. Most design firms are divided into cells with little or no cross-fertilization between designers. I believe that this stunts creative growth. We often structure projects with more than one designer so that teamwork is cultivated. A good example of teamwork in creating a superior product was the Beatles music. After their break-up, no single member was able to create as interesting or as complex a sound.

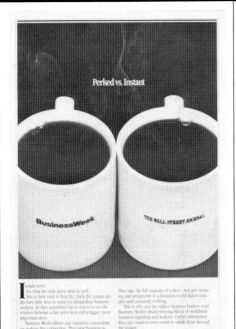

Beekman Downtown Hospital identity program.

Army recruiting identity.

Security Capital Corporation corporate identity program.

General Felt Industries corporate identity program.

GENERAL FELT INDUSTRIES

National Captioning Institute, Inc. identity.

Identity program for ESPN cable network.

THE TOTAL SPORTS NETWORK

HBO Premiere Films Identity

Business Week advertising campaign.

A PHOTO FINISH

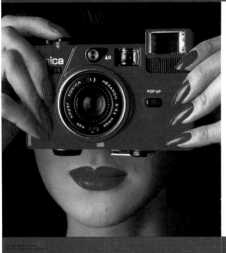

The best camera work deserves the best reproduction. The ultimate test is faithfulness to the original. Panaprint's blade-coated gloss surface is manufactured to perform consistently across the full range of printing requirements. It takes heavy ink coverage and unusual special effects with equal ease, and gives back snappy colors and precise details in return. Under the most difficult conditions, process color reproduction on Champion Panaprint is picture-perfect.

Champion International Corporation Promotional Brochure

ST. ANDREWS

PRIVATE ESTATE RESIDENCES

BOCA RATON

St. Andrews of Boca Raton identity and advertising campaign.

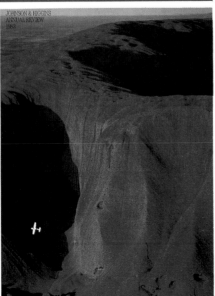

Johnson & Higgins Annual Report

A native of San Francisco, Jerry Berman was educated at the Academy of Art. Shortly after graduation he opened his own firm, where he concentrated on corporate identity, packaging, printed sales promotion, and exhibit design. He had already established an outstanding reputation as a designer when, in 1978, he formed a partnership with the renowned designer Nicolas Sidjakov.

In 1981, Flavio Gomez joined them, bringing with him extremely strong marketing credentials. The combination caused the firm to experience an immediate jump in sales, especially in the areas of large scale corporate identity and packaging programs.

Among the many design awards the firm has won are the Caldecott Medal, the New York Art Directors Gold Medal, Communication Arts Magazine and the AIGA award.

Sidjakov Berman & Gomez is a relatively new design firm of four years. Since its start in 1981, it's become one of the fastest growing design communications companies in the country. Having all been trained in design, we sharpened our marketing capabilities through real life experience. Together, the team of SB&G has more than 85 years of experience in marketing and design.

Nicolas Sidjakov and I each had our own design businesses before we became partners in 1978, while Flavio had been working for other companies before he decided to go on his own as a design consultant.

We met Flavio Gomez when he came in to interview us for one of his clients. Nicolas and I were so impressed with him we tried to hire him right then, but it wasn't until about six or seven months later that he decided to join our firm. Nine months after that he became an equal partner and we changed the name to Sidjakov Berman & Gomez.

Flavio is a household name in the halls of the great packaged goods marketers. His specialty is major brands backed by major TV campaigns . . . brands in which design costs are minuscule compared to overall introductory costs, but those designs must be exactly right or the rest of the costs are an expense rather than an investment.

Because of Flavio's experience, we have been able to jump very quickly into the corporate identity-packaging business on a national scale.

When Flavio joined us, we had twelve people working for us. We now have 31 and expect to have another 3 or 4 within the next few months. We have 10 designers and 6 production artists. All of our copy needs are answered by hiring freelancers. The normal facets of a growing business include bookkeeping and clerical departments; marketing people who specifically handle projects as account executives, and computerized operation controls.

Our designers are experts in packaging, trademark design, systems implementation, and handling everything from corporate identification programs to new product introductions for major packaging clients. We're also in involved in collateral materials and annual reports.

Welch's Orchard
Client: Welch's Foods, Inc.

Annual report
Client: Pabst Brewing Co.

Mac Farms Macadamias
Client: Mac Farms of Hawaii

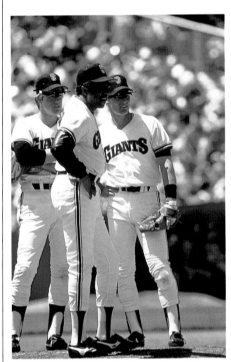

San Francisco Giants logo and baseball uniform
Client: San Francisco Giants

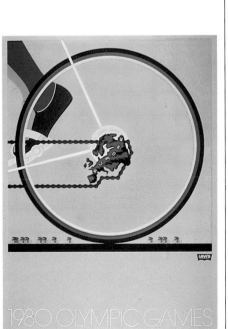

Poster for the 1980 Olympic Games
Client: Levi's

Bonner Brand
Fruit Basket
Client: Bonner Fruit
Packing Co.

Our account people are responsible for positioning the needs of the client as well as managing the projects. The primary function of both Nicolas and myself is creative (making sure that the design answers the marketing goals); we are always involved in client meetings and design presentations.

We're not the most expensive or the least expensive design firm, and we don't try to win new assignments on the basis of price. We feel our prices represent value received and that our design solutions work. And, we pride ourselves that we get most of our business by referral and repeat business from our existing clients.

After a client accepts our proposal, we all sit down and discuss the marketing objectives. Documents will be written so that we design to a set criteria that has been mutually agreed upon by all of us. Then we set up our design teams.

Nicolas and I get involved in creating concepts and participate very heavily in directing the design solutions. Obviously, there are moments of frustration when we are not getting exactly what we want, or a designer is not happy with our critique. But we don't have a big problem in that area. We're designers, and the other designers feel comfortable with our ideas. They might not always agree with us, but they respect our judgment. We discourage our marketing people from trying to make design decisions and we don't want our designers ignoring the marketing goals of our clients.

Most large design firms are run by marketing people. Some consulting groups have more MBA's on their staffs than designers. They tend to produce what we call the "matrix school of design"—logical solutions which fit all the research-generated criteria. Everything is in its place. The problem is that most of the client's competitors are designing to the same matrix, so that creative design does not have an opportunity to play its real role as a marketing tool.

We're not against marketing-oriented design. We are advocates of it . . . up to a point. Anytime marketing overpowers design to the point where it becomes ineffective . . . we draw the line.

One of the reasons for our rapid growth is that our clients recognize the difference. Some say our work is the best they've ever had. We fill a niche in our industry which provides "designer" solutions to marketing problems.

Chase & Sanborn Coffee
Client: Hills Bros.

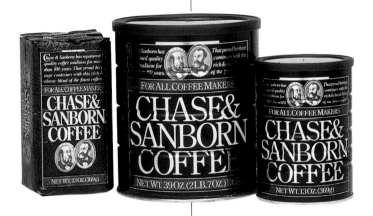

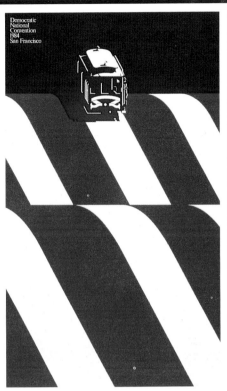

Poster for the 1984 Democratic Nat'l. Convention

*Mindshadow Computer
game package
Client: Activision*

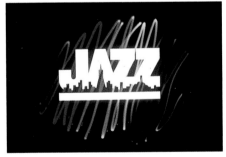

*Logo
Client: San Francisco Jazz Festival*

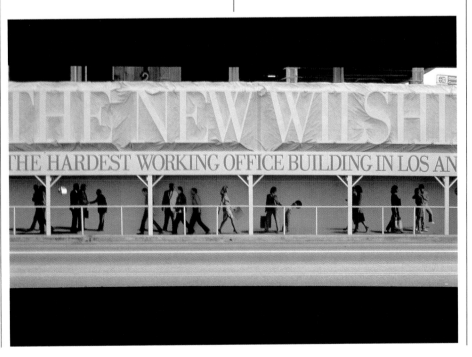

*Building barricade for new office tower in LA
Client: The New Wilshire (Developer Mahoney/
Sewell Associates)
The New Wilshire lettering is 6' high, 3-dimen-
sional and wrapped in canvas. People are painted
on the fence to depict life on the street.*

After graduating from college in 1957, Keith Bright began a professional career which, while it has gone through many metamorphoses, has always been consistent in the outstanding quality of the work produced. Bright and Associates, Inc., based in Los Angeles, concentrates on corporate identity, packaging, environmental designs and printed graphic communications.

The firm has won numerous design awards and has earned a reputation for producing work which is distinctive in solving particular marketing problems in highly aesthetic ways.

I started my own business in 1957, right after graduating from U.C.L.A. Initially, I was content to be the owner of a small design firm with only two to four designers. I was proud of the quality of our work and gratified to receive virtually every major design award. However, in a few years I became a partner in a wine business. I did all the packaging and all the creative work. Not creative in the business sense—I was clearly not a businessman—but the design, marketing, advertising creative work. During this time, the prospect of actually becoming a millionaire from the wine business had a profound affect on me. Although I continued to work as a designer on projects other than for the wine company, I was no longer satisfied just doing design. I wanted to be "really" successful. And success had come to mean something more than recognition in the design community.

Sure, awards were ego-gratifying, but I wanted something more. I wanted money. I wanted prestige. It was at about this point that the $1.2 million that I was going to make from the wine venture went to creditors! No more wine business. Once again I was a small graphic designer—but this time, with different goals. Now I wanted to work for large companies doing major design programs. But how was I to change from a "boutique" designer to a major design and marketing firm? How was I to do major work for major corporations for major dollars? By now I realized that my best shot at "success" would come from doing the only business I really knew—design. Now, how to make it happen?

First I decided that I needed marketing assistance. I met with Mike Agate, a veteran advertising/marketing professional. He became a full partner and president of our company: Bright & Agate.

I learned a lot from Mike. Our business grew. Within two years I had built a foundation for the kind of firm I wanted. But the management mix was wrong. In 1979 I bought Mike out and I became sole owner of Bright & Associates.

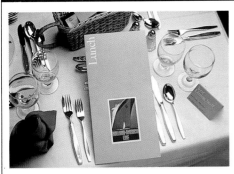

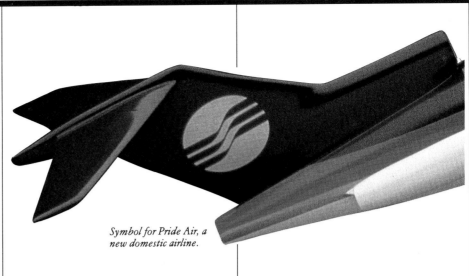

Symbol for Pride Air, a new domestic airline.

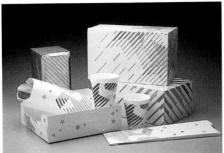

Upper: Holland America Cruises lunch menu. Lower: 1984 Los Angeles Olympiad food packaging program.

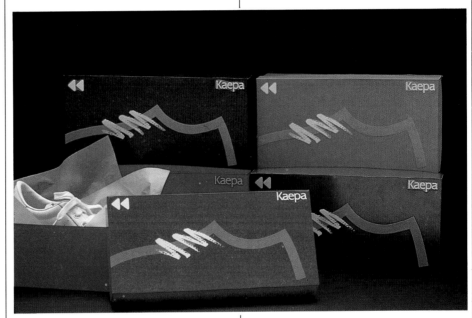

Symbol, logotype and packaging for Kaepa, an athletic shoe manufacturer.

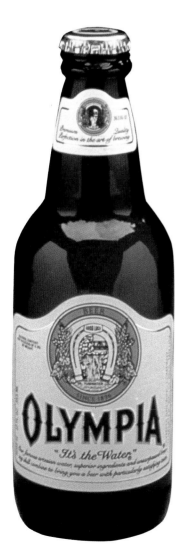

Olympia Brewing Company, revitalized product packaging.

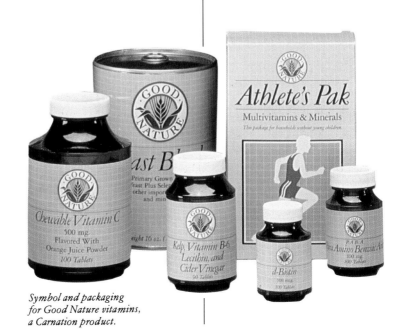

Symbol and packaging for Good Nature vitamins, a Carnation product.

Three years ago we picked up one account that totally changed our business. Because of this account, Holland America Cruises out of New York, my manageable staff of 25 grew to an unwieldy staff of over 50. There were 15 people in our New York office, 18 in San Francisco. Triple the profits. Weekly flights to New York. Trips to Europe. An enormous design program. A monumental amount of work. I worked too hard. Drank too much. Gained 20 pounds, and, having really "done" it, learned something about myself. I never wanted to do it again.

Today I'm still sole owner of Bright & Associates and we're a successful company. But it's been a slow evolutionary process and not without growing pains. Dave Goodman, a marketing/design consultant, helped me to understand and implement management systems for controlling and monitoring time and costs. Prior to working with him I always thought that timesheets were strictly for factory workers. In the process of growing from 7 to 25 people, I had to learn to understand fixed overhead, how to monitor job time and costs—what's feasible, profitable, desirable. I had to learn to let go—to trust, to delegate. And I had to learn where and when I shouldn't let go.

I made lots of mistakes but I learned from them. I learned that while systems are essential this is still basically a service business, and, as such, a people business. There has to be a balance of loyalty to one's own personnel and to clients. You have to accept that no one person has all the answers and there's always someone out there who might do a job better. I've accepted that I am what I am and I do the best I can with what I have.

I no longer want offices all over the country. I don't want to spend my life traveling around the world. I want to be in control of my life and my business—right here. Mostly I want to do good work, build on a manageable, profitable business. Twenty-five to thirty employees—no more.

Today we have around twenty-five people. Mostly designers, with two to three account executives, a sales and marketing team, four to five production people, a small billing group, and three to four clerical assistants. We also have a couple of computers.

The designers are in control of the "look" of the job. The project directors in charge of managing day-to-day activities and job profitability. Sales and marketing personnel together with project directors write proposals for new business. (We do no spec business!)

Once we have the job, we follow a surprisingly systematic procedure to complete it. First, we study the competitive marketplace—either through a visual audit or through management interviews with our client or both. Often this involves research among dealers, sales personnel and consumers/end-users. We evaluate the data and then, together with the client, define specific design criteria based on overall program objectives. Next we do a broad design exploration which is shown in its entirety to the client. Although we usually have a few favorites that we point out to the client along with a rationale for our recommendations, the actual narrowing-down process is a joint venture between us and the client.

Having narrowed down the designs, we then refine them and, together with the client, select a final design. After this, we implement the designs as necessary—that is, for packaging, corporate identity, brochures . . . whatever the required end product happens to be.

The process, while creative, is really pretty cut-and-dry. What's most important is this process works—for us anyway. I can't recall ever disappointing a client.

My advice to young people is to go to work for the very best designers they can and learn as much as possible as quickly as possible. Don't go into your own business too fast. For those designers already in business for themselves, I would say hire consultants as quickly as possible. Get help! It is too hard to learn it on your own. And it takes too much time. Perhaps most important, if you have your own business, keep your fingers in the business—all the business—the design, sales, financial, personnel. Yes, delegating is important—but more important is that as an owner, you must know what's happening in all areas of the business—all the time.

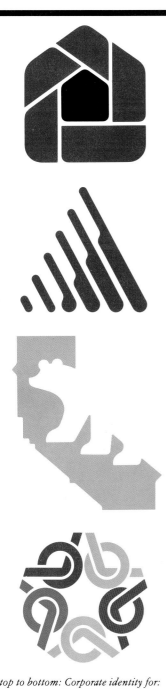

From top to bottom: Corporate identity for: Red Carpet, Ashton Tate, The Californias, and the Los Angeles Olympic Organizing Committee Alumni Organization.

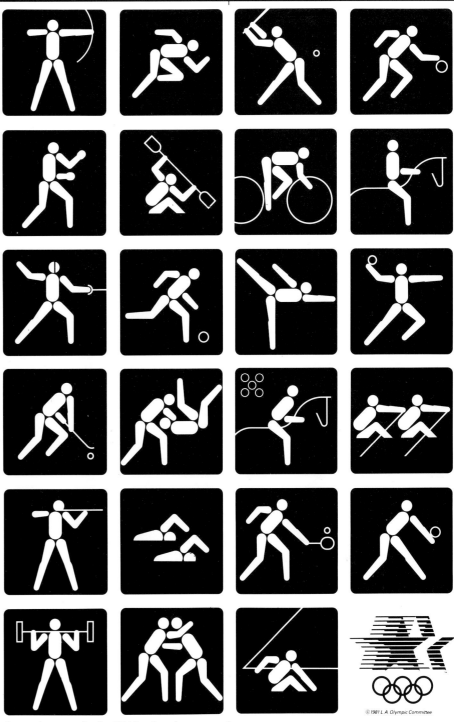

Event pictograms for the 1984 Los Angeles Olympiad.

© 1981 L.A. Olympic Committee

Kenneth Carbone and Leslie Smolan are principals of Carbone Smolan Associates, formerly the New York office of Gottschalk + Ash International. Both are graduates of the Philadelphia College of Art. Carbone was design quality control manager for the 1976 Olympic Games in Montreal before returning to New York to establish an office of Gottschalk + Ash International. Smolan joined the office in 1977. The firm specializes in corporate identity programs, annual reports, print communications, packaging, and architectural signage. Both Carbone and Smolan have received international awards for design excellence.

KC: When I opened the Gottschalk + Ash International / New York office in 1976, it was a very small operation—basically me and a few freelancers. No money, no clients. I was on my own for about eight months building a client base when Leslie heard that I was looking to expand and came in to see me.

LS: I was living in Philadelphia where I was teaching and running my own design business. I heard from one of my colleagues at the Philadelphia College of Art that Ken was looking for another designer.

KC: In fact, a lot of our growth has occurred through word of mouth. Not only in terms of staff, but business was generated that way. Certain designers, knowing that we were just getting started, would refer clients to us. Fritz Gottschalk would come down maybe one week a month to critique projects, or get on the phone to drum up business. But soon we started getting more work through referrals to us directly.

LS: In the beginning we had no idea of what a business plan was or how to run a design firm. We were under-capitalized, working in a very lean environment and literally worked eighteen-hour-days—but of course we were 25 and 26 at the time. I think surviving those times made Ken and me a very tight unit.

KC: In 1978 Fritz returned to Switzerland and everything changed. Leslie and I gradually bought out Stuart Ash's residual interest in the US corporation and Stuart and Fritz resigned as officers and directors. We had decided to retain the G+A name until recently, since we had expected more joint projects with the G+A network members. But, as the overwhelming portion of our work has been entirely self-generated, and based on our own reputation, we decided to change the firm name to reflect our ownership, keeping the G+A name for our international subsidiary only.

So by the time we bought the company we'd learned a lot about how to do business in New York. New York is a world unto itself, with its own unique set of rules. Elsewhere, some deals may be done with a handshake; in New York we discovered it's a very different story.

LS: I remember how excited we were when we hired our first employee. She was a woman who did mechanicals and was also our receptionist. A client of ours from a large advertising agency warned us "Everytime you add another person, you'll have to spend more of your time communicating. You'll never be as efficient as you are now."

And he was absolutely right. I'm not saying we are not efficient now but I am saying it takes time and skill to keep ten people all headed in the same direction, which means less time to design. That can be one of the most frustrating aspects to owning a design firm.

KC: Over the years we've developed systems to help streamline the administrative hassles. This allows us to remain active in the design process and not spend all our time as managers.

LS: For example, paperwork such as proposals, contracts and invoices can be one of the biggest time consumers. We've recently revamped our whole system for dealing with these so that we're more efficient and the client is better informed.

KC: We always use contracts which all our clients sign. They're not formal contracts, they're basically letters of agreement. The back section consists of boilerplate information, which defines design industry terminology for the client. It's a kind of glossary which prevents misunderstandings. The front section is a letter and of course is different for each client. We describe our understanding of the project and outline the exact project components.

LS: We break the design process down into three phases. The first is Project Analysis and Preliminary Design. Here we investigate a number of different design directions and present them to the client for feedback. When the client selects one of the directions we move onto Phase 2: Design Development. The second phase involves detailing the design. For instance with a brochure, it means preparing a full size dummy of the entire piece, or with a signage, preparing prototype signs.

In Phase 3 we prepare final artwork and manage all of the outside suppliers to ensure that they do their jobs according to our specifications. We're very concerned with quality control and our clients rely on us for this.

Our invoices are structured in line with our proposals. A client can always compare our invoices to our proposals. If

Brochure for food-related clients of Touche Ross.

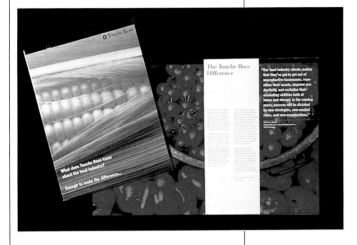

Signage for The Market at Citicorp Center.

300 page book A Day in the Life of Hawaii

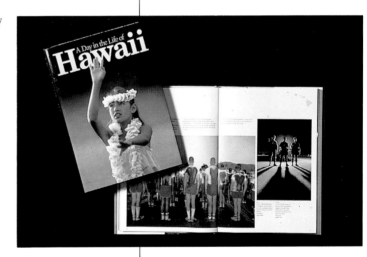

Spread from a brochure describing the sixty-six companies who listed on the New York Stock Exchange in 1984.

Brochure for Merrill Lynch's Bank Suisse.

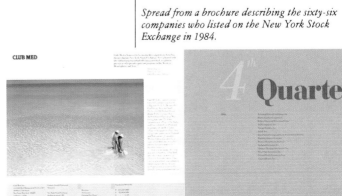

project costs are exceeded, we always let the client know in advance.

KC: We used to take a whole week to do a proposal. But since we got a computer 4 years ago, we've been able to standardize our proposals, which has added speed and flexibility so that if a client makes a change or request, we can respond to that immediately. We use the computer for all our word processing as well as financial planning, signage schedules, and mailing lists. We don't use it for accounting; our accountant has his own computer.

LS: Anything that helps to streamline a client's understanding of how we bill and how we expect to be paid is what we're really looking for. In this economy, getting paid on time can be a real problem. We've eased this by requesting one third payment up front.

One of the reasons our clients are willing to comply is that we have a clear system of detailing our costs.

KC: Once the contract is signed, Leslie and I review the project, discuss the criteria and decide which one of us is best suited for the job. For example, I handle most of the signage projects while Leslie handles a good portion of the print work. This doesn't mean each of us works alone, it means one of us takes final responsibility for a project while the other consults. We'll lay out the basic concept and then assign the project to one of our designers. We then check in at specific points along the way, to make sure the job is on the right track.

LS: Ken and I do the upfront thinking and work together to set the design personality. We try to determine how it should feel, how it should look and what the message should be. We define the context of the piece and give the project direction before delegating it to one of our designers.

The key to good delegating is planning! It's very important to know what you want to do and where you want to go before you hand the project over to someone else. When I am uncertain about the exact direction of a job, then my designers have every right to be confused. The design goes nowhere and we get stuck. With planning, each of our designers knows where the project is going and can function as a project manager. This kind of delegating frees us to direct a number of assignments at one time without getting

bogged down in the day-to-day management of only one. And each of our clients gets the full attention of a specific designer.

KC: I like working this way. It makes me feel more like an orchestra conductor. I actually enjoy the creative process much more now. Before, I used to spend most of my time managing the business and then designing at night. Now that I've learned to delegate, I can get involved at very key points only. I think I can give enough input at point A to get the job to point B. Then come in again at B to get it to C, and so on.

LS: Teaching is also a big part of what we do. We don't just give directions, we encourage our designers to think on their own. And not only about design. We try to teach them about the business aspects of our company as well.

KC: We have made it very clear to our people that the only way we can grow is to distribute the various responsibilities. Before, Leslie and I were drafting all the proposals, meeting with all the suppliers; paper merchants, photographers, and printers . . . some of these jobs have now been delegated to others.

LS: Here's a perfect example. Two of our junior designers came to us and said that they wanted to support the intern program at RISD (Rhode Island School of Design). We said "Fine, you organize it, you review the portfolios, you select the people and you manage them and tell them what their jobs are." They thought that was great, welcomed the responsibility and have done a good job. And by doing this, they've learned that the design business is more than putting pencil to paper. I wish that Ken and I had had that opportunity.

KC: And our office is now a perfect size for this kind of management. We wouldn't like to get much bigger than we are now. Ten is a nice number. It is not so big a staff that we can't move people around. If someone has been doing too much signage we can move him or her on to an annual report.

For some of our people this a first job and they're really growing here. They also have a lot of work to show for their efforts and they also have a lot of responsibility. It's unusual to gain that kind of experience so early on.

LS: In addition there's a good team spirit in the office. Our designers consult with each other and critique each other's work. If someone is up against a

deadline, we all pitch in to get it out on time.

KC: We work very hard to keep a positive atmosphere. To do this it's very important that Leslie and I communicate well with each other. We meet every Tuesday morning for an hour and a half outside of the office, just the two of us. We follow a standard agenda which includes a review of our cash position, projected billings for the month, receivables and accounts payable. This keeps us aware of what's happening in our business on an ongoing basis.

LS: At our weekly meetings we also look at short- and long-term goals. For instance we review staffing and work load, as well as the type of work we're doing now and the type of work we'd like to be doing five or ten years from now.

KC: Clearly, getting work is an important issue. We've finally realized we're our own best salespeople. When we meet a new client, we can discuss real design concerns as well as budget matters. We tried hiring a marketing person but it just didn't work for us. He didn't have enough of a design background. We've also tried some cold calling. But the effort you have to put into it doesn't pay off. The best source for new business is a referral from a satisfied client. Interestingly enough, we also get referred by people who weren't able to hire us but were impressed by our work.

LS: We do a little bit of everything to market ourselves. For instance, I'm active in an organization that helps me meet a lot of people in communications, which has also helped us get business.

KC: Also, entering shows and exhibitions helps. And Leslie and I are often asked to judge competitions. Such recognition from our peers assures our clients that our work is outstanding.

LS: If I had to say what the three most important aspects of design management are they would be: (1) To bring the same attention to detail and level of quality to the *business* of design as to the work itself. (2) To know what your strengths and weaknesses are and how they affect your business and (3) To retain your sense of humor . . .

KC: And especially number 3!

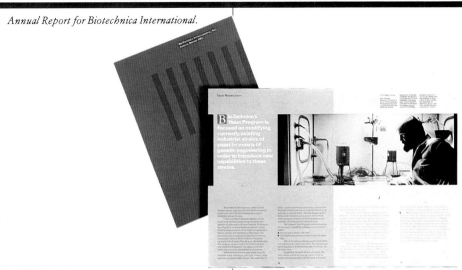

Annual Report for Biotechnica International.

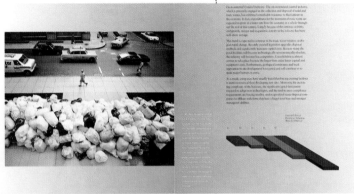

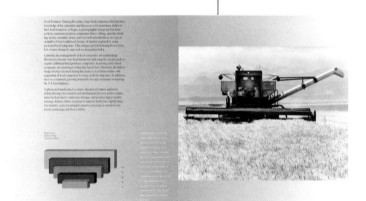

Brochure on Mergers & Acquisitions for Merrill Lynch.

Sign sculpture for Flatbush Avenue, Brooklyn, New York.

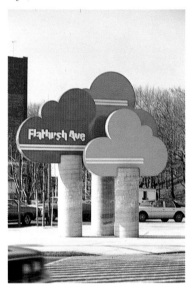

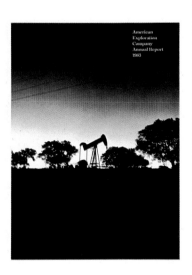

Annual Report & Quarterly for American Exploration Co.

Roger Cook and Don Shanosky are partners in the design firm of Cook and Shanosky Associates, based in Princeton, N.J. They first worked together for three years at Graphic Directions in New York. They left to begin their own firm in 1967, relocating to Princeton in 1978. Cook and Shanosky Associates is internationally recognized and is particularly well known for its corporate communications, including corporate identity programs, annual reports, collateral/promotional materials and advertising. The firm was selected by a special committee of the AIGA to develop symbols for the U.S. Department of Transportation to be used in all U.S. airports and other transportation facilities.

Cook and Shanosky Associates had its beginnings at a New York design firm called Graphic Directions, where at one time we were both employed. After working on many projects together, we started thinking about going into business for ourselves, which we did in 1967.

Our first office was on Park Avenue in New York City—a terrific address, but a space so small that we had to sit across from one another, with our drawing boards head-to-head. We used our savings to get things going, and had no idea where the first job would come from. We announced ourselves with an ad in GRAPHIS magazine, but that first job came from a friend of ours, an art director in Virginia. Others quickly followed.

Somehow, those desks facing one another as they did had an important effect on our relationship. During our entire 18 years of business, we have always worked on projects together. At times, we feel we are with each other more than with our spouses. When you consider the stress and pressures of being in business, not many partnerships have fared as well as ours; we really do have a fantastic business relationship. After the first five years, we moved to a new office on the Avenue of the Americas. The space was larger, but we still kept those "partners' desks," still continued to work together—and across from one another—on every job.

Our first employee was an assistant/receptionist, hired while we were at our first office. Our books were kept by Roger's brother; his wife did any typing we needed. We were—and are—very conservative businesspeople and have never wanted to hire anyone unless we were certain we could keep him or her on. This principle has been a guide in the growth of the company.

The decision to move to Princeton was a difficult one. We were both commuting several hours a day from New Jersey and Pennsylvania, and we were beginning to have serious questions about the toll that was taking on our lives. We felt that New York was the Mecca for communications and the center of good design, and that moving to Princeton would be perhaps a little like being put out to pasture. And we weren't sure whether we were established well enough to carry ourselves through the move and continue to grow.

Despite these reservations, in 1978 we relocated to downtown Princeton. The business never faltered, but continued to grow. We not only continued to receive assignments from New York, but we also acquired new clients from Philadelphia, New Jersey, and Connecticut. To help us handle the business, we have augmented our staff with a bookkeeper, a secretary, and four designers, as well as freelance mechanical support.

Everyone who has ever advised us about operating a design business has said that if you are good, you will grow, and if you grow, you will have to learn to delegate responsibility. We have found that to be a real struggle, though we knew the disadvantages of being small—of not being able to handle really important assignments. The problem isn't growth *per se*, but handling it it with ease and grace. Whatever our hesitations might have been, we feel good about it now; we can do so many exciting things.

The secret is that we have surrounded ourselves with people who are conscientious and who feel about design the way we do. We can't clone ourselves; there is never going to be another Roger Cook or Don Shanosky. So just as other people gave us opportunities, we are now giving a new generation of designers a chance. We have to share our responsibilities, or we will become stagnant, and there will be no growth for any of us.

As recently as a few years ago we were still doing too many things ourselves. When you have 25 or 35 client phone calls a day, you have no time to breathe. Yet you don't want your clients to feel that you have no time for them—each one should feel that he is your only client. So you have to take the calls.

Also, we were spending a lot of time outside of the office, seeing people. We were writing all the proposals and all the invoices. Today, we have people to help us with these tasks.

Cook and Shanosky.
House logo.

A capabilities brochure for Pickering, Corts &
Summerson, Inc., engineers.

Environmental

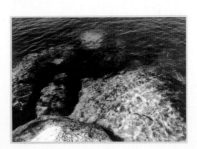

One of a series of calendars
produced by Cook and Shanosky.

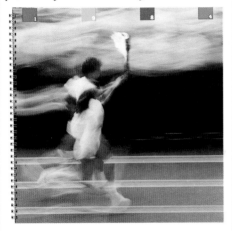

Educational Testing Service. 1984 Annual Report.

Search Services
Thanks to computer technology, ETS is able to help students and educational institutions "find" each other speedily through a number of "search services" that facilitate the admission process. Among them are these:
□ The College Board's Student Search Service, which was established in 1972 and supplies colleges with the names and addresses of high school students who match desired characteristics–SAT or PSAT score ranges, grade averages, and majors, for example–specified by the institutions. Janice Harvey, who manages the service at ETS, says it accounted for more than 32 million individual contacts nationwide in 1983-84.
□ The Graduate Record Examinations Board's Minority Graduate Student Locator Service, a free service to students now in its thirteenth year. Designed to identify minority students interested in graduate education, the service is used by about 20,000 students annually. Their names are reported to more than 200 graduate institutions that request information on the basis of a number of background variables.
□ The Graduate Management Admission Search Service, sponsored by the Graduate Management Admission Council. All who take GMAT are eligible to participate, and about 75 percent of those planning full-time study do participate.
□ The International Student Identification Service, now in its second year. About 50 percent of the international students who took the Test of English as a Foreign Language in 1983-84 opted to participate in this service, and they were matched with specifications set forth by 179 universities and colleges.
English Proficiency
Language is a formidable barrier to education for many Americans who are not native speakers of English, as well as for students from other lands. In a nation where English is the language of instruction, proficiency in it is of profound importance to student success. ETS provides a number of testing programs and services to assess English-language skills.
Chief among them is the Test of English as a Foreign Language, which was taken worldwide by 535,469 people seeking admission to U.S. universities and colleges in 1983-84. Russ Webster, who directs this program sponsored by the TOEFL Policy Council, says that figure represents a decline of slightly more than 2 percent from the previous year. Contributing to the decline, he says, is the tense political and economic situation in Nigeria, which has led all African nations in number of test takers in recent years. Last year, the number of Nigerians taking the Test of English as a Foreign Language dropped by about 80 percent, he says.
One nation registering increased numbers of test takers was the People's Republic of China, where both this test and the Graduate Record Examinations were offered for the third year under a historic agreement. The tests were administered three times at six centers last year with nearly 2,000 taking the Test of English as a Foreign Language, Webster says.
Another exam for nonnative speakers, the Test of Spoken English, is experiencing rapid growth, he says. Used primarily to assess the speaking and listening skills of foreign-born teaching assistants at colleges and universities, this test is also valid for foreign-trained nurses, pharmacists, and doctors of veterinary medicine who seek certification to practice in the United States or Canada.
Offered worldwide, the Test of Spoken English is administered in a tape-recorded mode. Tapes are forwarded to ETS, where trained specialists rate the

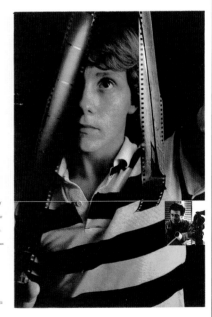

Make the most of
yourself, for that is
all there is to you.
Ralph Waldo Emerson

Vision of the Future

Symbol for the Center for
Housing, Building and
Planning, a United
Nations agency.

AT&T Bell Laboratories.
Special report on the
impact of information
age technology on society.

One of the biggest changes for us was to hire a marketing coordinator. It seemed there were a lot of situations which didn't really demand that one of us personally make a call or court an account. We have a portfolio and a slide carousel and some material that explains who we are and what we do. Our marketing coordinator now responds to these calls, although if it's potentially a major client, one of us will probably go along, too. Our marketing coordinator has also been a great help in getting out proposals, estimates, and schedules quickly, leaving us more time to design and service existing clients.

Cook and Shanosky has never gone out and beaten the bushes for new clients. We are a little afraid of that; it might put us in a position of having to lower our standards just to handle the increased volume of work, which is something we'll *never* do. Nor will we likely ever have account executives. We don't want to lose the closeness that exists today between us and our clients. Any one of our designers is capable of talking to and meeting with our clients, and our designers—including the principals—will continue servicing our accounts.

One of the terrific things about being in our business is that you not only get paid for what you do, but you also get a great deal of satisfaction. It's something like a musician feels after having given a good performance. You know your audience responded and liked the work that you did. We don't have to wait until after work to feel good about what we're doing—we can wake up in the morning and start living right away. Sure, there are a lot of problems, but every business has them. And the feeling that you get when you know you have done a job right is utterly fantastic. We feel fortunate to be in a profession that offers such rewards.

But there is also a business side to this business, and we have to concern ourselves with a lot of things far beyond design. We have to be businessmen and deal with the economics of running a business. For example, we manage a pension and profit-sharing plan which allows an employee to earn up to 25 percent of his or her income as a bonus at the end of the year—10 percent in pension, the rest in profit-sharing. We do this to make it attractive for people to stay with us. We want them to share the responsibility of our success, to benefit from it, to know that they are doing good work, and to make a decent living from it.

But how do we set a price on this work? And not just a price for work, but a value for a reputation? The products of all designers aren't the same, and a client who hires a designer also hires a mind with a certain value. You have to set a price for that. But you also have to realize the costs of doing business; you have to bill enough to make a profit and still give the client his money's worth.

So you have to start with basic operating costs—furnishings, rent, utilities, salaries—whatever it costs for you to be in business. Using these figures, you must estimate what it costs to provide each of your services. We have a price for mechanicals and production, and for production supervision—say, overseeing a job at the printer. We have a price for each designer, depending on his or her involvement and experience.

Although most clients want an up-front figure that they can plug into an estimate, we feel the fairest way to charge is by the hour. Some projects take less time, but a major project, like developing an identity program, involves a great deal of time, whether the client is large or small. But whatever the fee, we treat our clients' money as if it were our own. When we purchase services for their jobs, we can be very hard in keeping costs in line. We feel we're tough, but not unreasonable. Clients have given us that responsibility, and we have to look out for their interests.

In the everyday management of business, communication is of paramount importance. This begins with accurate job tracking, and we have always had job cards on which we record every day all the information about each job—who worked on it, doing what, how much time was spent, what supplies or services were purchased.

As a business grows, communication becomes more difficult. Everyone is going off to do his or her job, and information is not always clearly transmitted. So we have regular meetings every other week, where we all come in early and sit around a table and talk about our jobs. Everyone is there, from the principals to the bookkeeper and the secretary. We go over a list of every job in the house and see where it stands, what problems there have been, at what stage are type and mechanicals. Each person must talk about whatever projects he or she is involved with. That kind of communication is absolutely vital to the success of our work.

What we are trying to determine at this point is where the future will lead us, and how we can continue to succeed in this business. We have never wanted to be known as annual report designers, or as logo designers, or as signage people, or as brochure people. We do not see ourselves as generalists, but as graphic designers capable of solving a wide variety of communications problems—from annual reports and corporate identity programs to signage and capability brochures. Defining this goal and planning for it early on has helped keep us from becoming producers of only one kind of product, and this diversity has contributed significantly to our growth and success.

Symbol for Christian
Theological Education.
The United Presbyterian
Church.

Capabilities brochure. The Henderson Corpora-
tion, a construction firm.

Spread from the 1984
Cluett Annual report.

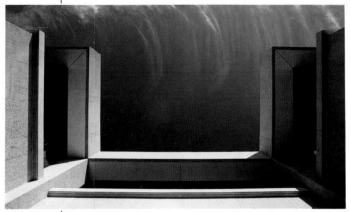

Smith Kline Pharmaceuticals.
Measles vaccine.

One of a series of folders
designed for Squibb
Pharmaceuticals.

Antibiotic News
from Squibb

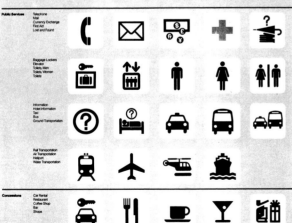

The Department of
Transportation. Poster
showing some of the
symbols created for a sys-
tem of international signs.

Logotype for a pharma-
ceutical mailing house.

After graduating from UCLA's School of Fine Arts in 1956, James Cross began his professional career as a corporate art director with the Northrop Corporation. In 1963 he formed his own company which now has offices in Los Angeles, Newport Beach and San Francisco. The firm's design work, especially in the areas of annual reports, collateral materials and corporate identity, have earned it a reputation as one of the most innovative design firms in the world. In addition to his many other design awards, Jim is honored to be a member of the Alliance Graphique Internationale, an international association of designers "who are regarded by their colleagues as having made a significant contribution to design not only in their own country, but internationally as well."

I started in business with no clients and not much money. But I had a lot of friends and had managed to build a pretty good reputation. My wife and I had just had our fourth child, just moved to a new neighborhood—and here I was starting my own business! I didn't know anything about business, as most artists don't. In the beginning, just to supplement my income, I went back to teaching at UCLA. I recall very, *very* well going from an excellent salary to practically *nothing*. It took me about three years in business before I was able to equal the salary I made at Northrop.

The company has grown fairly steadily. First I added one man, then a few more, now we are up to 23. We never did have a *big jump* in personnel, it was just a steady growth, adding just one or two or three people at a time. Also, we have never reduced our staff because of lack of work.

About four years ago, we opened our second office in Newport Beach, California, which is about 60 miles south of Los Angeles in one of the fastest growing commercial areas in the state. That office now bills an equal amount to our LA office. Last August we opened a third office in San Francisco.

I have never had a problem with ego, that I can recall, although I have had the problem of not getting things done just the way I want. The only answer is to hire really good people. Not only people who are good designers, but people who don't have ego problems and know how to work with clients and can call on them directly.

Because we have been able to maintain our quality level so well, there are always plenty of people who would like to come to work here. We get three or four résumés every week. When we do look for someone, which isn't very often, we have never had a problem finding an excellent person very quickly. When I am looking for a designer, I usually have two or three interviews with each applicant before I will make a decision. The applicant also meets with my key people, and we discuss the whole compatibility issue.

I want people who have social skills as well as design skills. Who know how to order wine. Who know how to dress. Like other businessmen, I place a lot of importance on these social skills.

There are also other important skills: design skill, which obviously is number one. Communication skill. Verbal skill. Production skills. However, the whole area of social skill is very important to me because my people represent me. Very often my client is middle management and will have to introduce us to his superiors. The clients want to feel that they are not bringing in some weird guy who is going to embarrass them. Unfortunately a lot of people today have very poor social skills. They don't dress well. They have bad manners. They don't pay attention to all the important little things.

I used to operate my business by instinct mostly. What was left over after all the bills were paid was what I made. If it was a good year, I considered myself lucky. If it wasn't, I didn't know how to change it. So I hired a management consultant to help me analyze the business. I told him, "So far we have been pretty successful and made a profit every year—but *I don't really feel I'm in control.*" I paid him $5,000 for consultation over a period of six months and it was well worth it.

The most important thing he taught me was how to establish the fee and time budget for every job. I never knew how to arrive at the percentage of the fee on each job to be allocated to overhead. Ours is 30 percent. This means that if we were to take a job that we were going to charge, say, $50,000 in fees and mark-up, $15,000 of that would have to be allocated, right off the top, to operating expenses. Since we want a 20 percent profit on a job, we allocate $10,000 for profit. There is now $25,000 left which can be spent in designer's time, freelance time, and staff time. Depending on individual salaries, which dictates hourly rates, this amount would dictate who could work on the job and for how long. Our rule however, is to work on a job we have accepted until we are satisfied, whether we will make a profit on it or not. But we have at least established a guide for estimating fees, and we can keep track of where we stand at all phases of the project.

Computer Automation. Trademark based on a modified circuit board configuration.

Cover for an in-house magazine for Fluor Corporation.

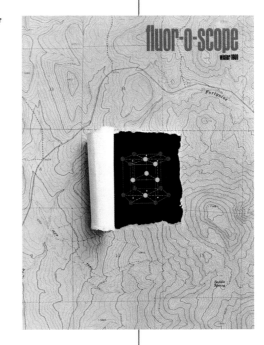

Picture Magazine. A limited circulation magazine that looks at photography as a fine art.

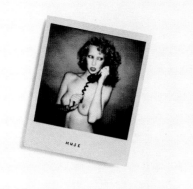

Issue 18 Tableau $10.00
Photography

Ingram Paper Company. Based on a stylized "i," formed from a stack of paper with the top sheet turned down to form the dot.

Monogram Industries. A conglomerate involved in several unrelated businesses.

One of the posters in a series created for Simpson Paper Co.

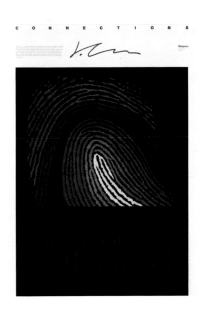

A spread from a development brochure for the Los Angeles Music Center. The painting is by David Hockney.

The price we quote for a job is determined pretty much by competition and by experience. We usually know what it will take to get a project. We are also very much aware of our operating costs, which help determine what our price will be.

One of the policies I have instituted, that seems to work well, is giving the design director a bonus based on his profitability. Getting back to that $50,000 job for instance, we said that $15,000 goes to overhead and $10,000 goes to profit. Actually we don't even call it profit. We call it retained earnings, because it is the money retained as working capital. Profit really comes after retained earnings. The design director knows that he will get as a bonus 25 percent of anything above the 20 percent already allocated for retained earnings. So at the end of a year, a guy can make a lot of money if he does good work, is efficient, knows how to direct people, and knows how to solve the problems quickly.

Again, our policy is that first, the job has to be done right before we worry about money, and second, I have to approve every job.

For twenty years now, our time sheets haven't followed an individual employee. They have followed a job. So if three people have worked on a particular job for two hours each, on a specific day, the initials of those three designers would go on the time sheet with their individual times. When the job is completed, we can then see, in one place, all the costs that pertain to that particular job without having to transcribe from individual daily time sheets.

Basically, in my mind, there are two aspects of a design business—the internal business and the external business. Selling, doing work for clients, billing it, and keeping them happy—all that is external. But then there is the internal side—running the business itself, looking at the bigger picture. I have a whole set of forms just to do that.

Personally I don't think getting my financial statement from my accountant really gives me enough information. I want to understand the financial condition of my company every month. Actually I could find out our exact financial condition every *day* if I wanted to. I have devised a financial summary which tells me *exactly* where everything is. I like to know how my receivables are doing. I like to know how much cash I have in the bank. I like to know what my payables are. Then I look at the total amount of fees to be billed for jobs in process, add them to the cash on hand, deduct the payables from this total, and the final total gives me a quick picture of the health of my company.

Then I look at our monthly fee billing and compare it to last year's, for the same month.

We *rarely* mark up the printing on our jobs. We usually recommend a particular printer to a client, let the printer and the client work out their own contractual terms, and have the printer paid directly by the client. We are paid a fee to supervise the printing.

Design directors take a job from beginning to end and are really completely responsible for it. They write the specifications, they obtain printing bids, they sometimes even write the proposals. They make presentations to the client. They direct other staff or freelance people. They supervise the printing and prepare the billing. This doesn't mean that I'm not involved, but it does mean that they take a lot of details off my back. I have seven people right now who do that for me. Under them are staff people who assist them but don't have the same responsibility.

There are 23 of us, in three offices, of whom 17 are designers, including myself. I also have 3 secretaries, a bookkeeper, a personal assistant, and a person who is responsible for generating new business. She is also responsible for some client-liaison work once she does get the business. Her background is in marketing. She writes pro-

posals, responds to any requests we might get from new clients, and generates new work by writing letters to prospective clients and following up on any response. She also helps direct a public relations effort for us. I also employ a PR firm to help me get some publicity.

Our marketing tools include a book, which took us about ten years to produce, and a slide show, which is not quite put together in as tight a form as I would like. It is used mostly to accompany my lectures.

I give five or six lectures a year to art directors' clubs and schools. It is a lot of fun. I meet a lot of people. I get to travel. But it doesn't really affect our sales as far as I know. I am talking to my peers, my competitors, but I do it because it's an ego trip.

On the other hand, entering shows is terribly important to a designer. For a lot of reasons. For someone who has been in the business only, say, three years and is still trying to build a reputation, shows can affect his future greatly. Out of the many thousands of graphic designers in the country only a thousand or so win all the awards. Out of that thousand there are about a hundred who do all the judging, make all the speeches, and comprise the leadership of graphic design in the country. I think a lot of people try to be counted in this group.

There are clients who regularly go to exhibitions such as the Annual Report Show and the AIGA show and often contact the judges and winners for business. We constantly get letters, inquiries and phone calls because of such exhibitions. So we know that it can pay off. You never know where your next project will be coming from, but if nothing else you will become well-known in your profession.

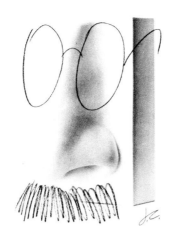

A few of the many project management forms used
by Cross Associates.

Spread from First Interstate Bank annual report.

Summit Management
Company, Inc., an
investment counseling
firm specializing in man-
aging large pension plan
accounts.

*Spread from a series of oversized brochures
designed for the Boy Scouts of America Develop-
ment Fund.*

Ditelo con gusto. Filare. From Simpson.

*A poster designed for the
Simpson Paper Co. to
introduce a new line of
paper.*

Richard Danne (r.) and Bruce Blackburn (l.), each recognized as a leader in the graphic design field, became partners in 1973. Danne & Blackburn, Inc. is a communication design firm engaged in annual reports and other publication designs, graphic identification systems, and editorial and film design. A subsidiary, Danne & Blackburn Associates, Inc., is active in the environmental and architecturally oriented design field. Danne is a graduate of Oklahoma State University and attended UCLA Graduate School of Design. He was a partner in Gips & Danne from 1964 to 1969, then was owner-director of NewCenter, Inc. before joining forces with Blackburn. He has served as president of the American Institute of Graphic Arts and is a recipient of the New York Art Directors Club Gold Medal. Blackburn is a graduate of the University of Cincinnati. He began his career as an assistant to John Massey in Chicago. After serving as a communications officer in the U.S. Navy, he joined Chermayeff & Geismar Associates as a designer in 1966. He became a partner there in 1972, but left the next year to form Danne & Blackburn. He is the author of Design Standards Manuals, *published by the National Endowment for the Arts and is currently Executive Vice President of the American Institute of Graphic Arts. Both Danne and Blackburn have been elected to the Alliance Graphique Internationale, a worldwide honorary association of designers.*

DD: It was still possible in the '50s and early '60s for freelancers to get plenty of design projects. Firms made up of partners who were both designers were just beginning to flourish when we first got started.

BB: Dick was in his own business at the time and I was working with Chermayeff and Geismar. We were looking at things from opposite poles. Dick was out there by himself and I was in a somewhat protected environment. We have now been together for thirteen years.

DD: Our getting together took a while and was not casually done. There is a message in this for young people: Do not go into partnerships in a cavalier fashion. It is a real undertaking. First of all, you have to have your business goals in mind. Second, one person's strengths have to fit together well with the other partner's and add up to more than the sum of the individuals. Finally, the partners must be able to get along and see the world in roughly the same way.

BB: When the two of us started, the projects were always short-term. We tried to fill our calendar with the best things we could. We were interested in doing projects that we could do well in order to get some attention and generate other projects down the road. We started with nothing. It never crossed our minds to capitalize our business by borrowing money from a bank. I think that was symptomatic of a more naive time.

DD: From the time we started, our goal was to do programmatic work. For a couple of years after we started, we were still doing mostly individual jobs—one-time things. We knew all along this had to change. It was one of the reasons we were together—to work on the larger programs.

We try to plan in a more offensive mode, working on the kinds of things that would be very good for us; then we control our market rather than have it control us.

BB: Today there is a lot more pressure than ever before on design firms to fit into a business matrix. If you are more than project oriented and you want to do more than just annual reports or brochures, you have to be able to offer a client more than brilliant design.

DD: When working for major clients, we have to respond on any number of levels to the bureaucracy with which we are working and make certain that we touch all the bases. In a sense, we live their lives with them while we are working for them, in order to get a product at the end that we can hold up and say "This is good!"

When you start on your own, you have to do good work, to attract new clients. You also have to make a profit and pay for the business. It takes a good deal of savvy and hard work to achieve this.

BB: We have always believed that a lot of what we do as designers lies beneath the surface; beneath the visible part of the design. Philosophically, we always believed that you can't do a good design job unless you truly understand what is going on, why it is being done and whether or not, in our estimation, it should be done at all.

I think it is fair to say that we are very concerned about editorial content right across the board. In fact, we refer to what we do as "communication design." It gives us a way of emphasizing the concern we have with getting the job done and making it work without sacrificing the esthetics. This can be seen in many ways: how you enter the assignment, how you manage it, how you come out in the end.

F.I.T. Continuing Education brochures

The U.S. gasoline market.
Uncompetitive?

Mobil

One of a series of NASA
Shuttle posters

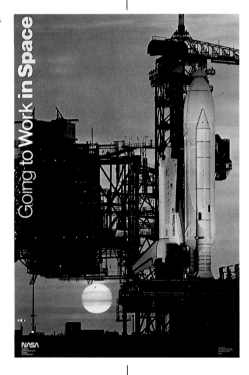

WilsonJones

Logotype for Office Prod
Manufacturer and

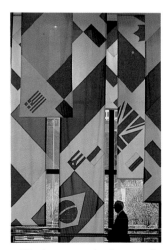

Symbol for the Young
Presidents' Organization

Owens-Illinois corporate headquarters banners

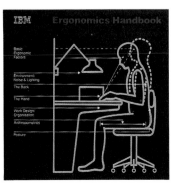

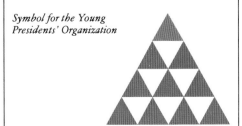

IBM ''Ergonomics Handbook'' cover

DD: Our rule is that one of the two of us is involved in every job the firm does. We also assign a senior designer to the core group. There is a production person who sticks with the job for the term of the project as well. We try to build a team that will give us continuity throughout a project. Keep a principal involved. Keep one of our designers involved on a day-to-day basis. Our entire staff carries a lot of responsibility for client contact.

BB: Due to the fact that most of our business comes either through referrals or repeat business from existing clients, more time can be put toward project management—making sure the jobs are handled efficiently and in a timely fashion—than cultivating new business through traditional sales efforts. Currently we have four people with major project management responsibilities, including the two of us. Other staff members take on project management as necessary, usually on an individual assignment basis.

DD: As far as handling personnel management, I think there is an equation of management ratio to personnel, which I believe is about seven-to-one. This might vary, depending upon the particular talents of that principal. Beyond that you find that you are just chasing your tail all the time. I think there are distinct limitations on how many people you can realistically manage and still enjoy your life.

BB: One of the reasons we are even as large as we are right now is that our interests tend to range a lot more widely than do those of most of our colleagues. We started with the notion that we were going to be a generalist firm and not become totally specialized. Sooner or later, if you are any good, comes the inevitable growth that you experience when you finally do get the opportunities that you have been working so hard to find. Then the business takes on a kind of life of its own.

DD: I think it is interesting that we have managed to maintain a generalist stance when it hasn't been that fashionable to do so. In almost every area of our business, specialization has taken root and is firmly in place. When you do the tremendous variety of jobs that we do around here, it can be a real juggling act. And we have continued to do that kind of juggling for a long time.

BB: We have managed to build a strong foundation for the business on the programmatic work that we do which is long-term by its very nature. We also have a number of clients with whom we have been able to maintain long-term relationships and from whom we can expect to do a certain amount of business over a given period of time.

DD: Based on these long-term programs and relationships, we have been able to formulate an informal plan on how we should proceed. Beyond that, we have behaved in a fairly experimental way in the last couple or three years. In effect we have created a new profit center by delving into project management as a useful and identifiable commodity for our clients. This is usually in the context of a relatively long-term project (six months to two years) where there is a very high budget on the production end. There is a lot of justification in situations like this, particularly because the clients are able to look at us not only as professionals doing something for which there is a given fee, but also as objective managers, helping them with the continuity of their projects, even to the point of assuming some financial responsibility for production.

BB: It would be unfair to suggest that we don't have hourly rates to help us estimate the costs on jobs, but I think experience is probably our basic tool, and our long-term relationships with our clients gives us a little more confidence when we are pricing our services. Obviously, we keep specific records on everything. And we try to keep the client apprised of the status of a project. Having worked with many types of clients in many different ways, our preference is to keep contracts fairly informal. Mostly they take the form of letters of agreement. We don't use a printed, formal contract at all, except in the case of a large government agency or similar institution where the requirements are already drawn. The proposal letter, more often than not, clearly spells out everything we will be doing and what is to be included in the project as well as estimates for fees and expenses.

DD: We try to hire people who have considerable range. If we just look at the portfolio alone, I don't think we could pull it off. We are very interested in their communication skills. Are they articulate? What is their presence? That is the only way we could do as much work as we do, while maintaining our standards.

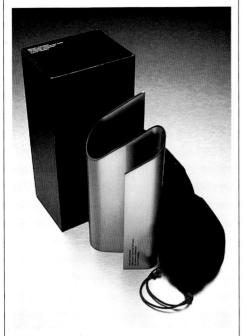

Bell Laboratories Distinguished
Technical Staff Award

South Street Seaport
Museum magazine

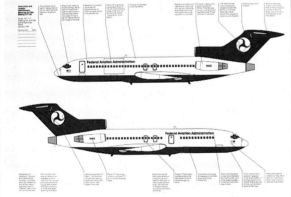

Federal Aviation Administration manual foldout

NASA

The NASA logotype, the
familiar symbol of the
space program, has been
applied to all NASA's
visual communications—
everything from station-
ery to the Space Shuttle

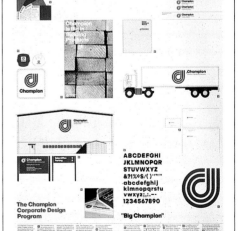

Champion Corporate
Design Program
Introduction poster

John Follis is president of Follis Design, which, from its inception in 1960, has been considered one of the nation's leading design firms, specializing in architectural signing, corporate identity, printed graphics, environmental design, and exhibit design. Follis received his training at Art Center School, where he studied under Alvin Lustig. Follis was appointed to the board of the California Design Council in 1974 by then Governor Ronald Reagan, is one of the founders of the Society of Environmental Graphics Designers and has been a board member of the AIGA.

Being located on the West Coast for all these years has not been easy. Outstanding clients are as rare as hen's teeth anywhere, but probably even more so out here.

In the beginning, as far as business procedures are concerned, we were very primitive. Our main concern was survival, so our business procedures consisted simply of billing and collecting. That was about it. There was no planning, no statistical tracking. We just "rolled with the punches."

We now employ between 17 and 20 people. Of that number, we have a bookkeeper, a timekeeper, a secretary-receptionist and a sort of general-all-around gentleman who helps to keep the place clean, delivers, keeps the slides and film equipment in good order, and assists in some production work.

The rest are senior and junior designers, production people, and, most important, project managers—all capable of wearing several hats when the situation demands it.

Our pay scale runs from $8.00 per hour for a junior designer fresh out of school to about $20.00 per hour for experienced senior designers.

For a long time we were like architects, multiplying our labor costs by two and a half times to determine our billing rate. Then we went to three times. Then three and a half. We finally dropped that, and now we charge a flat $60.00 per hour for everybody in the office, including myself, unless it is for consulting. Then I may jump to $150.00 per hour or more for my own time, depending on the situation. Our present flat fee billing simplifies matters for us and still comes out about the same as the old method.

The skills required to practice architectural signing and environmental graphics are quite different in many ways from those needed to practice printed graphics, I think. Also, the fees are usually much higher. A fee of anywhere from $50,000 to as much as $500,000 is not uncommon for signage work. Also, the projects are larger and take longer, sometimes lasting for one or two years.

As the practice of architectural signing is relatively new, determining the cost of design fees at the outset is virtually impossible without being allowed to first go into what we call our Phase I Study, which consists of planning and analysis. The fees for Phase I are normally 10 percent of our total fee. Tight preliminary, rather than schematic designs might add another 5 percent to 10 percent. In this phase we put together a report in which we list all graphic elements very carefully. Once we have this document, we can take a pretty good guess at what our fee would be to do the whole job. The only thing that might fluctuate in our estimate would be the amount of supervision that we may have to put into a job. The better the fabricator, the less extra supervision time is needed.

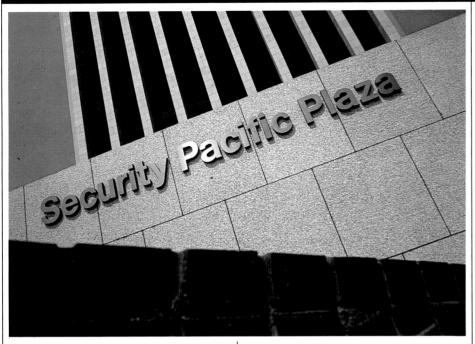

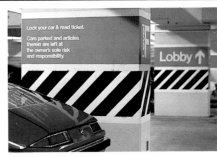

Security Pacific World Headquarters, Los Angeles.

*1985 New Year's card
Self-promotion for studio.*

Atlantic Richfield Plaza, Los Angeles.

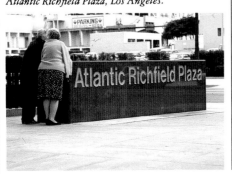

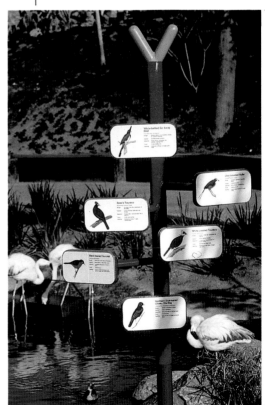

*Wild Animal Park,
Escondido, California.*

At the end of Phase I, we give the client an accurate estimate of our design fees, as well as an estimate of sign fabrication, plus or minus 15 percent.

At the end of Phase I, the design phase, we start Phase II, in which we give the client a fairly tight fabrication estimate. We don't do that entirely on our own— we bring in qualified fabricators and discuss the job with them. We then move on to Phase III, which is documentation or working drawings and specifications. These are similar to, but not as detailed as, working drawings from an architect. Our project-management system is the same regardless of the size or kind of project. A project manager in our office is responsible for approximately ten medium-to-large jobs at any given time. He or she usually does all the planning, coordinates all activity, monitors the budget, and is the client's daily contact in the office. We use our own forms, which mainly are daily time cards, budget control personal expense and change order forms.

All our jobs are reviewed once a week, sometimes more often.

We operate on both a fixed-fee and an estimated-fee basis. We prefer the estimated-fee, but more and more clients are pushing for fixed fees. Because they try to anticipate extras that will occur, fixed-fees are normally 20 percent higher. When the fixed-fee figure is exceeded any extra work is charged for, which necessitates keeping very careful records. Of course, there is an obligation on our part to advise the client before an overrun has been reached.

When we give a client a contract we are very specific about what we will do. We don't merely say "We will design a brochure for you." We say, "We will design a sixteen-page brochure, with two pieces of art (illustrated plans, charts, symbols, etc., etc.), which we will charge separately for." If that brochure goes to twenty pages, we charge them for the additional pages. Our estimates hold for six months only, after which time we reserve the right to review them and make a decision as to whether they need changing.

We have two basic contracts—a short one and a long one. We usually use the short one for small jobs and old clients and the long one for new clients or large, complicated jobs. But if someone comes to whom we are a little leery, we will use the long contract and ask for half the fee in advance even if the job is very small.

One thing about controls: I am proud of the fact that in our operation we try not to overdo controlling our designers. In other words, we don't drive our people up the wall. We tell them to do the best they can, even if once in a while it means we're going to lose money on a job. We would prefer to do that than to cut our quality in an effort to come in on budget.

Our business consultant, whom we hired about fourteen months ago, has stressed the importance of budget control, productivity, and planning. In other words, if you do your planning properly you shouldn't be surprised by shifts in demands for manpower or the ups and downs of business. By the time the demand comes, you would have already hired the people you will be needing and are ready for it. Planning is the difference between order and disorder. The more you know about where you are, where you are going and what happened to you in the past, the better off you are. At least in theory.

The Village of Woodbridge.

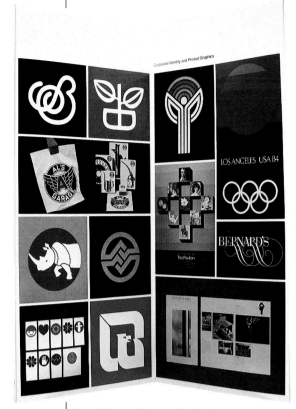

Spread from self-promotion brochure.

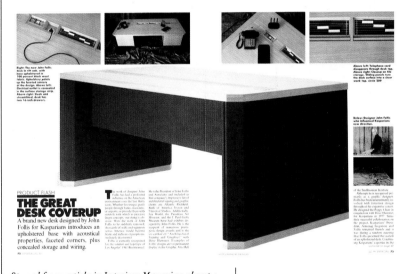

Spread from article in Interiors Magazine about a desk designed by Follis.

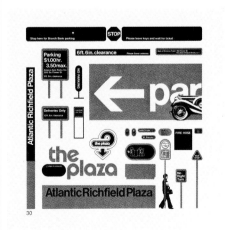

Self-promotion brochure.

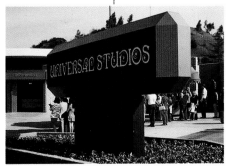

Universal Studios.

Colin Forbes is one of eight partners in the firm of Pentagram Design Ltd., which has been ranked among the best and most influential design firms in the world since its inception in 1972. In addition to his design activities he is also the group's executive partner internationally.

He was born in London in 1928. In 1960 he established his own design practice and soon afterwards joined with designers Alan Fletcher and Bob Gill to form the partnership Fletcher/Forbes/Gill, which eventually led to the formation of Pentagram, with offices in London and New York.

The other partners in the firm are architect Theo Crosby, graphic designer Alan Fletcher, industrial designer Kenneth Grange, graphic designer Peter Harrison, who works with Colin Forbes in the New York offices of Pentagram, graphic designer David Hillman, graphic designer Mervyn Kurlansky, and graphic designer John McConnell.

Pentagram started in London in 1962 as Fletcher, Forbes and Gill. We were individual freelance designers and we felt that we could present a better face to business as a partnership than as individuals. We each had good reputations in our own right. We were all in our early thirties. Alan Fletcher and I are British. Bob Gill is American and had relocated in London. In a way we were just following Brownjohn, Chermayeff and Geismar, who had recently joined together, and whose work had greatly impressed us. They were then doing work for Pepsi Cola. It was a very important period, I think, both for American and British graphic design.

We did one or two things that most designers, certainly in England, didn't do. We invested a lot in our offices, and we invested in self-promotion.

The business was very successful immediately. Everything was right. It was the early '60s. Things were changing in England. And the three of us were the perfect age.

After we had been in business for two or three years, and we had been obviously successful, we looked at the business and decided that we were doing something wrong. Half of our business was trouble-shooting for advertising agencies. These were jobs that came to us when an agency was either in danger of losing an account, or wanted to gain an account, or something of the kind. They would typically come in on a Friday and want the job by Monday. We were being used as a "hot shop." We felt that we were building somebody else's business.

So we took a hard look at ourselves and asked ourselves, "Should we be an advertising agency or should we be a design firm?" Because they were really two different businesses. Since we had neither the interest nor the skills to be an advertising agency, we decided that we ought to get more into the mainstream of design.

At that time, we had been working in collaboration with an architect, Theo Crosby. We were designing the graphics for an exhibition in Milan, for which he was the convener. We got on very well.

We reasoned that anybody who needed a letterhead also had some kind of environment. They had to have a showroom, an office, a shop or whatever.

And also, we knew that the skills of graphic designers, three-dimensional designers, or architects are often needed in combination, for example, on exhibitions. We decided that it would make sense to bring in Theo, who is a very unconventional architect and is very interested in graphics anyway.

The next stage in our development was that we got Cunard for a client. Then we were appointed to be the consultants for BP, Britain's largest oil company, which proved our multidisciplinary proposition to be correct. The BP project was to design service stations for the '70s. We just didn't have the kind of skills to develop the equipment, the pumps; and we hardly knew what ergonomics meant. Just as we had done with Crosby, we collaborated with Kenneth Grange, who is an industrial designer. We decided we would ask Kenneth to join us. When he did, we decided to change the name to Pentagram for the five partners. Fletcher found the name in *Roget's Thesaurus*.

Because we were giving up the goodwill of Fletcher, Forbes and Gill; and of Crosby; and of Kenneth Grange; we wanted to do something fairly important to transfer that goodwill to Pentagram. We decided we would produce a book entitled *Pentagram (the work of five designers)* that reproduced the work we had all done over the years. At first it was going to be just a promotional piece. Then I had the idea that wouldn't it be nice if we could sell the idea to a publisher? Then the book would be in bookshops and get the kind of circulation far beyond that which the normal promotional tool could ever get.

So we made a deal with a publisher. The initial pressrun of 5,000 copies sold out in nine months. And we sold 5,000 copies in the United States, which was a real surprise to us.

In 1978, we published *Living by Design*. We printed 24,000 copies of that book, which has been sold worldwide. It has even become required reading in many universities. We had discovered by accident that there are really no other books that describe the breadth of the design business for a first-year student just going into design.

The next big step was the move to New York. There were a number of reasons for it, some of them personal. I had

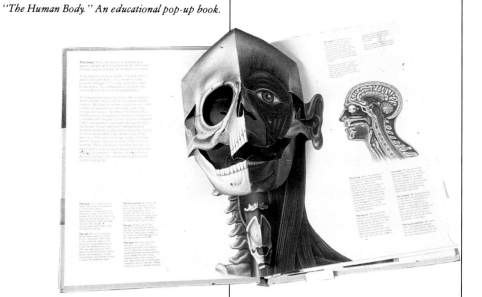

"The Human Body." An educational pop-up book.

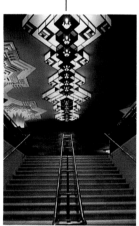

Gebruder Heinemann. A German company that retails duty free goods.

Unilever House, London. Pentagram was commissioned to renovate the exterior and interior.

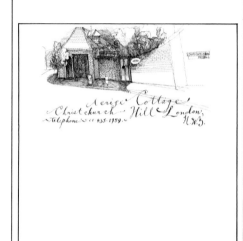

Stationery designed by one Pentagram partner for another.

MCI Communications 1984 Annual Report.

always wanted to come here, ever since I had visited 20 years before and had been absolutely mesmerized. I felt that we had made it only in the second division. That somehow or other New York was where it was. When I saw New York, it was the first time I had ever felt provincial. I was a London city kid, but this place threw me. I also felt that it would be wonderful if we could somehow recreate the enthusiasm and energy that we had when we started in England.

There were also several sound business reasons for becoming more trans-Atlantic. One, there is a lot of business in Europe for American companies. It seemed to us that we would have a better chance to get business in Europe if we had an American base.

Secondly, 50 percent of the Fortune 500 companies are located within the tri state New Jersey-New York-Connecticut area. This has to be the biggest market for design services in the world. Thirdly, there is an international market for design. We were doing a couple of projects for Japanese firms in our London offices at the time, and we wanted to do more. Also, we had expected the European common market to be a better marketplace. But it was a disappointment to us.

In Pentagram, we are all equal partners. We have to have meetings and somebody has to chair those meetings, but we try to keep formality to the minimum. We have created a very good system. I have had some good advice. Talked with clients or consultants or people who are interested in the theory of business. We have learned how to separate minor decisions from operational decisions and to decide what we will discuss at meetings and the things we won't. We discuss proposals and try to make decisions. We say, "Okay, we are going to do that job." And one of us takes the job and runs with it. You have to accept the fact that you shouldn't really be arguing all the minor points, considering you were a party to the policy decision in the first place. We have learned to do that fairly well.

The idea of trying to separate policy from operations is really quite important. We have operations committees for finance, for publicity, for administration. An individual partner will be designated one of these committees as his responsibility. These committees deal with all the routine problems: chasing debtors or deciding which material to send to *Graphis*.

When we meet as a policy committee, we discuss those things which are policy—what we should be doing in the next five years. We talk about the quality of the work going out.

Between the two offices we probably do $5 million in sales. It is probably divided two-thirds fees and one-third costs.

We charge everything on the basis of a 17.65 percent markup. However illogical that seems, the trade understands it. Some very smart guy worked it out one day. He got more than the 15 percent. I have done some work here for New York State and their standard contract says 17.65 percent will be accepted for typesetting. So it has become an industry norm.

We try to make 20 percent on time apart from the markup on costs. I think a lot of law firms try to make 25 percent or 30 percent. If we really made our 20 percent that would be a substantial amount of money on the volume that we do. But we are too concerned with quality, and once we have commenced a job, we do as much work as the project requires.

We are in so many different businesses. We do interiors. We do exhibits. We do product design. We do graphic design.

In the main, graphic design is billed on a lump-sum basis, a fixed-fee basis. Interior design is billed on a percentage-of-the-contract basis. A lot of industrial design is billed on an hourly-rate basis because the projects go on for such a long period.

In our system we don't care which method is used. We charge by all three methods according to which one the client is more comfortable with, or which one is more normal in the trade.

But we calculate, very accurately, a cost-basis, and it is the difference between this cost and the final sale that matters.

Every project has one partner directly responsible for it. He makes all the critical decisions with the client. He works out a contract and generally supervises the entire job. Most of us divide our own groups into smaller groups of two teams, and each of us supervises two or three senior designers. Then there is another level below that of assistant or junior designer.

The way I do it in my team is that I directly work with six to eight clients and each of my senior designers handles about four. But I keep a close eye on their work.

The open plan of our office seems to help us to discuss the jobs with each other easily. The danger in our system is that it could easily transform itself into eight independent businesses that just share space. So each partner must work very hard to communicate with the other partners in order to prevent this from happening.

It is even more difficult when you are trying to communicate between London and New York. So partners come here regularly. About once a month there is somebody here or there.

To summarize, I believe the success of Pentagram was inevitable because of the personalities involved. There is a collective ambition in there somewhere. We share an entrepreneurial spirit, an interest in business, and an interest in the kind of collaborative efforts that we find in a community of designers. We also have an interest in extension and in life in a big city, even though it is illogical. If we really thought, "Where can I make the best living, the most easily, have the best weather, or whatever," it probably is not New York, London, or Paris. And it certainly isn't running offices in two cities.

But on the other hand, we want a full life and we get tremendous benefits in terms of the energy created by living a more difficult life. So knowing us, we would have ended up here anyway. But I admit I sometimes envy the individual designer, and think, "Why do I need all this?"

Lead Development Association. A mark designed in association with events and publicity about lead(pb) and electric(+−) battery-powered vehicles.

A symbol for Fred To, who designs and constructs his own aircraft.

Wilkinson Sword "Royale" razor.

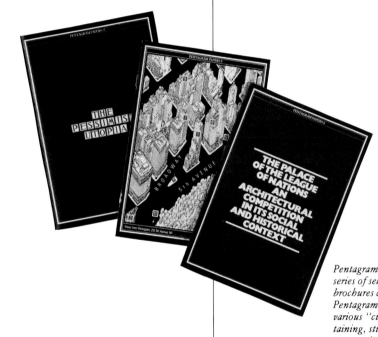

Pentagram produces a series of self-promotion brochures called "The Pentagram Papers" on various "curious, entertaining, stimulating, provocative and occasionally controversial points of view."

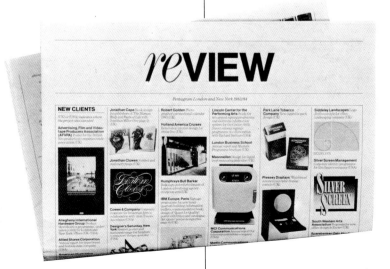

The "Review," Pentagram's "annual report" of their work produced over the previous year.

Commercial Bank of Kuwait, The star, a strong Islamic symbol, is constructed on the Arabic words for "commercial" and "bank."

TOM GEISMAR

Thomas H. Geismar concurrently attended Brown University and the Rhode Island School of Design. He graduated cum laude and Phi Beta Kappa from Brown and has a Master's degree in graphic design from Yale University. As a partner in Chermayeff & Geismar Associates, the New York design firm he founded in 1960 with Ivan Chermayeff, Geismar has been responsible for the design of over 100 major corporate identification programs. He and Chermayeff are also partners in Cambridge Seven Associates, an architectural design firm which designed exhibits for the US pavilion at Expo '67 in Montreal and created all the graphics for the Massachusetts Bay Transportation Authority. Geismar is a member of the Alliance Graphique Internationale. His work has been exhibited throughout the world and he has received numerous awards. In 1979 Chermayeff and Geismar were awarded the Gold Medal of the American Institute of Graphic Arts. They were 1983 recipients of the First International Design Award by the Japan Design Foundation.

Neither Ivan Chermayeff nor I had very much experience when we opened our own office. So the way we have run the business has been pretty much what we have made up as we went along. We have worked out systems for doing things which have been refined over the years and seem to work well for us.

Chermayeff and Geismar has four partners, all of whom are designers. We all like to do as much designing and as little management or administrative work as possible, though it seems difficult at times. We purposely have no managers or sales representatives or account executives. The partners share various aspects of those roles, and we are, of course, assisted by a full-time staff, including a bookkeeper, a billing person, secretaries, etc.

The office is based on a principle that Ivan and I have always felt strongly about—that our office should be a very open kind of place. There is a great deal of communication between the partners, and between the partners and the staff. Everyone is on a first-name basis. There is no formal structure, at all. Unlike Pentagram, for example, where each partner has his own staff, in our office someone may be working for one partner one week and another partner the next.

Aside from a few freelancers, there are about 30 people on staff. We would like to stay at this size. We have always felt that if we can keep our space small enough we will resist the temptation to bring too many people on board, and consequently incur more administrative headaches. There is a tendency to hire more people if you have the work. We think it is better to keep the staff smaller in order to take only the work that we really want to do.

We are pretty bad about meeting formally with our staff and talking about what they are doing. We realize you should do those things, but we don't.

On the other hand, we have often been told that there is a terrific spirit here. People are very willing to stay at night, they come in on weekends. They work hard and long and they become friends. I guess we are doing something right.

Basically we feel that we are a service business. We base our charges on how much time we spend on a project, everyone has to keep track of his time. If a project comes in which needs a budget, we basically try to determine how much time it is going to take to do the job in order to establish a price for the job.

We keep time slips and every week we hand these in. The time slips are put into a job jacket along with any expenses related to the job, such as photostats, typesetting, etc. If at any point we want to know where we stand on a job, it is a matter of adding up the various papers in the jacket. For the past year we have been using a small computer in preparing bills and job-status reports. While it has enabled us to have some information not previously available, we have not found it to be a timesaver or a costsaver.

Much of the work we do is continuing work for the same clients. In these cases we invoice on a monthly basis or at the completion of the project for the time that was required.

We sometimes work on a retainer, but by "retainer" we may mean something slightly different from what other people understand the term to mean. We use the term "retainer" to mean a fee to cover time spent in consultation. Time on the telephone. Time writing letters. The time spent discussing as opposed to designing. So even if we have a retainer, the design fees are calculated on the basis of time.

Each design staff member has a certain billing rate. That billing rate is a combination of their salary plus their benefits, plus our overhead percentage, plus a profit margin. In determining a budget we estimate their time and multiply it by their hourly billing rate.

Child Development and Mass Media

Making Children Healthy

Injured

White House Conference on Children.

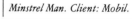

Mobil

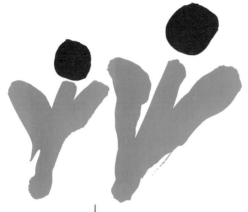

Minstrel Man. Client: Mobil.

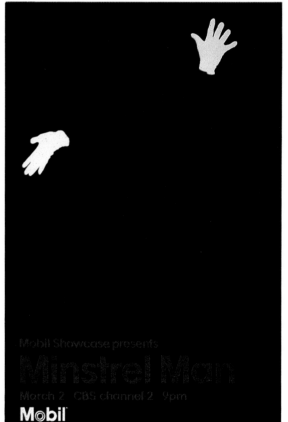

Mobil Showcase presents
Minstrel Man
March 2 CBS channel 2 9pm
Mobil

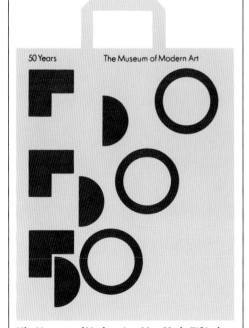

50 Years The Museum of Modern Art

The Museum of Modern Art, New York. Fiftieth anniversary shopping bag.

Street sculpture for 9 West 57th St.

Burlington Industries. Diversified textile manufacturing companies.

We figure 37½ hours a week as the norm. An employee might hand in his time slips for that week and there might be three hours of nonbillable time. A record is kept of these nonbillable hours, so that we know at the end of the year what the ratio is of nonbillable hours to billable hours.

Most of our contracting is done by a simple letter of agreement. Formal contracts are used only when we are doing a major exhibition or something for a government agency.

We like to control the quality of the printing, but we prefer to have printers bill the client directly. Partly, this is so because we want to emphasize that, like an architect, we are providing a professional service and not a product. We feel that we should be looking out for the client's interests, and be free to make demands on the printer, or even reject the printed piece if it is warranted. This is much more difficult to do if you are actually supplying the printing.

We try as much as possible to take a rather objective look at our client's needs. We look at design as a problem-solving activity, not an excuse to apply our latest ideas to whatever problems the client may have. If you look at our work you will see that it is very varied, because the clients are varied. Our clients are sympathetic to this attitude.

They trust us to do something that grows out of *their* needs, not *our* needs. There is a lot more competition now than ever before. Still, where the firm is headquartered counts for a lot. It is unlikely that a company that is headquartered in New York is going to go to Indianapolis to find a designer. It is more likely that a firm in Indianapolis would come to New York. But I think more and more clients are looking to local sources, and there has been a greatly increased regionalization of design and design firms.

We don't really have any formal marketing strategy. Occasionally, we will put together a brochure of our work, but it usually takes us years to get around to doing so. If we hear about some project that we are interested in, we make a phone call to see if there is any interest in our making a proposal.

We very much want to deal directly with the client. Even if someone in an advertising agency or a public relations firm recommends us for a job, as occasionally happens, we tell them right away that we would be interested only if we can deal directly with the client. It is just difficult for us to work in any other way.

I am not saying that any of these approaches are the right way to do things. I am saying that this is the way that we do it. Obviously it has been possible for us to work in this way only because we have been fortunate enough over the years to have potential clients call us about doing work.

The problem with relying on work that comes in only by referral is that you tend to be categorized and thought of for only certain kinds of projects. This is good if you like to specialize, but not if you prefer a broader mix of challenges. I guess that the problem I and many other designers have is that my day tends to be eaten up with all kinds of administrative matters, phone calls, or whatever, that make it difficult to have concentrated periods for designing. If there were some way for me to organize my life so that this wouldn't happen, I would certainly do it. I have great admiration for a painter, for example, who is able to just put the world aside and concentrate completely on what he is doing without interruptions.

I think there is a tendency for many designers to be too narrow. I think that design, as we practice it, requires quite a breadth of not only understanding but interest. For example, in order to work for large businesses, you have to understand their problems. A designer needs a broad range of interests. The kind of business that is taught in design school is more about how to manage your office and so forth. I think a student would be better off studying English, history and math than how to manage an office. That can be learned later.

If you look at it in its broadest sense, graphic design is both fun and interesting. It can also be a pretty good business.

Xerox Corporation.

XEROX

The Chase Manhattan Bank.

Official symbol of the United States Bicentennial.

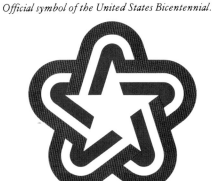

BEST

*Best Products Company,
Inc. Catalog merchan-*

The American Film Institute

BRENTANO'S

Brentano's. Book & gift shops.

American Film Institute.

*Seatrain Lines.
Container shipping.*

Jerry Herring, born in Iowa in 1946, attended Minneapolis School of Art and graduated from the Kansas City Art Institute in 1969. From 1969-1971, he worked for Stan Richards and Associates, a graphic design firm in Dallas. Herring moved to Houston in 1972 and worked with Baxter & Korge and the Kelvin Group Partnership. In 1973, he formed Herring Design. For a brief period the business was a partnership with Woody Pirtle. The studio today consists of five people and specializes in brochures, annual reports and trademarks.

The work of Herring and the studio has been the subject of articles in Communication Arts magazine, Print, Idea, The Kansas City Star and The Houston Post. Herring is past president of the Houston Art Directors Club and is currently president of the AIGA-Texas chapter. Beginning in the fall of 1985, he will serve on the national board of directors for the American Institute of Graphic Arts.

I was fortunate enough to be hired by Stan Richards. That was the best thing that ever happened to me in my working life. For designers, their first job is their graduate school. If you are lucky enough to get a job someplace where you can really learn, you are way ahead. For instance, in school we would take four months to do a logo. At Stan's we had three days.

I worked for Stan a couple of years and then I was accepted at the Yale University graduate school. Took a nice car trip up to Yale and had a wonderful time.

As soon as we arrived, we found out my wife was pregnant. I had no intention of being both a father and a student, so we just turned around and came back to Texas. We like to joke about that being a two-week vacation with all our furniture.

I decided to try to find work in Houston because I had already worked for what I considered to be the best place in Dallas. So in 1971 I came to Houston and went to work for Baxter & Korge.

A short time later, two different studios were trying to form a third company to handle their overload. They hired me to be that company. They gave me their overload, plus a percentage of the income I could generate myself. That was the best training in the world. What they were teaching me was how to run a business, because when I would go out and get work I would have to check everything out with them. "What would you charge for this?" "What is this worth?" They were giving me very good advice.

This arrangement probably could have lasted a long time, but we started to get into arguments about which clients were mine and which ones weren't. Also, I began to get so much work that it began to squeeze out theirs, which kind of defeated why they started it all in the first place. That is when I went out on my own—in 1973.

When I started on my own, I was strictly a freelancer. One person. All my work was for agencies because the agencies had art directors and they were quick sells. They understood if you were any good or not. Eventually these agencies would give me referrals if a job was too small for them to handle.

Working for an agency was always frustrating, but I have to say that it was a simple relationship. You would do some things that you didn't necessarily think were right, and you thought that if you could only have talked to the client you might have done them differently. But there was no way to get to the client.

However, the money was always right up front. The agencies knew the value of work. When I started to deal directly with clients, I started to do better work but the money became more of a problem. A lot of the clients had no idea what anything was worth. Everybody and his brother has a 35-millimeter camera, and I am in there telling them it costs $750 a day for someone to take a few photographs. It was real hard to understand. Also I was picking up a lot of clients who could not see why one printer should cost two or three times as much as another.

I just tried as hard as I could to sell quality, quality, quality. A lot of times the connection was never made. That is when it dawned on me that I was going to have to stop generating projects and start generating relationships.

I started putting all my energy into really servicing an account that I thought was good or had real potential. I began to see how important it was that I start generating ideas for them. If they asked me to do a small facilities book, I would also look at other ways that I could help them out, even if I had to do them on a speculative basis.

The first big break was when Rice University became my client. I did their work for six or seven years. The budgets were small but the work was steady. It was a good relationship with plenty of give-and-take—just perfect for a small studio.

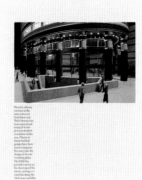

Gerald D. Hines Interests leasing brochure for a new office building located in Manhattan. Its name and address are the same.

A brochure produced as a dramatic way of saying "thank you" to a client. It pictures all the people who contributed to the marketing brochure pictured above.

Tachycardia

Bursts of rapid heartbeats threaten the health of 1.5 million people in the U.S. each year. 300,000 die. Now there's hope for a solution.

Intermedics is the only company to receive FDA approval for commercial distribution of an automatic implantable anti-tachycardia device.

Spread from the 1984 Intermedics annual report.

135

I have fewer clients now than I had two years ago, and I have half as many as I had five years ago. But I am doing more work and more dollar volume. I have better clients who spend more. Really that gets back to the servicing aspect of it. I now have two, three, or four clients who spend enormous amounts of money with me and with whom I really spend an enormous amount of time.

I price projects by lump sums. A lump sum for design. A lump sum for photo direction. A lump sum for this and for that. I will estimate each piece separately, but my estimates are not based strictly on hours. We don't keep any time sheets. The fees are more or less what I believe the market will bear for that piece, for our studio.

A lot of my profitability comes from my ability to work efficiently, quickly, and to keep waste to a minimum. I basically have a "work to please" attitude. Once I give someone a price for a design, I work with them until they are happy with it. So there is some risk in there on my part. But in using someone like me, the client is paying a premium and they are expecting to get a premium product for their money.

I think my strength is reading a client and solving a problem in a way they are going to like. I really believe that most of my design is done in my clients' offices. When a project is explained to me, I usually leave with a real sense of what I plan to do. If ideas occur to me while we are talking, I will bounce them off the client and sort of test myself to see if that is where we should go.

Later, when I bring the layouts back, I don't set up a presentation and go through a big dog and pony show. I generally sit down on the same side of the table with the client and go through the whole project with them. My normal method, especially in brochures, is to comp-up two or three spreads—real high comp with the exact type; colors; maybe a photograph similar to what I am going to use—then the rest of the job is in thumbnails. The comp is mostly for them to get a sense of what it is going to look and feel like. The thumbnails serve as the organizational, problem-solving flow.

Anytime I show a design, I am also presenting prices to produce the job too. Clients really can't tell whether a job is what they want unless they know what it will cost them. A lot of times, early on, I will ask the client if they have a budget in mind. If they don't, I still try to get a sense of where we are, cost wise. But if they tell me they have a budget of $30,000 and I get something costed and it comes out to $34,000, or $42,000, or whatever, I may adjust what I am going to show them. Or I may decide that this is really the right approach, and when they see it they may change their mind about the budget.

It is kind of like going in to buy a car. You want to spend only $20,000 but over there is a car for $24,000 that is fabulous. You may move up to that. But if I ask you directly if you will spend $24,000 for a car, you would say no.

We do an awful lot of self-promotion, soft-sell promotion. We have done the Herring Design Quarterly now for three or four years. It grew out of other things that we had done before. It has really been very effective. We get a lot of referrals from people we have never dealt with. When I meet someone, we exchange business cards and I put them on my mailing list. I have a mailing list of 400 or 500 people. I probably work for only eight of them. The mailing list consists of friends, acquaintances, people we have met. It is really sort of a way of keeping in touch, not only with friends in the community but business prospects. There is no doubt that some of the things that I send out probably go right past them. They don't understand, even vaguely, why I even did the piece. But I also get some really nice warm comments back, and even a few referrals, which is how I get all my work.

Relationships with bankers are very hard to come by. I have a banker now who will lend me money without even knowing, specifically, what projects I am working on. I can't imagine anybody loaning a graphic designer money to start out. I think he would be one of the worst risks anyone could take, because all you are really loaning somebody is money to pay themselves. Since most graphic designers have pretty expensive tastes, the money doesn't last very long.

If I had it to do all over again, I think I would have hired some people earlier. I worked by myself too long. Perhaps this was because financially I am very conservative. I tend to want to be certain that I can afford to do something before I do it.

I can't emphasize the importance of relationships too much. We do work for a large land developer here. Because we are so knowledgeable about his business, we know so well how he likes to market himself, we were able to bill about $100,000 gross last year on projects he didn't ask for. We are constantly looking for ways, not only to make more money for ourselves, but to answer the kinds of problems he might have before he even thinks about them.

When I first started in business I did most of my work for my friends, people I had known in other studios. I think it is terribly important when you start your business that you have some decent-sized account in your hip pocket. Somebody that you know. Somebody that you have been able to get close to and somebody that you are going to be able to work with. After that, I think the most important thing is that you try not only to do good work but that you try to be what I think a designer is, first and foremost—a problem-solver—so that you are doing what is appropriate for your client. That's the best way to keep a client and build a long-term relationship. I think a lot of designers go out on their own because they want to be stars or they want to do slick graphics, or they want to be in the magazines, or whatever. This is terribly wrong. If a designer wants to get anywhere, he has to realize that his most important job is to solve other people's problems.

The Herring Design Quarterly, a series of witty self-promotion brochures on various subjects.

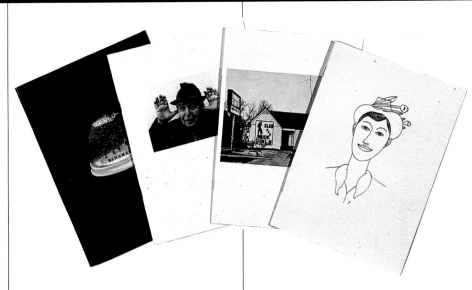

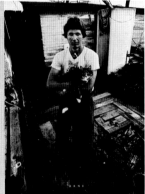

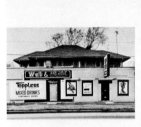

In the heart of every prosperous city there is always one building that reflects a business district's past triumphs as well as its future promise. In El Paso, that architectural landmark is The Centre.

A comprehensive restoration of the historic old downtown White House Department Store and Hotel McCoy, The Centre now has even surpassed the prominence it enjoyed as a commercial venture when the structure first opened in 1912.

Designed at the turn of the century by Henry C. Trost, the building, now listed on the National Register of Historic Places, is an outstanding example of the Chicago School of Architecture. Trost followed in the footsteps of his noted contemporaries, Frank Lloyd Wright and Louis Sullivan. He was also greatly influenced by Spanish Mission Architecture incorporating the use of ornate iron work—a popular regional feature in the early 20th century—which is now fully restored on The Centre facade.

As envisioned by Al Lum Properties, the redevelopment of this historic site into the finest quality office and retail space integrates the charm of the building's original exterior with an innovative, contemporary approach to its interior space. The Centre is designed to tastefully blend El Paso's heritage with its ever-expanding role as a progressive, energetic Southwestern city.

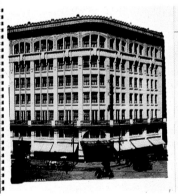

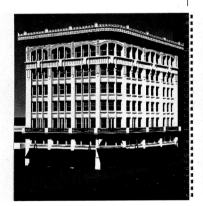

Situated downtown on Mills Avenue at the intersection of South El Paso Street, The Centre is at the very crossroads of the city's commercial district. The renovated structure now offers El Paso business professionals more than 136,000 square feet of quality office and retail facilities.

Overlooking Pioneer Plaza, the gleaming white facade that has long been a tribute to the city's proud history has been authentically restored to its original style. Wrought-iron grillwork, originally patterned by Trost, graces the third floor balcony level of the building's exterior. Street-level awnings, in rich green, accent The Centre's arched entrance, just as they did when the building first opened. The crafted glass look preserved in the structure's mezzanine-level windows is also a reminder of the special characteristics of a by-gone era.

Housed within this graceful framework, modern materials in a traditional setting mark a smooth transition from the elegance of yesteryear to present-day functional office and retail needs.

Al Lum Properties.
Leasing brochure for
The Centre, El Paso.

137

Kit Hinrichs is one of five principals in Jonson Pedersen Hinrichs & Shakery, a communications design firm with offices in New York, Connecticut and San Francisco. During his 20 years as a designer, Hinrichs has been a design consultant to numerous corporations, including Atari, Champion Paper, Crocker Bank, Potlatch Corporation, Royal Viking Line and Warner Communications. He is the recipient of numerous awards and was listed by Idea Magazine as "one of the important American graphic designers in the past 25 years." He has been an instructor at the School of Visual Arts in New York City and at the Academy of Art in San Francisco and a guest lecturer at numerous other colleges and universities.

Twenty years ago, when my partners and I entered the graphic design business, we were still considered commercial artists. There were few graphic design offices as we know them today.

I went to New York when I graduated, like 90 percent of the people in our class. I had every intention of working as an art director in an ad agency. But then I discovered this new area of graphic design beginning to emerge, and it sounded fabulous. Names like Herb Lubalin, Milton Glazer, Arnold Saks, Tom Geismar, and Ivan Chermayeff were being mentioned as important leaders in this new field. I was a fresh scrubbed kid from LA in the wicked city, and it was all very exciting.

I worked in two small design offices briefly. Then, at age 23, I started my own firm with a partner, Tony Russell. We both had a few free lance accounts at this time, and we were pretty naive. So with $300 between us, which we used for one month's security, we rented an office and bought two-dollar chairs from the Salvation Army. We put doors on sawhorses for tables.

I would not recommend to anyone that they do what we did. But, wonder of wonders, we did pretty well and grew very fast. In a matter of seven years, we had about thirteen people working for us.

But what was happening to us, I think, is what happens to many young designers. We were not mature enough, at that time, to be able to manage the designers we had working for us to enable them to produce the level of work we had produced ourselves.

Tony and I were both becoming purely account people, working 18 hours a day. We would go out, have meetings, talk to people, come back to the office, and turn the job over to someone else. But because the job had a deadline, and we had a lot of overhead, we had no choice but to let the job go. We were growing too fast and getting too much work. More work than we could really handle well, and we didn't know when to say "Stop!" The quality of the work was suffering. We were working longer hours. We were taking home less money. Our overhead was so large that the only thing on our minds was getting enough work to stay afloat until next month. There didn't seem to be an end in sight. It was not a wonderful time. Eventually it all overwhelmed us and we separated.

My wife, Linda, is a graphic designer also, so at this time she and I opened a new office called Hinrichs Design Associates. A couple of interesting things happened to us at that time. We had been doing some work for *McCalls Magazine* on and off. They asked us to design a special eight-page section in the magazine. A regular monthly project like that, with the kind of exposure that it gave us, together with a couple of other nice breaks, put us on the map. Warner Communications became a major account as well as West Point Pepperell. We were established as a firm that did a certain quality of work and we had reached a point where we could attract a high level of clientele.

It is hard to tell why success comes when it does. Perhaps because we were designing things that were a little different from the standard eight-and-a-half by eleven, Helvetica, flush left material. I think some corporations were beginning to realize that they were starting to look too much like other corporations, especially in their annual reports.

We continued to refine what we had been doing for a number of years. At some point, it all started to click and say, "This is a very special look." We tried very hard to engage the audience in whatever we were working on.

Spread from the oversized Nature Company Catalog. Actual size of the spread is 21³/4" x 27¹/2"

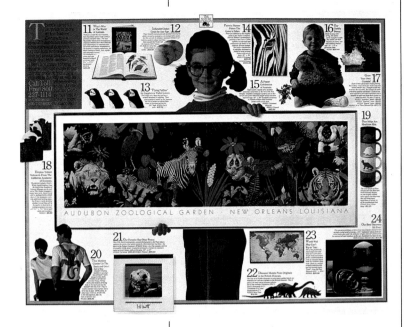

Champion Paper Co. Calendar.

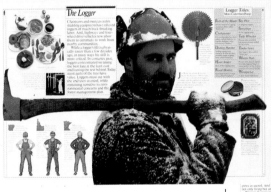

Spreads from the 1982 & 1983 Potlatch annual reports.

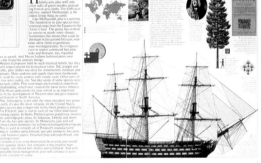

Poster for the AIGA California Graphic Design Exhibition.

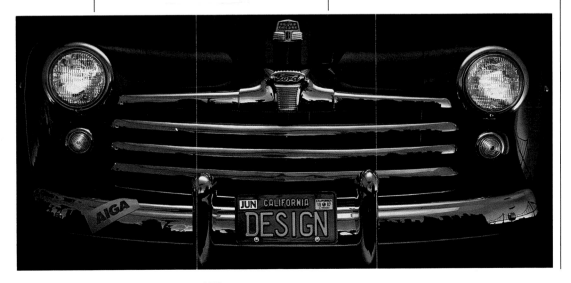

One thing we did naturally, that turned out to be good for us, was that we were always very concerned about our client's needs. What they thought, what their point of view was. We never put our needs before our client's needs.

There were many times when we lost money on a job, but we never stopped working on it just because it became unprofitable. If it took us more time to make the job better, we would take the time.

I think that the adversary relationships that some designers get into with their clients get them into trouble. Most of the time we have been able to persuade our clients that when they bring us a box of terrible photographs and say, "Make a book out of this," they are only defeating themselves. If we can get them to identify their real goals and to understand that this kind of material won't help them achieve these goals, then we can usually get them to let us show them what will. Ninety-nine percent of the time, as long as you are dealing with their ultimate goal, they can be persuaded. If you throw up a brick wall and say, "We won't do that," then you obviously force your client to take an equally hard position. "You *will* do that, or I will get someone else!" You can never win back the trust that is required to create good communications.

In 1976 we merged our still small Hinrichs Design Associates with two designers who were also in the process of joining forces, B. Martin Pedersen and Vance Jonson. With the later inclusion of Neil Shakery this became Jonson Pedersen Hinrichs & Shakery. Linda and I started a new office in San Francisco and Neil joined us several years later, after working first in the New York office.

If you are coming to San Francisco from New York and you are trying to be perceived as being different from the designers who are already here, you don't move into the nice, exposed brick wall, "fern bar" kind of design office which San Francisco is loaded with. So we moved right into the best building in the city. That was one of the smartest things we ever did.

To be able to talk to a major San Francisco corporation and to be in a building that was the equivalent of theirs said to them that we were not just another design firm that had come to San Francisco because life is "cute" here. It said we were really serious about what we were doing.

More and more we find that clients come to our offices. Having them on our turf, in offices that are sometimes better than their own, helps us make our clients feel very confident, very sure. They feel that the kind of advice that we are giving them is sound.

Having an office in both New York and San Francisco gave us tremendous credentials. When one of our clients was in New York, he could drop in to our New York office and have lunch with Marty or Vance.

There are 24 full-time people here in our San Francisco office. Eighteen of those 24 are involved one way or another in the design process. This includes production people and project coordinators. The people who are not actively involved are our bookkeepers and receptionists. The principals in the company are all actively involved and function as designers as well.

We do not have any account executives or other people to represent design. Not that working through a sales force is wrong, but for us it has not been effective. We have always felt that too many questions come up during the course of a meeting that only a designer should be responding to. Answers like, "I'll get back to you," "I'll check it out with so and so," just don't help build any confidence and trust.

We don't have a scientific sales approach. But we do have some rough guidelines. They are:

1) We project our work flow three to four months in advance and anticipate any "soft" spots and try to fill them.

2) We try to analyze our project mix and perhaps pursue a new, more interesting, and more profitable area of business.

3) We also try to include a reasonable mix of pro bono charity work.

We don't want to do the same thing over and over again because it is important for us not to sit back on our laurels.

We determine our budgets by taking the entire cost of running the office, together with the number of hours that it is reasonable for a designer to work during a day and attempting to relate this to the cost of a project.

While it is obvious that you cannot afford to lose money on every project, you nevertheless have to produce things that are the best quality possible. You have to convince your clients that it is appropriate for them to spend the money to do this for their own sake, not yours.

The nice thing about working on larger projects is that when you are doing an annual report that is printed in huge quantities, most of the money spent on the report is spent in paper and press time. So whether you spend $30,000 on photography or $15,000 on photography makes marginal difference in the total bill. But that extra $15,000 worth of photography may make a 500 percent difference in the final product. Corporations today are producing better annual reports, seeing them as a benefits for the company as a whole.

Learning how to work with people may be the most important thing that designers will ever do. Their relationships with their clients and their employees is what will ultimately determine their final success. How well they communicate to both audiences determines the quality of design they do and the success they have within the design and corporate communities.

I like to think that people come to us because we are the most talented, most creative office in San Francisco. I know that is not true—not because we may not *be*—but because that is not the only reason. I think a more important reason is that we understand that we are in a business. I guess we treat our clients as we like to be treated—as human beings. We do not have a supplier attitude, either with our clients or with the people who work with us. We very much feel that the entire group, from the client to the typographer, is part of the team that makes a job an excellent one. We respect contributions to the project on all sides. If you don't have that respect for both your client and the people you are working with, then something is very much missing and the quality of the project suffers.

Calendar for American President Lines.

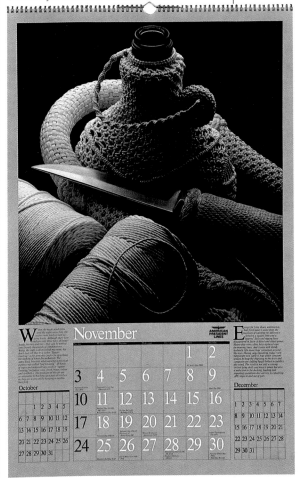

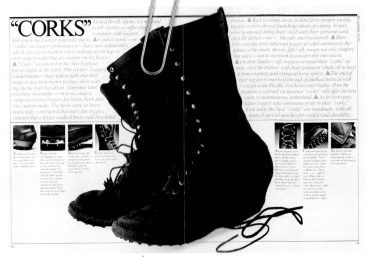

Spread for an issue of The Potlatch Story, in-house magazine of The Potlatch Corp.

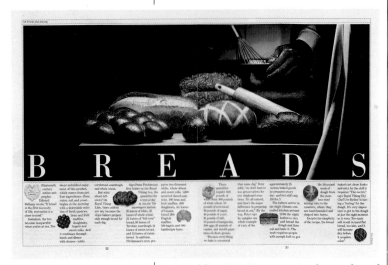

Spread from SKALD, a magazine for members of Royal Viking Line's SKALD Club.

Gavilan Computer Corporation. Product brochure.

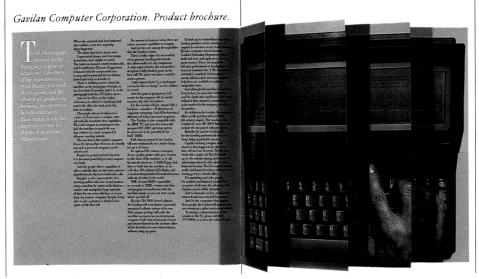

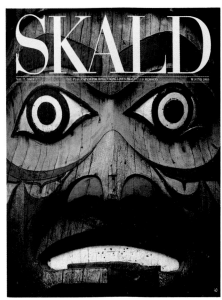

Cover from an issue of SKALD.

MICHAEL MANWARING

Michael Manwaring studied design and art at the San Francisco Art Institute. His early career concentrated on architectural graphics, exhibition design and filmmaking, working on such projects as the IBM-sponsored Astronomia *exhibit at the Hayden Planetarium in New York; the* Hemisfair '68 *theme exhibit in San Antonio, Texas; and the signing for the Oakland-Alameda Coliseum Complex.*

In 1976, The Office of Michael Manwaring was established in San Francisco. Projects have included identity and environmental graphics programs for the California Academy of Sciences, Century City Shopping Center in Los Angeles, and Plaza Lyon and Centro Nuevo, mixed-use urban centers in Santiago, Chile. In 1982, The Office of Michael Manwaring was selected by the American Institute of Architects, San Francisco Chapter, to design its centennial exhibition at the San Francisco Museum of Modern Art.

Manwaring has taught at the College of Environmental Design, University of California at Berkeley; was a guest lecturer at the Escuela de Diseno, Pontificia Universidad Catolico de Chile; and for the past seven years has taught graphic design at the California College of Arts & Crafts.

I went to school at the San Francisco Art Institute, which is primarily a fine arts school. I was taking design classes just to appease my father. I didn't like design and I did very poorly in it. After my first year, an instructor came along who opened up the world of design and architecture for me. After about two years of graphic design, I wanted to go out and do it, so I never graduated.

In 1965, I went to work for Robertson Montgomery, a graphic design firm doing films, exhibitions, and museum master plans. The projects were large and long-term. But I got tired of waiting so long to see results. So, after two and a half years, I left and went into partnership with Jerry Reis, a colleague of mine from art school. We did well.

The reason our partnership was so successful, I think, was also the reason I eventually had to leave it. We shared everything equally. We were both designers. We were both illustrators. We did *everything* together. *Every project.* But after eight years of doing that, you start to lose your sense of identity. I decided that I needed to find out again just who Michael Manwaring was. So I gave it up.

Looking back on it now, the only way I think a partnership can work is if both partners manage and design only their own projects. The only exceptions to this might be if something came in that was just too large for one designer to handle. I just don't think the way that we did it was right and I am amazed that it lasted as long as it did.

The other mistake I think I made was in not paying enough attention to the *business* side of the business. When I was working for Robertson Montgomery, my first job right out of school, the proposals and fees were all taken care of by someone else. I could manage the design of the project. I was able to get bids from fabricators and make sure that my projects came in on budget. But I had no idea how we got the job in the first place or how it was billed. Nor did I care.

So when I left and started the partnership with Jerry neither he nor I knew anything about business. We just made everything up as we went along. And we made a *lot* of mistakes. Like doing all our contracting verbally. No contracts. No written change orders. Just making sure that everything is confirmed in writing is an amazingly simple idea. I don't know why it took so many years to understand that we *had* to do it.

When I left the partnership I started working out of my house. In about three months I realized working at home was too difficult. It was so pleasant that I wasn't getting anything done. Plus, I was starting to miss people. I missed all those ringing phones. The other problem with working at home is your work is always there. You may work all day, have dinner, and not plan to work that evening. But you happen to walk past your studio and look in. You know there is a design problem waiting inside. So you just go in and sort of play around with it. All of a sudden you are there until one o'clock in the morning. You can't get away from your work. It is always drawing you in. I think just a few miles' distance forces you to forget about your work for a while, and I need that.

I also think there are still a lot of people who do not take you seriously when you are working out of your house. You can say to yourself, "Well, I am not interested in working with those kinds of people" and that is fine. You can say that. But after I moved back to the city I asked people about what they thought about my working out of my home. They said, "Oh, we thought you were just slowing down. Gradually phasing out." And I wasn't at all, but that was how they perceived it.

I think a design office should look like a design office. I go to a lot of architectural offices. When you are sitting in *their* waiting areas you have no idea what they do. They could make computer software. They could be an insurance company. They are all nicely designed, but they have no identity with their profession and their rich heritage. But I understand why they do that. They want to look like their clients. They want to be safe.

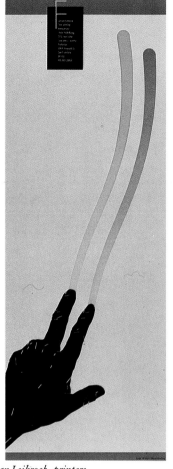

Forman Leibrock, printers.
Announcement for their new two-color press.

Symbol for
Bon Air Center.
A shopping center
in Marin County,
California.

The Office of Michael Manwaring. Letterhead.

A spread from a catalog
for Esprit De Corp, wom-
en's fashions.

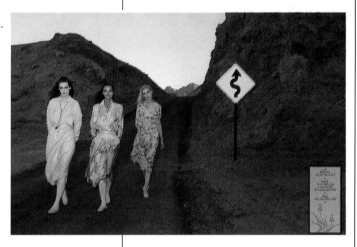

Anshen & Allen, architects
Capabilities brochure.

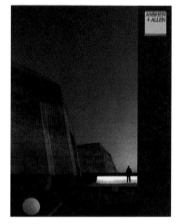

Logotype for The Charcuterie,
a gourmet and specialty food store in Los Angeles.

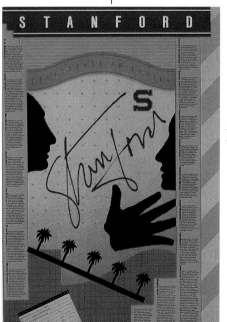

University of Stanford.
Poster for a design
conference.

Most of our clients love our office. They love all the stuff on the wall. They don't object to the fact that there is no receptionist. The corporate clients enjoy coming here because it's different from their offices—it's exciting!

In my second year, I tried an experiment. I hired a fellow purely as a business manager and rep. He was paid by straight salary—no commission. He went out and found jobs for me. He was very successful. He found a lot of work for me. More work than I could ever handle. The work came in so fast that I couldn't find the right staff to do it, people I felt were really responsible enough to handle the jobs. So we had to turn down some jobs. He did his job very well. I didn't do *my* job well. I didn't spend enough time with him showing him what was a desirable project for me and what is an undesirable project. All the jobs he brought me were for quality clients. They were jobs that a lot of other people would have liked to have, but they weren't *me*.

I think reps work very well for illustrators. They can show the book and the art director says, "We want this style." "Fine, okay. I'll tell him." But it is different for a graphic designer who chooses to work in many vocabularies. When I start a project I have no idea how it is going to turn out. What can a rep tell a client other than "This guy is good. You are not sure what you are going to get, but this guy is very good!" That can make some people very nervous.

I decided, after a while, that I couldn't use a rep.

When I formed this office, I took my portfolio around looking for jobs. I have to tell you, it was a humiliating experience. I was surprised that so many people didn't even know who I was. The people who had heard of me thought I was the business end of the partnership I had been in. So I had to prove myself all over again, which was devastating to me. Consequently, out of all the schlepping I did with my portfolio that first year, I didn't get a single job. *Nothing.*

I think my biggest mistake, as far as sales calls went, back in those days, was in not having some kind of a sales strategy. Some kind of plan. I didn't think about the people I was going to see. I didn't say, "Let's go after these kinds of clients." I just said to myself, "Well, that is a good architectural firm. I'll go talk to them." Or, "That is a company that does a nice annual report. I'll go after them." It was all just sort of haphazard. There was no follow-up. There was no strategy at all.

So I just stopped calling on people. I couldn't stand it any more. And I haven't gone out since then. I don't even have a portfolio. I have a little slide show that I use when people ask me to speak somewhere, but basically I just wait for the phones to ring.

Even though I wasn't actively seeking jobs, the work gradually came in. I got a lot of phone calls from people who tried to give jobs to my former partner but found he was too busy, so they would call me. When that happened, I just sort of swallowed my pride and said, "Sure. I would be happy to do it." I just waited for whatever came in the door. Just like I am doing even now.

Now we find that we don't ever need to look for work. But I think you can always improve your clientele. So I have been considering seeking out certain kinds of jobs. I am going to do it right this time. I am going to plan it out. Have follow-up and do it in a very organized and strategic way. I realize that this will take a lot of time and money and traveling. I won't be able to do it in the San Francisco area alone.

To do my estimates, I try to break the job down to its components, and mentally go through the process of designing the whole project. I just break it down and assign total manhours to do it. Then I multiply that times our hourly rate, which is based on our costs times a factor of 3.5.

Then I look at that figure. I look at the project. I look at the client. I look at what we call the x factors, which are things that are intuition—promotional value, common sense, etc.

Once I give the client a figure, I am committed to living with it. If the client has not changed the scope of the work, and we are spending too much time on it, then that is my problem. I have never gone back to a client and asked for more money unless the client changed the scope of the work.

Of course, to protect ourselves, as soon as we sense that a decision has been made that changes the amount of work we have to do, we immediately send a note to the client saying, "This was not included in the scope of work outlined in our proposal. This decision will mean so many extra hours of work, at so much money," and so forth.

I think of business as something that *has* to be done in order for me to do what I love to do. If there were some magical way that I didn't have to do business, I probably wouldn't do it. I really don't enjoy it. I don't hate it, but I don't really get my pleasure from it. I want to be only as efficient in my business as I have to in order to get my work produced properly. My interest is design, and I am trying to keep *business* in perspective in order to help me to do my design. I think that basic business ground rules could be taught to anybody in one day. But the trick is to discipline yourself to use those basic ground rules in a consistent manner.

Young graphic designers should have an acute awareness that if they are going to survive in graphic design, they must come to grips with *business*. If they are not prepared for that, then they need to do something about it.

The other thing I think they have to realize is that to do innovative graphic design and also be financially successful is *very* hard. The reward for all this hard work is the satisfaction of doing work that you are really proud of.

Spread from Executive Design, an architectural and business journal published by Whisler-Patri, architects.

Symbol for Eastface. Ski condominiums on the eastern slope of the Sierra Nevada Mountain Range, Nevada.

Oakville Grocery Co. Logo.

Performing Arts Services, Inc. Letterhead.

Cover and spread from a catalog for the California College of Arts and Crafts.

Covers from publications designed for the California College of Arts and Crafts.

Symbol for Serramente Shopping Center, San Francisco.

Logotype for My Child's Destiny. A large children's store in San Francisco.

Woody Pirtle, one of the most honored designers in the world, is president and creative director of Pirtle Design in Dallas, a multifaceted design firm offering graphic consultation and creative services to major corporations, public relations firms, and advertising agencies. Pirtle graduated from the University of Arkansas in 1967 and returned to Shreveport, La., where he had grown up. After a year, he left Shreveport to work in a Dallas advertising agency. While there, he met Stan Richards, whose firm he joined in 1969. Along with so many other young designers, Pirtle developed and honed his design skills under Richards' tutelage. He left The Richards Group in 1976 for a short collaboration with Jerry Herring in Houston, returned to The Richards Group, and left to open his own firm in 1978.

As I began to try to determine what I wanted to do with my life, I had no idea what role a graphic designer played in the overall scheme of things. From the very beginning I was leaning toward the creative disciplines, however, I thought I wanted to be an architect. I enrolled in the University of Arkansas to study under the resident instructor, Fay Jones, a protégé of Frank Lloyd Wright, but once in the program I realized that the design aspect of architecture was minimal compared to the more technical side of the profession. I became disenchanted very quickly and transferred to the School of Fine Arts. The program was not specifically graphic design oriented, but had more of a fine arts focus with a few design-related courses. The bulk of my work early on was comprised of paintings, stone lithographs, etchings, and some sculpture. It wasn't until my last two years that I took several design courses and I was introduced to magazines like *Graphis, Communication Arts, Print,* and the other trade publications for the design industry. It was then that my interest in design began to surface.

When I graduated from college in 1967, I didn't have a slick portfolio of design work, only a collection of drawings, prints, and paintings. Somehow, I was fortunate enough to land a job in the bull pen of a medium-sized advertising agency in Dallas. I was there just long enough to begin to get a grasp on what it really took to make an effective piece of communications—that ideas were important, that it was essential for words and pictures to relate—but I still could not successfully put all the pieces together. While there, I have to admit that I really spent most of my time putting together a portfolio to help in bettering my position as a designer. I went through a period where I stayed up all night an average of three nights a week, working on hypothetical pieces to build a stronger portfolio. I was also doing every "freebee" I could get my hands on, you know, birth announcements, posters—anything I could do to fine-tune my skills and generate visibility with my peers in the community.

One day in 1970 I got a call from Stan Richards, who ran the premiere design firm in town. He said he had heard that I was unhappy with my job and that I wanted to make a change. I scheduled an interview with him, showed my portfolio, and subsequently went to work for him. I feel that the seven years I spent there were the most valuable in my early development as a problem-solver. Stan taught me to assess a problem and distill the solution down to its simplest and most effective form of communication.

As his business developed, Stan became increasingly enamored with advertising and less interested in pure design. Because of philosophical differences and my love for design, I left the firm in October of 1978 to open my own design office. I was immediately retained by the publishers of *D Magazine* (Dallas's city magazine) on a consulting basis to redesign the publication and act as design director. That was my start. I had handled T.G.I. Friday's account while working with Stan, and after I had been in business a month or so, they asked me to continue working with them on their design-related projects.

Spread from 1983 annual report for National Gypsum Company. Theme related to the indispensible nature of shelter as it relates to human life.

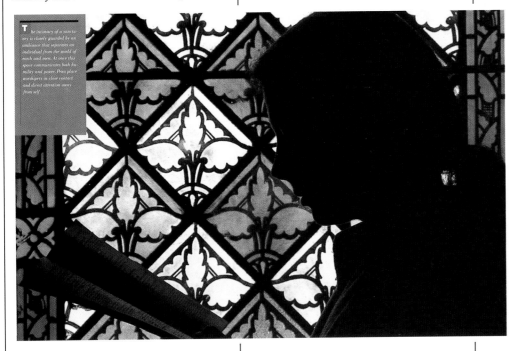

Railex. Railroad line.

Poster advertising a lecture by Milton Glaser on "Imitation and plagiarism."

Heart Center. Clinic for cardiological disorders.

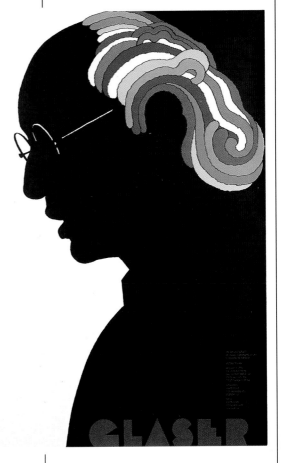

Spread from the 1984 National Gypsum Annual Report. Theme of the report described the relationship between the technology of the Industrial Revolution and the technology of the present computer age.

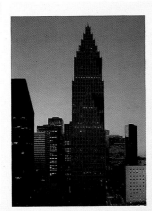
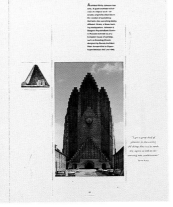

Radio Ranch. Radio production service.

One of the first things I did was to establish a line of credit with my bank. The interesting thing is, I never really used it. I started my business with about $3,000 in cash.

Most of the work I did that first year was for *D* and T.G.I. Friday's. As Friday's grew, so did their need for design services, and I grew with them. Last year, we did a total of eight menus for them as well as their first annual report. After seven years in business, we have a staff of 10, including 7 full-time designers and an administrative support team. Each of the designers does most of his own production to maintain the highest level of control. We also try to have at least one student intern available to run errands, shoot stats, etc.

When we get a new project, the first thing we do is to look at the problem and establish a budget. Once we have analyzed the problem, we establish a fee based on the complexity of the project, the estimated number of hours and manpower it will take to complete the project, plus the related outside expenses. We also quote a fee to coordinate and supervise print production, which is based on an hourly estimate. After the budget is presented to the client and approved, a letter of agreement is drawn up between Pirtle Design and that particular client. It outlines in detail what the project entails and projected costs. Both parties sign, forming a binding contract. In conjunction with our letter of agreement, we also provide a production schedule that outlines the tasks to be performed. This schedule is presented in summary, subsequent to our proposal.

When we do an annual report, I usually assign a designer to the project who functions, depending on the experience level, either as an assistant to me—I might design it, and he or she puts it all together—or as an associate to me, designing it under my direction. That person art-directs photography, makes sure copy comes in on time, coordinates the printing, etc. Periodically I sit down and go through the scheduling and the budgeting to make sure that everything is on target, and I attend critical meetings with the client as well as with our suppliers.

The designers keep daily time sheets which are used as a guide to monitor profitability and to establish future budgets, as well as a reference for tracking the steps taken in producing a project. On his time sheet, the designer initials each job he works on, so we know who did what on any given day and how much time has been spent on design, production, coordination, etc. during the progress of that project.

We generally do progressive billing, dividing our fee by the number of months anticipated for completion of the project. On larger projects, this helps us maintain more consistency in our cash flow.

We have staff meetings every Monday morning. During these meetings, a list of active jobs is reviewed. We try to determine where we stand on all our jobs and what needs to be accomplished that week. Our office manager takes notes in the meeting which are subsequently typed and distributed to the staff. The notes outline the tasks to be performed by each designer for that week and serve as a reminder for scheduling.

The key to the ultimate success of any business, I feel, lies in the company's ability to market its products and services effectively. In order to produce outstanding design, one must first possess the ability to sell outstanding design. Before getting involved in the design field, I think it is wise for a student to take some business courses in college and learn about marketing and salesmanship. Of course it helps to be an outstanding designer, but the most important part of business is establishing lasting client relationships, selling, and making sure you show a profit.

3311 Oak Lawn.
Retail and office building.

Lakeside Village.
Condominium development.

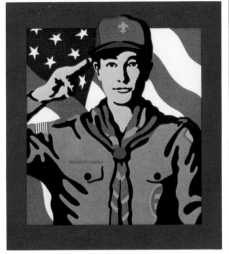

Illustration from 1983 annual report for the
Boy Scouts of America.

Spread from a capabilities
brochure for Shepherd &
Boyd, architects & interior
designers.

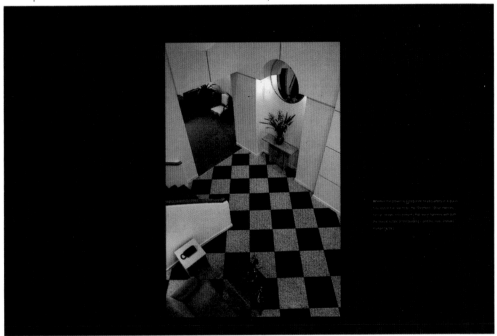

Spread from self promo-
tion book of trademarks,
logotypes and picto-
graphs. Symbol is for Sea
Wings, an exclusive char-
ter service.

Sea Wings
Exclusive Charter Service

Dallas Opera

Stan Richards founded The Richards Group 30 years ago as a graphic arts studio, only one year after he graduated from Pratt Institute in New York. Over the next 20 years, his studio established itself as one of the nation's outstanding creative resources, a reputation that was enhanced in 1975 when The Richards Group became a full-service advertising agency. In 1976, Richards was chosen by the Dallas Society of Visual Communications as "the single individual who, over his career, has made the most significant contribution to the advancement of creative standards in the Southwestern United States." In 1982, when Adweek *announced the results of a national poll, The Richards Group was named one of the eight most creative agencies in America, and in 1983 Richards was himself chosen by* Adweek *as top executive and "All-around Creative Star" in the Southwest advertising community. Most recently, The Richards Group was named by* Adweek *as the 1984 Southwest Agency of the Year. The Richards Group has grown to 150 employees, with billings of $70 million. Stan is also principal in Richards, Brock, Miller, Mitchell & Associates, a full-resource design studio. A public relations subsidiary, Pharr Cox Communications, was established in 1977 and is already the largest public relations firm in Texas.*

The early years were pretty tough because the market just wasn't prepared for the kind of work that I was trying to do and I have never been one who believed in compromising my standards. Many times Betty and I ate potato soup because we couldn't afford anything else, but I would rather live that way than do mediocre work. I feel that good people are irretrievably tainted when they start to do mediocre work.

Then, as the market grew and there was more business here, we began to get the lion's share of the good work. There were other studios in town that were much larger than we, but they were always more concerned with volume. They did competent work, but nothing more than that. Whenever anybody in this part of the country decided he wanted something really extraordinary, he always found his way to us.

I began to add good, young people right out of school. Trained them our way and built an extraordinarily strong design organization doing both advertising and graphic design.

One of the things that we did, and still do, that is unusual is that we have never done comps. We avoid them like the plague. We have sold everything from the roughest kind of thumbnail to a full-sized rough, but always just barely enough to get the idea down. We never even make any attempt to indicate typeface. The client doesn't really need to know whether the headline is going to be in Caslon Bold or Garamond Light. We will make that decision when the time comes for it.

When our clients began to realize that what I was saying made perfectly good sense economically, we began to be successful in converting the agencies that we worked with to our way of thinking. Let's assume that what we are talking about is an ad. That ad has a budget for concept and layout of, say, $3,500. I would much rather spend most of the $3,500 on the thinking, finding nifty ways of putting words and visuals together, than spend only the first three hours of that $3,500 in conceptual work and the rest of it in wrist-work, getting it to the point where the client can see it. The client is the only person who is ever going to see a comp. We think that money is badly spent if it is spent anywhere but concept.

We never watch the meter. We know what the value of a given piece of work is. Once that value has been established, our task is to find the best answer, not merely the best answer that comes just before the time runs out. In 50 percent of the things that we do, we probably take longer than the budget calls for, but I can't be concerned about that. I want us to keep digging for the best solution no matter what the time card says. We will worry about that problem later. We will either tell the client, "We went over, can you help us with some of it?" or we will just simply absorb it. We figure that over the long haul, if you learn to project your costs properly, things are going to balance out.

The fact is, our clients usually get more than their money's worth.

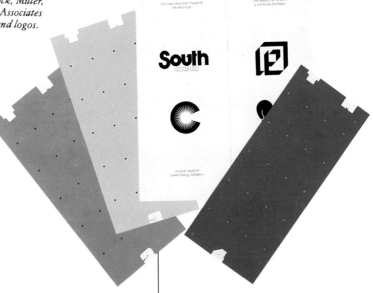

Four collections of Richards, Brock, Miller, Mitchell and Associates trade marks and logos.

Anniversary poster for a printer.

An invitation which requested New York media buyers to view a presentation by The Dallas Times Herald *over breakfast.*

This menagerie of animals is accompanied by bar codes which can be read by T.I.'s Magic Wand Speaker Reader. Even a three year old can summon up the sounds of his favorite animal with this magic wand that's more than a toy.

Earth Grains brand raisin bread.

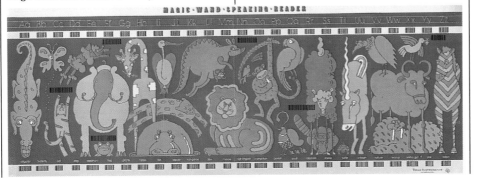

Our designers' billing rate is essentially salary times three, and they are all paid on a straight salary basis. At the end of the year I take whatever profits are left, after a reasonable corporate profit, and give bonuses. Years and years ago, before anybody in the studio business ever thought it was possible, we had a pension plan, a profit-sharing plan, and a very nice hospitalization plan. We were still able to give reasonable bonuses and pay reasonable salaries.

The fact is that the work is so exciting and the opportunities are so great here that we usually have to throw our people out of the office. Consequently, we may be paying a designer for, let's say, maybe 1,300 or 1,400 hours a year chargeable time, but he is really giving us 1,800 hours because he cares so much about his work. That is part of the answer to being profitable too. And it is a significant part of the answer.

We don't use any production people. Every person is a designer. One of the things that we do differently is that I insist that every art director do his own mechanicals. That is part of the reason that we don't do comps. We expect the rough to capture the verbal-visual concept. All the design is going to happen at the mechanical stage, so we can't have nondesigners doing mechanicals.

In the design business there is almost never a moment when your staff is right for your load. Either the load is too heavy or the staff is too great. The only thing that you can do is hope to hit those midpoints fairly consistently.

We encourage some friendly competition among our designers. For example, we may be working for a client and instead of saying to a single designer, "You solve the problem," we will toss it open and let everybody work on it. They will find the time somehow. The wonderful thing that accomplishes is it gives the outstanding young person, a person who has been in the business for six months or a year, a chance to show everybody how terrific he can be.

We have been very fortunate. Business has tended to come to us instead of our having to seek it out. A year ago, we hired a sales rep, for a couple of reasons. The primary one being that I was no longer available to do much selling. As a result we were not able to call on some people who we felt would be good clients for us. I have a lot of gifted people in my organization. But it is very difficult for a lot of people to make cold calls, which is why we hired a person to call on prospective clients for us.

When we take an assignment, we usually write a letter of agreement that outlines all the anticipated costs and deals with the major issues. But in the studio business, you can't always anticipate everything and cover it in a contract. So we always operate more by a verbal contract rather than by anything else.

Because our clients know that we will always bend over backwards to accommodate them, we don't have any dissatisfied clients. I would rather take a loss on a job than have a client feel that we were paid too much for what we delivered. We have been burned once or twice, but for the most part our clients

are on our side. And they are looking out for our interests as much as we are looking out for theirs. The truth is, if someone really wants to get you, no contract in the world would stop him anyway.

The one thing that is constant here is the standard of excellence. So if someone comes to us and says, "I only have a thousand dollars for a mark," we still have to put the same effort into it to do the job right. We are still going to spend $15,000 worth of time to design the mark. If we are only going to bill $1,000 for it, we will be in big, big trouble. So if I took on those kinds of projects and expected to do them at some reasonable level of profitability, I would have to lower the standards of the shop, which is one thing I'll never do. If the project was such an interesting one that I just couldn't resist it, I would say to the client that "rather than bill you $1,000 for this, we won't bill you anything. We will do it free because we want to."

If I had it to do all over again I would have done one thing differently. I wouldn't have waited so long to start the agency. That has been terribly exciting. I spent all those years helping other agencies grow by providing first-rate work that they got all the credit for. They literally built their business on our work.

I totally believe that if young designers address themselves, 100 percent, to their work, growth and profitability will take care of themselves.

The Trails garden homes.

A shopping mall.

A bread company.

A gourmet caterer.

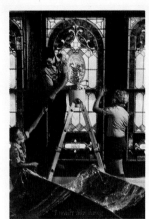

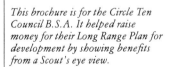

Sports Illustrated.

This brochure is for the Circle Ten Council B.S.A. It helped raise money for their Long Range Plan for development by showing benefits from a Scout's eye view.

The cover of this Lomas & Nettleton Financial Corporation Annual Report helps illustrate the balance between nature and development. The TransAmerica building is on the back cover.

A typesetting company.

A great hot dog stand.

Bennett Robinson is chairman and creative director of Corporate Graphics Inc. Since Robinson and partner Michael Watras founded Corporate Graphics in 1976, it has rapidly risen to a position of pre-eminence in the design of corporation annual reports. Robinson is a graduate of Syracuse University.

I was in my own design business for a number of years before I met my partner, Mike Watras. I designed just about everything but annual reports.

I met Michael through a chance telephone call to a printer asking about some inserts they were printing for Westvaco. I simply called to find out how they got such terrific quality. I got in a conversation with Mike, who was very grave, very sober, and sounded like he might be 50 to 60 years old. When I finally met him in person, I will never forget how surprised and delighted I was to see that he was my age. We became very friendly right away.

We started doing a few jobs together. Among them was my first annual report, for a tiny company. Mike did a beautiful job printing that report and later kept telling me that, of all the samples he had shown to big companies, the report we had done together was always the one they would pick out as outstanding.

Shortly after, when Michael got out of the printing business, it occurred to me that we could join forces and really go after the annual report design market. I didn't know then that it was a *very* highly developed and competitive business. So we two neophites jumped right into the thing, working out of my apartment. Mike arrived the first day, parked his car out front, and started making telephone calls.

Mike has a remarkable personality. He has the ability to make cold-calls which last three quarters of an hour. We sat around treading water for about a week. One day I said, "Mike, we've got to do something dramatic here. What do you think of publishing a newsletter?" He thought that was a great idea. I said, "Our first issue should include an interview that will make everybody's ears perk up. Why don't we go down to Washington and try to talk with somebody in the SEC?"

So Mike picked up the phone and called Mary Beach, who was the Communications Officer of the SEC. After about a half hour—they were best friends by then—he said to her, "I bet you grant interviews like this all the time." "This is the first one," she said.

The next day we flew down to Washington and spent the whole day with Mrs. Beach. Delightful lady. She put to rest a lot of these myths about type sizes and all those other rules the SEC is supposed to have. They're really not as rigid as everyone supposes.

The more I got into it, the more intrigued I became with the idea of doing annual reports. They *don't* have to be dry and deadly. These are *terribly* exciting businesses. Finding a way to help bring these companies to life, instead of producing boilerplate reports year after year, is a pretty great challenge.

Another *very* attractive thing about doing annual reports is that, by law, they have to publish by a specified date. Annual reports seemed to be the kind of product around which one could structure a business. Indeed, it has turned out exactly that way!

In the beginning neither Mike nor I was drawing a penny from Corporate Graphics. I started swinging over some of the projects from my own business into Corporate Graphics just to get some cash.

Michael, as he still does to this day, was spending most of his office time on the telephone . . . sending out pop-shots all over the landscape. We finally got a very, *very* important break. Mike was able to get an appointment with Tom McIntosh of H. J. Heinz, in Pittsburgh. Tom had been described as a delightful guy . . . a guy who never used the same design firm two years in a row—*ever* . . . who wrote beautifully, had a great sense of humor, and produced the best reports in the country.

Mike was ready to consider himself lucky if he could spend just a half hour with Tom. He spent the entire day with him! He called in about five o'clock in the afternoon. I got on the phone, together with Carol Nash, who had worked for me for about ten years, and who I love dearly. I said, "Hi, Mike. Did you get to see him?" There was this long pause, then Mike said, "Get to see him? We got the report!" We almost fell off our chairs.

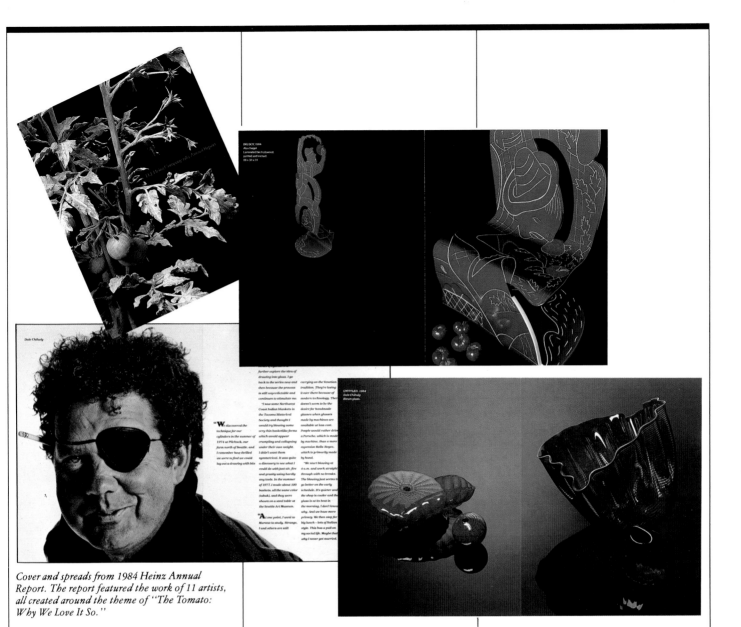

*Cover and spreads from 1984 Heinz Annual
Report. The report featured the work of 11 artists,
all created around the theme of "The Tomato:
Why We Love It So."*

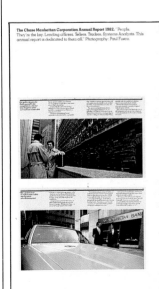

The Chase Manhattan Corporation Annual Report 1982. "People.
They're the key. Lending officers. Tellers. Traders. Systems Analysts. This
annual report is dedicated to them all." Photography: Paul Fusco.

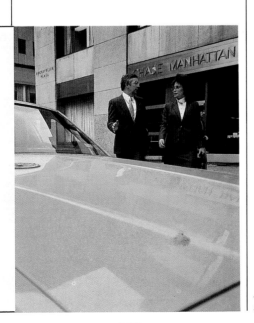

*Spread from CGI's capabilities brochure featuring
the 1982 Chase Manhattan Bank Annual Report.*

That was the beginning and it has just been a skyrocket ride from then on. And we're still doing the Heinz report. We began to compile samples which we send out periodically to a list that Michael has developed over the years. This usually brings back a tremendous response. Clients often say, "I've been receiving your things for years. I've got them all right here." They'll open a drawer and pull out a stack of Corporate Graphics books. That is always so satisfying. The usual comment about annual reports is that people throw them away after 45 seconds. I try to design annual reports that I hope will be saved. They should say something. They should have some meaning. They should be like a good magazine.

I think that each year our work gets better. There are no shortcuts to the creative process, whatever it is: whatever combination of intellect and enthusiasm and well-being that causes a wonderful idea to explode in your head. I don't know of any shortcuts to that. I am, however, less anxious and more comfortable with the process as time goes by.

I think it is very, very important that all the designers who work here have their own projects. I oversee the quality of everything and constantly confer with all the designers. I believe a creative person must do his or her *own* work—not carry out somebody else's thoughts. I think that the pyramidal structure, with the master sending out all the creative signals and all people below him carrying out his ideas, is not very conducive to individual growth.

We have 10 designers now, including myself. There are five teams, each with a senior and junior designer.

One thing we do that I think is unique is what I call the "astronaut technique." Every time we send up a "space shot"—an annual report—we put a different crew on it. We rotate the crews each year, much to the dismay of some of our clients.

They say, "Oh, I want Jim," or, "I want Bob back." "We can't come unless we get the exact team we had" . . . You have to make them relax a bit. Later you will see them at a Christmas party or in some other informal situation, and they'll say, "Hey, you guys have a deep bench there. I feel I can go to almost anybody in your company and get good creative quality." It is very, very impressive. We rotate teams because I think it is another way to keep our people interested and keep the client's solutions fresh.

I am, and always have been, a terrifically, obsessively organized person. This is a business that cherishes organization. The number of details is absolutely mind-boggling.

We all use the same terms. We keep our procedures the same. We have a big, thick book which outlines our procedures in great detail.

We have specific design procedures such as the development of grids. We typeset our grids. We set a typographic manual for each report just the way it's done in the book world. All heads, leading and widths are specified in great detail . . . we do that for all of our annual reports. In that way we involve the typographer early on. He's in on the project from the beginning. That is the way I've always worked.

Our scheduling is done on a computer, using a proprietary program which enables us to feed in milestone dates. These include the most likely publication date of the annual report, the day that the financial data becomes firm, the day that the color or the art work is released. We can feed those key dates into our program and come out with a 200-step schedule.

We are no different from any other business in the world. Our product happens to be design—just like somebody else is putting out a widget, we produce design. We must meet obligations. If we fail in meeting our obligations we are making somebody in the client office look very, very bad. The most important thing we are selling, really, is the ability to make the person who hired us look good after the project is finished.

Budgets are sacred to us. If we go into overtime or exceed a budget, we make sure the client knows about it beforehand. We have learned a bitter lesson: nobody in the corporate world wants to be surprised, except pleasantly so. You can tell them anything in advance and they will pretty much buy it, if it is within reality. But if you add in as much as a nickel later on, they need a detailed explanation for that nickel. If you add a lot more than that, you're in trouble.

With most of our clients—and Heinz is a notable exception, since Tom McIntosh comes up with the concepts for the reports—we will come in with a totally open mind. The higher up we can get in the corporate organization in our first meetings, the better. We gently insist that we meet with the chairman or the president as early as possible.

Usually the first input session turns out to be a give-and-take, with us trying to find something we can build on. I would say that in the majority of cases the management of the client company has no idea what the annual report should be, other than that it should report on the last year. They are always open to ideas if the ideas aren't presented in an overbearing way.

After the first few meetings we'll have a definite concept for the report. I feel the report that doesn't have a concept loses its purpose.

I think that the heart and soul of the design business is two-fold. One, you have to sell to get the business. Then two, when the business comes in, you have to try to give your all to create something that is exciting and wonderful. You'll never be a better designer or a more informed designer or a smarter designer than you are a person. I think that a designer is no more than a visual commentator and he has to have something to talk about. He has to have beliefs. He has got to bring something to the table.

CGI news

SEPTEMBER 1983
PUBLISHED BY
CORPORATE GRAPHICS INC.
630 THIRD AVENUE
NEW YORK, NEW YORK 10017
(212) 599-1820
TLX 7594420 CGIA

Bringing the Contract Catalog to Market

BY BENNETT ROBINSON:
Vice President/Creative Director, Corporate Graphics Inc. New York City

Several years ago, I was attending a planning session for a catalog for a major manufacturer. Our session was interrupted by the arrival of a customer in the showroom area where we were meeting. Without hesitation, the president of the company rose to meet the potential buyer. He returned a half hour later with the news that the customer had bought two small end tables; we could now continue with our catalog planning.

This is not an unusual occurrence. I relate it simply to point out that in the contract industry long-term catalog planning often takes a back seat to the more immediate job of selling products. What is not realized is that an effective furniture catalog is one of the best sales tools.

1 THE NEED
The reasons that prompt the creation of new catalog materials are varied. Leading on the list are:

An Extensive New Product Line: The introduction of new products is the lifeblood of the contract industry. A company often makes a quantum leap in its product line by simultaneously introducing several new designs or a new system, such as an open office group.

Such a dramatic introduction of products often bespeaks of new design expertise to the company or management's desire for a new image. The reason might also be a foray into a new market area. For example, several companies are now turning their efforts to producing products compatible with the "office of the future." These include platforms, tables and seating geared to computer-oriented activity. Not since the introduction of the typewriter return as the comptometer configured desk have we seen products designed for such specific new usage. To be well understood and easily ordered, these products necessitate revamped catalog materials.

New Ownership: New ownership, or a merger, are often reasons for creating a new catalog announcing the change in direction.

Mergers are particularly challenging when fashioning the company's new image. For example, when smaller companies are acquired by a larger manufacturer and then regrouped to make new product combinations, the parent company often wishes to retain the identity of the smaller manufacturers and still use the combined facilities to their most synergistic advantage. Most helpful in such a situation are intelligently conceived catalog materials, designed not to confuse the specifier, but to open new opportunities built upon honored reputations.

Outdated Catalog Materials: Perhaps the single most important reason for a new catalog and price list is that the existing catalog is simply out-of-date and difficult for the specifier to use. Containing discontinued designs, out-

The CGI News, a newsletter published by CGI and mailed to clients and prospects.

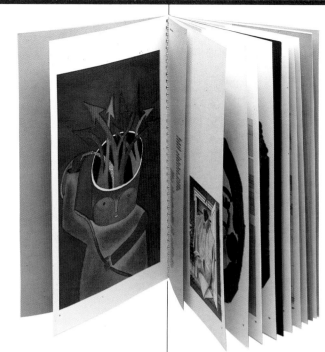

A promotion brochure on Illustration and The Annual Report, designed for Simpson Paper Company.

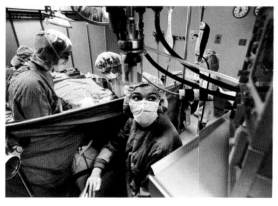

Hospital Corporation of America 1981 Annual Report.

Spread from CGI's capabilities brochure featuring The 1981 Hospital Corporation of America Annual Report.

Cover and spread from the 1977 Heinz Annual Report, the first report CGI designed for Heinz.

H. J. Heinz Company Annual Report 1977

This year, we said, let's introduce some of the people who have helped to make Heinz so successful. We are, after all, a people-oriented company, sensitive to the specific demands of millions of persons around the world and tailoring our activities to their varying tastes.

Just as important to our fortunes are the people who work for us. A sampling, necessarily small, appears on these pages. Let them represent all those (and there are many more) who have found interesting and often novel ways to enrich their own lives and the lives of others.

We draw no conclusions. The stories speak for themselves. Just possibly, however, we may persuade some of our readers that no corporation should be thought of in impersonal terms. Rather, each corporation contains a host of very human individuals organized for common and useful purposes and enjoying the freedom to pursue outside activities of their own undictated choice.

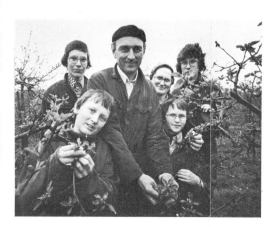

Ellen Shapiro graduated from UCLA and began her professional career shortly after graduation as UCLA's Art Director for Alumni Publications. After two years in New York at Lubalin, Smith, Carnese, in 1974 she became art director of the New York office of the Barton-Gillet Company, a communications consultant to nonprofit institutions. She founded Shapiro Design Associates Inc., in 1978. In 1980 an advertising agency subsidiary, Print Media was incorporated. Shapiro has won numerous design awards, including Gold and Silver medals from the New York Art Directors Club. She has taught at the Graduate School of Art and Architecture at Pratt Institute and has lectured at various U.S. colleges and universities.

Shapiro Design Associates has been able to succeed at both the art and the business of design. What has really made a difference for us is planned, logical growth based on a carefully thought-out business plan.

What is a business plan? It's a formal document written by the principal of the firm, frequently with the guidance of an outside expert such as an attorney, accountant, or management consultant. Experience has shown that taking the time to do a plan will create the environment and set the stage for attracting and serving those clients who will make your best creative work possible.

Before explaining how to go about doing a business plan, I'd like to give you a little background:

In 1981, when Shapiro Design was in its third year of business, our profit and loss statement didn't look quite as good to me as our design work did. So I sat down with a partner at an accounting firm and the heads of their small business advisory service.

Three experts started firing questions at me like: "What percentage of your firm's income goes for overhead expenses?" "What percentage to salaries and employee benefits?" I didn't have the answers.

That occasion sums up one of the key things that makes graphic designers different from other kinds of business people. Those questions could have been answered easily by the president of another kind of company—manufacturing, retail, high-tech—who wouldn't be so hung up on the beauty of his product that he wasn't attending to the basics of his business.

Because designers aren't taught business basics in the first place, it's easy for us to rhapsodize about the way we are planning to handle the typography on the brochure we are working on, and at the same time be out of touch with how much profit we'll make on that brochure, or even know if it will make a profit at all.

While some firms who crank out mediocre work seem to do well financially, some good designers have gone out of business. In our profession, casualties do result from client agreements that are too casual. Designers end up putting in a lot of hours and up-front money for expenses—and then can't collect.

You need to set up a business plan so that this doesn't have a chance of happening to you. Working with a consultant is not as expensive as you might think. In 1981, we were charged for about 20 hours at $60 an hour. Remember, you will do most of the work yourself. It's as essential an investment as drawing boards and Luxo lamps.

And when you're finished—the decisions have been made and the document is cleanly typed and ready for presentation—you'll be as proud of your accomplishment as you are of any design project that wins an art directors' award.

Merrill Lynch & Co., Inc. Cover for a special edition of the company's employee magazine (distributed to personnel being relocated to Princeton, NJ.)

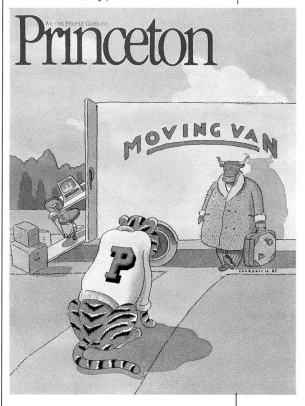

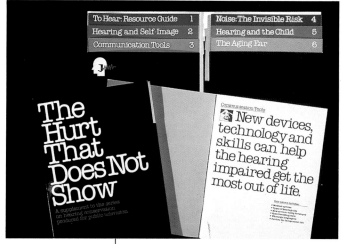

Grace Foundation, Inc. Series of six booklets in slipcase dealing with significant aspects of hearing loss.

American Express Company. Poster announcing a lecture on The MBA Handbook to graduate students.

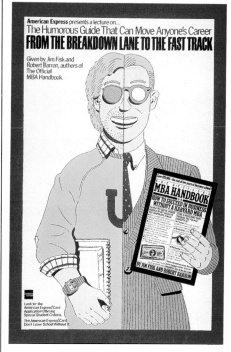

Alexander Grant & Company. Selected booklets and newsletters for the national accounting and management consulting firm.

More than 9,000 physicians have counted on us to help them treat 40,000 patients.

Electro-Biology, Inc. Cover of the 1984 annual report.

Here is a simple format I recommend to all designers who are involved in the first stages of their business:

I. BUSINESS SUMMARY

1. A statement of your current situation or problem.

2. A history of your company and/or your personal professional development.

3. The financial and legal structure of the company (sole proprietorship, partnership, corporation, etc.). Why have you chosen to set it up that way?

4. A list of clients (or potential clients, if this is still in the earliest planning stages) and real or projected annual income from each.

5. A list of products and services you provide.

6. Recent accomplishments and awards.

II. PLANS FOR GROWTH

1. How will you market yourself? (Sending out letters, a brochure mailing, advertising, reprints of articles?)

2. Who is your competition? What are they up to?

3. What are your plans (hiring people, renting new office space, buying or renting a copier, Typositor, or other equipment)?

III. FINANCIAL

1. How will you estimate, account for time on, and bill jobs?

2. What is your standard client agreement?

3. Balance Sheet. (Add up assets, such as accounts receivable and money in the bank, in one column and liabilities, like taxes and accounts payable, in the other.)

4. Income (Profit and Loss) Statement: Add up your projected revenues for a year; subtract the total cost of doing business (overhead, repaying loans, buying the new equipment, etc.); the difference is your profit or loss.

Even if you haven't been in business for a year, you should prepare projected statements.

You will be surprised at what a difference it makes to write everything down. The act of writing makes you think clearly and logically. For example, when it comes to a simple thing like the product/service list, you may find yourself realizing that although you can do exhibits and slide shows, your real strength is corporate identity and packaging, and it makes sense to stick to your strengths. In putting together the client list and the fees you receive from each client, you may see that you're doing the lion's share of your work for a small retailer and you're missing the opportunity to build your business with other clients who have larger communications budgets.

These were the kinds of issues I tackled four years ago. We took the opportunity to focus on our strengths, to make a definite commitment to expand in certain directions, to learn some basic cost-accounting procedures, and to set an approximate timetable for each goal.

For example, one stated objective was to expand our annual report business. A realistic look at the competition convinced us to take a direction other than Fortune 500 companies. We researched the fastest-growing companies with annual revenues under $300 million and found our own market niche.

We prepared a mailer which specifically addressed the needs of the CEOs or chief financial officers of those companies. Today, we are pleased to have built a new business segment which is profitable, gives us opportunities to do outstanding work, and still has tremendous growth potential.

In 1985, having fulfilled the objectives of the first business plan, I prepared a new one. It includes the following areas, and is an appropriate format for those of you who head an expanding business.

The first section—Business Summary—now includes detailed essays on our design and project management philosophy, and on how we structure a client relationship.

The Plans for Growth section is a survey of our increasing needs for office space, microcomputer hardware and software, and other facilities and equipment. We evaluate our products and services, our strengths and weaknesses, and determine exactly how and where to market ourselves.

A new section on Personnel profiles the growth of a professional staff, from a small office to a firm able to serve leading corporations. This requires outstanding people, so job descriptions are outlined for each position from receptionist/word processor to executive vice president. For example, we clarify what we are looking for in an entry-level designer.

The Financial section has grown to include topics such as recommended changes in current estimating and billing procedures—and about twenty pages of financials.

A plan of this magnitude is not only necessary to ensure continued, logical growth; it is essential for securing a line of credit or other bank loan you may need to finance that growth.

When I was describing reasons for design business failures, I should have mentioned another important reason. Being unable to manage the volume of business their talent attracted—inability to meet day-to-day client service needs and to stay on top of production—has probably caused more lost clients, more unpaid or partially paid invoices than any other factor.

One of the most valuable things a business plan can do is help you define and separate each function. It will help you identify your *personal* strengths. Ideally, you can then recruit other professionals to assist in the selling and management areas so that you can return to doing what you do best: graphic design.

But this time you'll be so much better at it because you'll be working within a sound framework that supports and rewards your efforts.

*Brooklyn Academy of
Music. Annual reports,
corporate development
brochures, audience
newsletter and maga-
zine.*

*Donaldson, Lufkin &
Jenrette. Logotype for an
international investment
fund.*

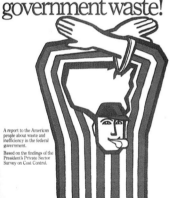

*The Grace Commis-
sion. Report to the
American people on
waste and inefficiency
in the federal govern-
ment. Cover and center
spread.*

*Cooperation Ireland
Incorporated. Symbol for
an organization working
to bring together North-
ern Ireland and the
Republic of Ireland
through civic and busi-
ness collaboration.*

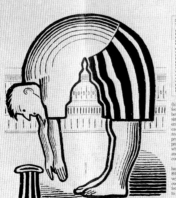

*The Grace Commission.
Symbol for the bipartisan
campaign to eliminate
wasteful government
spending.*

Jack Summerford, a native Texan, grew up in Arlington, near Dallas. He studied design at Washington University in St. Louis, graduating in 1965. He then returned to Dallas, intending to get a few years of experience before going to New York. His first job was as a layout artist for a retail department store, where designing newspaper ads taught him "how to use a pencil and how to work fast." He worked for an advertising agency for three years, then in 1970 joined Stan Richards & Associates, later renamed The Richards Group. Summerford opened his own business in 1978.

I graduated with a Bachelor of Fine Arts from Washington University in St. Louis, in 1965. Back then, I think everyone, especially people from Dallas or smaller markets, felt like they had to go to New York to find work.

I came back to Dallas because this area was where I had finished high school. I was getting married. My wife had a job teaching. It seemed like a nice safe place to start, a place where I could get a little experience, and then go to New York. But it just seemed like the longer I stayed here, the better things got. It ended up being *the* place to be. I guess some people would argue that point, but it is hard to deny that Dallas is a nice place to be as far as the industry is concerned. There is a lot of good work being done here.

My first job was as a layout artist for a retail department store here in Dallas. This job lasted about ten or eleven months, and then I went to work for a local advertising agency. I worked there for about three and a half years. After that I worked for a small design firm for a year and a half.

Then, in 1970, I went to work for Stan Richards. At that time his business was called Stan Richards and Associates. Back in those days design firms were called studios because very often they served as art departments for agencies which didn't have art departments. So we did a lot of advertising as well as design. In fact, when I went to work there, most of the work we did was advertising. I worked for Stan for eight years.

In 1978, when Stan started to move his firm in the direction of becoming a full-service advertising agency, I felt like it was time for me to leave. We parted on pretty good terms, I think.

I have just reached the seven-year mark of being out on my own. I was a sole proprietor for a couple of years and then I incorporated. Now I am a one-person corporation.

A little more than three years ago, together with two friends of mine, Jack Unruh and Bart Forbes, who are both illustrators, I bought the building which I rent to my corporation.

I used to do all my own production, but now I only do some of it. Most of it I farm out to freelancers. I use the same people most of the time. I also have a freelance secretary/bookkeeper who comes in four days a week. I found that from an economic standpoint, and even from a convenience standpoint, it works very nicely just to pay freelance rates. To have a payroll and pay social security, profit sharing, and all those extras just means added aggravation. When I don't have any work for them, I don't have to figure out a way to keep them busy.

It all goes back to my basic philosophy–I want to be a practicing designer. I don't want to be a manager of people. I don't want to train other designers to design like me. I don't want to train other designers to go out some day and compete against me. I also want to guarantee my clients that when they come to Summerford Design they are going to get Summerford designs.

I don't think there have been too many instances where I have lost business because the client thought I was too small.

Of course, who knows how many clients out there have never called me because they think I am too small. That is something that I will never be able to find out, I guess. But if you looked at the size of my clients you would find that I am dealing with some pretty large firms. I am very satisfied with the clients I have.

Most of my work comes in by referrals now, but that wasn't always the case. When I first opened my door six years ago, I honestly thought it was going to be easy. I had been in the business for a long time. I had been with Stan Richards' firm for eight years. I thought lots of people would be eager to give me jobs because they would see a chance to get a reputable, experienced designer, who had worked with Stan Richards for eight years, and who might charge them a little less than they were paying at the time.

I found out that there is an incredibly large number of businesspeople out there who have never even heard of Stan Richards and couldn't care less that I had worked for him. It was a very humbling experience.

The Children's School.
Sevierville, Tennessee.

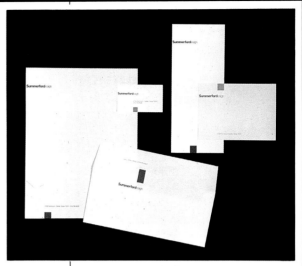

Stationery, Summerford Design.

Cover and spread from the Cimarron Corporation
1983 annual report.

KATZ UP

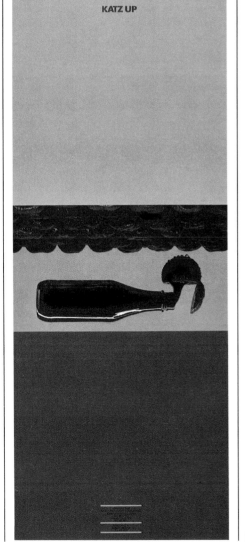

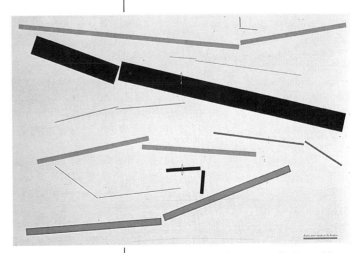

Spread from an issue of ''Typographic,'' a publica-
tion of the Typographic International Association.

Self-promotion poster for John Katz, photographer.

I figured I couldn't sit back and wait for business to come in. I had to go out and get it. So I subscribed to a business directory that had a listing of all the public companies in a five-state area, with their last-quarter earnings, the names and titles of the top three or four executives, their phone numbers, their mailing address information, on what stock exchange they were listed, and their fiscal years. I then just got on the phone and started calling.

I first called the companies in Dallas because I figured this would be the most convenient place to start. I would go on these periodic spurts of new-business solicitation. This is the hardest thing in the world to do: to pick up the phone and call these businesses *cold.* But I can honestly say that every time I made twenty-five calls, and followed up the leads that came out of those calls, I ended up with a piece of business. Obviously not all twenty-five came through, but one or two might.

As far as self-marketing goes, I did a little piece that announced my going into business. The only thing that I did after that was get samples of the annual reports that I had done during the course of the year and mail out three or four books to people and say, "These are the latest annual reports I have done. I hope you'll enjoy them."

This past year was pretty spectacular. I didn't promote myself at all, and I have done much more business than I did in all the years I have been in business. I am currently working on a promotional piece.

After I get an assignment, I get the job done by focusing only on storyboard roughs and concepts . . . not comps. If you can communicate on that level, number one, you have saved a lot of time. Number two, you have saved a lot of unnecessary input from the client. The design process needs a certain amount of flexibility. Showing the client only roughs gives you this flexibility.

I think sometimes we underestimate the perceptiveness of clients. We also *over-estimate* what is important to them.

The client doesn't care if his book is set in Times Roman or Garamond. He just wants it to look good and solve his problem, whatever it may be. He has hired you for that purpose, to tell *him* what type size and style the job should be in. The more decisions you can make for that person, the more effective you are in helping him.

It has been my experience that clients like to see the whole annual report all laid out on one nice little piece of paper which shows what the entire organization of the report is going to be. Along with the storyboard and thumbnails, I show them a blank paper dummy that is the actual thickness of the annual report instead of something four times thicker than it is actually going to be. So they can hold it in their hands, and say, "You know, this feels pretty good!"

Basically I charge by the project. I have arrived at my fees after working for twenty years. I sort of know how much time it is going to take for me to do a job, and I also have a pretty good idea of what a fair price is on a per-page rate for an annual report or a brochure.

I have a graduated per-page rate, depending on the size of the piece. If it is an 8-page brochure, obviously my per-page rate is going to be higher than for a 32-page annual report. There is as much "crank-up" time in an 8-pager as there is for a 32-pager.

If there are charts in the book and they are pretty simple, I can usually throw the charts in for the page rate. But if they are not simple, I'll charge out the charts separately for a few hundred dollars apiece.

I try to keep my hourly rate from dipping under $100 an hour. Sometimes it does. But $100 to $125 is what I shoot for. That rate might sound a little high to some clients, but I can get a lot more done for that $125 in one hour than most people.

As far as markups go, my rule of thumb is that if I pay for it, I mark it up. But the only things I usually buy outside are typesetting and photostats, which I mark up 20 percent, which seems to be standard. Photography and printing bills I have billed direct to the client.

Type bills that my client receives for an annual report are usually not very high, and that has a lot to do with the way I operate. I am very organized and that saves clients money.

For instance, I'll never stick down one piece of type on a board until I've run reading proofs by the client at least two different times. I'll get five sets of reading proofs. I keep a set and send four sets to the client. They distribute these among their accounting firm or people within their company, or whatever. Then I ask them to consolidate all the changes on one set and get them back to me. I use my set to mark up stylistic inconsistencies and things from the design standpoint. Then I send them out and I get another five sets of reading proofs and send them back to the client. We go through the process all over again. It pretty well purges any type errors long before I begin sticking anything down on a board. By the time the job gets to the brown- or blue-line stage, most mistakes are out.

Right now I don't see expansion in the immediate future. Someday I might mainly because I will reach a point in my life where I will want to do things other than just stay on the board. But right now, I like it the way it is.

I guess one of the nice things about having twenty years of experience is that you may not know what you want to do, but you know what you *don't* want to do.

I have often thought about whether I stayed at Stan Richards's place too long. I almost left there three or four years earlier than I did. It probably would have worked out fine if I had. The only advantage to leaving when I did is that I had absolutely no regrets. There was no second guessing.

To someone just starting out in business, I would say that one of the first things they should do is talk to a CPA. Get structured properly. Read as much financial material as you can. But if you do get a CPA, make sure you get a good one. Find yourself a CPA that is a former IRS agent. There are plenty of them. They will keep you safe.

Expertel, a telecommunications company.

Expertel

1984 address book for the Dallas Society of Visual Communications.

Joan Maehr, Inc. Interior designer.

Dallas Society of Visual Communications.

Breacans, a golf and country club.

Michael Vanderbyl founded Vanderbyl Design in San Francisco in 1973. His work encompasses all aspects of corporate communication, publications, annual reports, brochures, signage, and environmental graphics. His designs have received many awards and have been featured in a number of shows, among them the Communication Arts Annual Exhibition and the AIGA Exhibitions. A series of posters by Vanderbyl are in the permanent collection of the Cooper-Hewitt Museum, the design museum for the Smithsonian Institutions, and three posters are in the permanent collection of the Library of Congress.
Vanderbyl's work has been published in Communication Arts Magazine, Idea Magazine, Graphis, Novum, *and* Industrial Design. *Most recently, his work will be published in a book,* Seven Graphic Designers, *by Takenobu Igarashi.*
He graduated from the California College of Arts and Crafts, where he has taught a course in advanced graphic design since 1973. He has also been a guest instructor at half a dozen colleges and universities, and is a frequent lecturer on design.

Even back in college I knew I wanted to have my own business eventually, but I never wanted it to get so big that it would take me off the board. I find that I can solve a problem a lot faster if I am the one who is doing it. I can also sell the idea a lot easier if I am the one who designed it. I also think I can anticipate certain problems that might crop up in the presentation because I am familiar with the whole process—from meeting with the client to designing it, to producing it. So I scaled my office based on that concept.

In this office, all the idea generation really comes out of my head. The ideas could be in the form of thumbnail sketches, or I might carry them all the way up to a tight comp. I don't think that this is the way to create a huge design firm, but after seeing what happened to some other designers who got heavy into managing, I am even more convinced that I am doing what is right for me.

Initially my business was just me, although I shared space with two filmmakers. After about eleven months, I finally rented my own space. At first I used freelancers for the production work exclusively. After a while I discovered that it would be cheaper to hire one full-time employee, which I did. I didn't have a lawyer, didn't have a bookkeeper. If I had to do it over I would have certainly gotten both as soon as possible. I would spend one whole day a week doing bookkeeping, which I was very poor at. I should have been designing.

After a while things got even busier, so I hired a second full-time person and a freelance person as well. Then, after that freelance person had been there maybe six months, and it turned out that I was keeping him busy full time, I figured it was safe to employ him full time also. That is usually how it has been with me.

My business eventually grew to the size it is now: Three full-time production-designers, which is about as many as I can keep busy. I like to have one person who is more or less a three-dimensional designer. We do a lot of signage and environmental graphics, so it's nice to have someone who makes models, does hardline drawings, goes out on site, supervises installations.

The people I like working for me are people that have the greatest desire in the world to be designers. People who are always pressing to do the best possible job. What I don't want are a lot of little robots who just do what they are told to do. I try to hire people who are new to the field. That is the great thing about teaching. I get to meet a lot of young people who are really quite good and have excellent potential. By getting the experience of working in this type of design office, they probably learn more in one month than they did in four years of college.

We also have an intern program. We take someone for a semester. We try to get him two or three days a week. He does everything from typing letters to making coffee, hand-folding brochures, and making paper dummies. When he gets a little more experience, we let him try doing production work. Later, if we have a position, he blends right in.

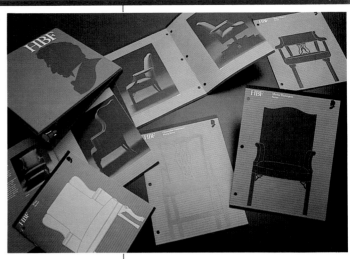

Brochure system and catalogue for Hickory Business Furniture, Hickory, North Carolina.

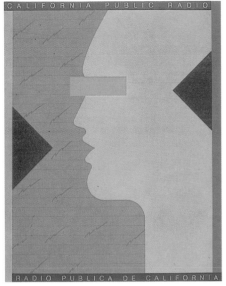

Poster for California Public Radio.

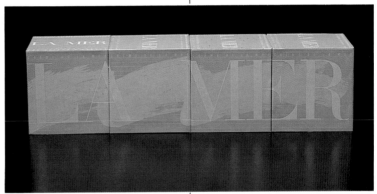

Package design for Creme De La Mer, Max Huber Research Labs, Inc. Agoura Hills, CA.

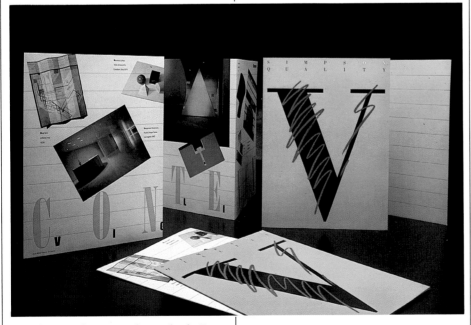

One of a series of promotional pieces for the Simpson Paper Company. This one features the work of Massimo Vignelli.

Mindset Corporation, Sunnyvale, CA. Manufacturers of computer graphic hardware and software. Software packaging is shown in transparency.

All the work I have gotten has been by referral. When a sales opportunity comes along that isn't a referral, it is usually a case where someone has asked for a proposal from three or four designers. I won't design anything on spec, but I'm not against doing a detailed proposal. I feel adamantly that doing work on spec is bad for the profession. I feel it is terribly important that the client know that this is a profession and that it costs money to think of ideas.

Establishing a long-term relationship with a client is very important to me. Because of this I am sometimes willing to bid a little less on a job. Then, if I can prove myself, it usually means I will be working for a client a long time. But most important, I try to take on projects that are interesting.

I have a furniture client. They said, "Well, we are selling Chippendale chairs to the contract industry. We need to approach this problem in a very different way. How can you help us sell our product to people?"

I said, "Well, first of all, we have to look at who the audience is. The audience is not the end-user. The audience is the designer who specifies the furniture—an architect or an interior designer. But your competitors in the industry are marketing their product with the end-user in mind."

I said, "Let's just go after the designers. Look at it in a contemporary way. With the post-modern movement in architecture, people are more willing to use the traditional chair in a modern environment, or a modern chair in a traditional environment. There is a little loosening up in the design field. Let's take advantage of it." And it worked. Spectacularly.

When they came to me they just wanted a small, single poster for a furniture show in Dallas. I said "Well, I'm going to do just a little more for you than that." I designed a poster which was twice as big, in a silk-screened, limited edition; also an entire brochure system and an identity program for them. We ended up changing the name of the company, and redesigning their showroom as well. This all started with a little poster project. And all this was still for the same fee that I was supposed to just do the poster for.

Their sales are up 300 percent in a little more than one year. In the long run, I have ended up making out far better than if I had only done the little poster. Now I have the entire account.

If a designer is only going to do what he is asked to do, then the client is never going to know what the project might have been. If you see an opportunity to create a long-term client, it makes sense to make an investment in the time and energy it takes to do it. Also, I find it a lot easier to think of the entire program at once, instead of trying to do it piece by piece.

For most of my long-term clients I have tried to work out basic rates for certain kinds of pieces, much like an illustrator would do. Photography, press proofs, type, any out-of-pocket costs are usually billed separately with a 15% markup.

Normally we try to bill all the printing, as well as any large outside costs, directly to the client. I don't think it makes sense for a designer to get a markup on things like that. It might encourage designers to do some strange things. After all, 17 percent of $100,000 is a lot better than 17 percent of $10,000. So the incentive to specify and be frugal just might not be there.

The fee I would charge for an identity program depends greatly on the extent of the program, of course, but generally, we won't do anything for less than $3,500.

I do know that I really enjoy this business. I am having a great time. I get excited when I just walk into the office, especially if I am working on an especially good project. Just think about it. You design something and within a matter of only days 100,000 copies of it are printed and the whole world is looking at it. There aren't too many other jobs where you can get that thrill. An architect designs a building and has to wait seven years for his building to be put up, and then it isn't anything like he originally designed. Here, when we want to experiment with something, four weeks later, there are thousands of copies of it all over the place. If the experiment didn't work, well, the copies just disappear and you try again. When an architect puts up a dud it just stays there, and everybody knows about it for years to come.

I think designers ought to remember that the business they are in is graphic design. The minute you start worrying about the money, the quality of the design suffers. If you always try to maintain the quality, the money will be there one way or another. Take a job based on its merit, not on what it can pay you. That has been a philosophy of mine ever since I started. I will do any job, no matter what amount of money the client has, if it is something that in the end will be fun and will help me to move into another market.

Poster for Workspace '85.

Workspace 85 The definitive annual

May 14-15, 1985 Exhibition & Conference

Moscone Center - San Francisco for the Office Environment

Work space

85

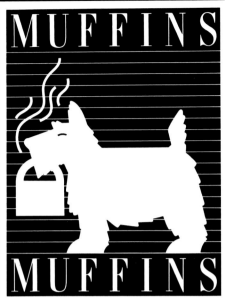

Logo for Muffins Muffins, San Francisco.

*Logo for Napa Valley
Corporate Park,
Bedford Properties,
Lafayette, CA.*

*Another piece from
the Simpson Paper
Company series, this
one featuring the
work of Porsche
Design.*

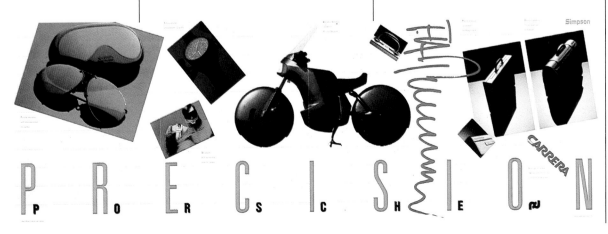

Ken White is president of White + Associates, a Los Angeles firm specializing in corporate identity programs, annual reports, marketing and sales tools, package design and exhibits. White attended the Art Center College of Design and Chouinard Art Institute. He started his career as a designer and art director for a Nashville, Tennessee publishing company, moved to an advertising agency, then was a partner and creative director in a graphic design firm. In 1968 he began his own firm in Nashville. He closed the office and reopened his own firm in Los Angeles in 1973.

I went to school at the Art Center School of Design in the early '60s. I also went to Chouinard Art Institute, which is now CalArts. I was married at the time and had one child. When a second child was born, things got pretty tight and I had to drop out of school . . . a familiar story.

I am originally from Tennessee. My wife and I decided to leave California and move to Nashville, where I thought good opportunities to practice my profession would be available.

My first job was with a publishing house where I worked as a designer. After a couple of years I got a job at an advertising agency as an art director. Two or three years later, the creative director, one of the media buyers and I decided to form a design firm. I put up about $3,000 . . . and that's how I started my first design business. We stayed in business about eighteen months and we did quite well. But the other two principals decided that they wanted to become an advertising agency. I wanted to remain a design firm. So we parted company. I took the accounts that were suitable to a design firm and they took the accounts that were suitable to an advertising agency.

At the time I started freelancing, practically all my clients were advertising agencies. I didn't understand how a designer got clients directly. I was still working by myself, so I did the conceptualizing, the designing, and some of the writing. I used a couple of other studios for production. A year or so later I began to get accounts directly.

I had an accountant at that time, but not a lawyer—doing business was easy and I never needed one. I had a very simple project control system! It was just sets of two envelopes, "Business In" and "Business Out." And "Money In" and "Money Out." I had no idea how much profit I was making. I didn't understand fixed-overhead costs, or anything like that. If I had money in my account I thought I was making a profit.

I didn't incorporate until later in 1968. That's when we began managing some aspects of the business and looking at our profit margin of 45 to 50 percent. I'll never see that again. My overhead was practically zero. That was the year before we started hiring employees.

Ninety-five percent of the business and contracts were effected completely on a handshake. Occasionally there would be a purchase order issued, but it was no big deal if there wasn't.

My total overhead, before we hired any employees, was something like $250 a month—*total—everything*. We were able to save a lot of money.

There was only one hitch in that beautiful, simple setup. I couldn't figure out how to grow and get more challenging work. The rest of the world was producing great work and I felt an overwhelming desire to do the same. I knew that there must be ways to get new, better clients and to upgrade my business. I talked to everyone I knew but they couldn't advise me. It was very frustrating.

The frustration was mounting. I decided to quit and close my office, even though we were billing $125,000 annually—mostly profit.

Six months later I finally said, "I can't quit! I can't give up!" I still had the desire to go on.

I decided to move to a larger city, with a large and diverse market. My plan was to work for a large design firm and learn all I could. So in late 1972, we packed everything we owned and moved to Los Angeles.

white+Associates

This striking poster provides a format for the awe-inspiring images of Saturn that were transmitted to Earth by the Voyager mission. The series of five posters was awarded a prestigious Presidential Design Award, as well as numerous national and international awards.

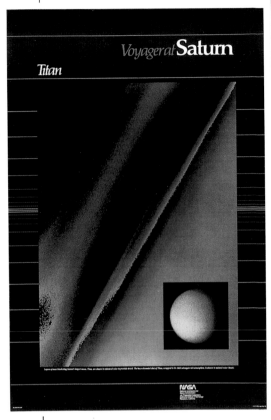

The capabilities brochure positions Lockheed-California Company as a technological leader with quality, state-of-the-art manufacturing methods and materials.

The Los Angeles Olympic Organizing Committee selected White + Associates to take part in the memorable 1984 Olympics.

This handsome brochure for computer software is designed to be appealing and accessible to the legal professional.

We got settled in Glendale and I began making the rounds looking for a job. To my surprise I discovered I was asking for too much money. I was only asking $20,000, but the design firms I approached said they would hire me at $12,000. I knew my family couldn't get by on that amount. I finally found a small design firm that agreed to pay me what I needed. I only stayed there for six months.

I had three freelance accounts, so once again I got my license and started a new design office, working out of my house. I contacted design firms and advertising agencies for work.

My whole method of acquiring business was through cold calls. I had no printed material to send out or leave behind, but I did have extensive experience and a solid portfolio. The thing that worked for me was sheer numbers. I would see as many as 10 to 15 corporations or agencies a day. The hard work and persistence paid off as I gained new accounts.

I worked out of my house until 1979. I loved it. But in 1978 we had another child. Things started to get complicated as the house started crawling with clients, freelancers, and suppliers.

I moved into space in Hollywood and redid my stationery and forms, retaining the simple procedures for accounting and job trafficking. However, it didn't take long to realize that the handshake and verbal agreement were things of the past. I had to refine my business methods.

Work in the new office started off with a bang! There were new clients and lots of work. I needed to hire another person in addition to the production person I had. A young designer came in to show me his book and was asking $22,000. He was terrifically talented but I told him that was way too much money. Then I remembered what I was told when I started looking for a job in LA and I said to myself, "You have got to take a chance; you have to step out on a limb." I called the young man back and hired him. That was the first major step in my company's growth.

The work was flowing in, but we were making mistakes on the business side. I must admit that I was flying by the seat of my pants. Then one of my clients took me for $15,000 and almost put me out of business. And almost broke my spirit. That lesson forced me to become a better businessman.

I went to business seminars and asked other designers for help and an interesting thing happened: When we started documenting our work with conference, progress, and revision reports, we started acting like a business. Our attitude changed about ourselves and our clients began to perceive us as businesspeople they could relate to, as well as a creative resource.

We initiated an agressive public relations and promotions program. Press releases are mailed to graphic arts trade publications and business publications as well as to our clients. We also mail our awards list to clients to let them know how we are being judged by our peers. We do a self-promotional mailing every six months to keep our name out there among clients, potential clients, publications, even professional organizations at which I could speak or judge shows.

By the end of 1984 there were 10 people on staff. Our team is working like clockwork and I think we are at a size now that can handle any type and size of project.

We've made major changes in developing a basic, dependable system of forms, reports, and time sheets. We require a signed contract (either yearly or per project) and a purchase order for everything we do.

When a job first comes in, we assign a number and fill out an in-house estimate control sheet. We estimate our projects by task; that is, we have determined a price for every task and we allocate a certain number of hours to complete a particular task. We estimate our buyouts based on previous similar jobs and mark up the basic buyout cost by 20 percent.

I then analyze the bottom line figure at which we have arrived. Is it reasonable? Will there be much research and analysis? How complex will the job be? How difficult is the client in terms of meetings, changes, approvals? Will this project greatly increase the client's profits? Many factors are taken into consideration when determining our price. In our office, a 24-page-plus-cover brochure might come in as low as $10,000 and as high as $30,000.

Our figures get translated into a proposal that we present to our client. We identify the scope of the project and what we will provide for our fee.

Because some clients don't understand the terminology we use, we prefer to go over the proposal face-to-face with the client. There have been instances when we have sent out proposals and the client would get confused about some aspect. He or she would blow up and we would never find out what went wrong. All the trust and rapport that you have built up goes out the window. If you present the proposal in person, there's less chance that the client will misinterpret what you are saying and you are right there to counter any objections.

After the project gets the go-ahead, we set up time log and buyout sheets. At any time on any project we can go to this system and know exactly how many hours we have put in and how much the buyouts are. By comparing these numbers to those on the estimate control sheet we find out how much time and money is left to maintain a reasonable profit. We try to make 15 percent profit on every project.

Looking back on my career, I think I should have tried to learn more about how to run a business. Most of us designers and creative people are too romantic. We live in a fantasy world. It doesn't occur to us that we are *in business* until we are in trouble. Running a design business is not a romantic notion or a game.

I would have benefitted from more specific business knowledge. But perhaps it was necessary for me to go through all those painful experiences to be where I am now.

The First Interstate Bank Forecast 1985–1986 emphasizes both the American dollar's strength in foreign exchange markets and London as the center of the world's financial markets.

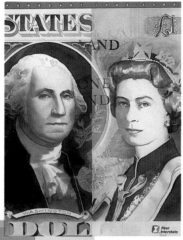

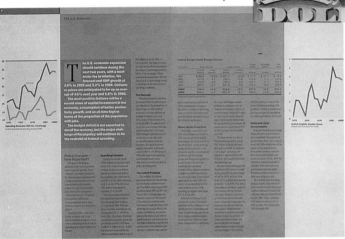

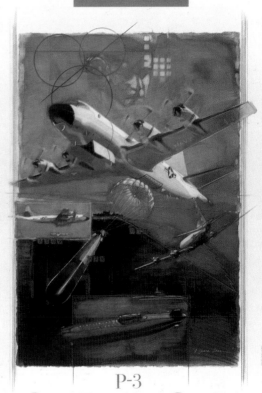

P-3
ORION

Illustrative poster for Lockheed Corporation that highlights the mission capabilities of the P-3 Orion airplane

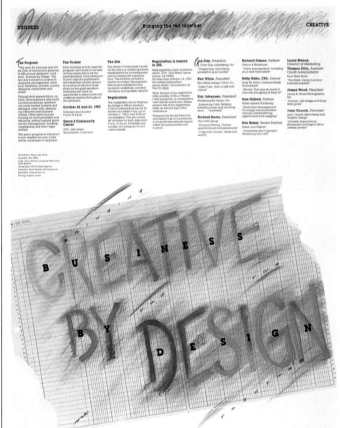

Ken White illustrates the duality of creative talent and business skills in this poster for a business conference at which he was keynote speaker.

Index